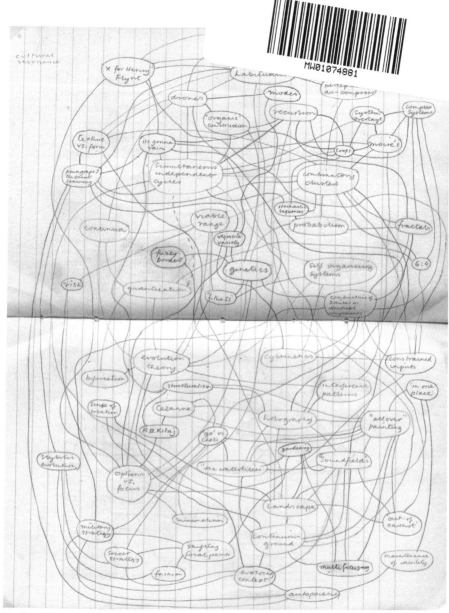

Page from one of Eno's notebooks, 1984–85.

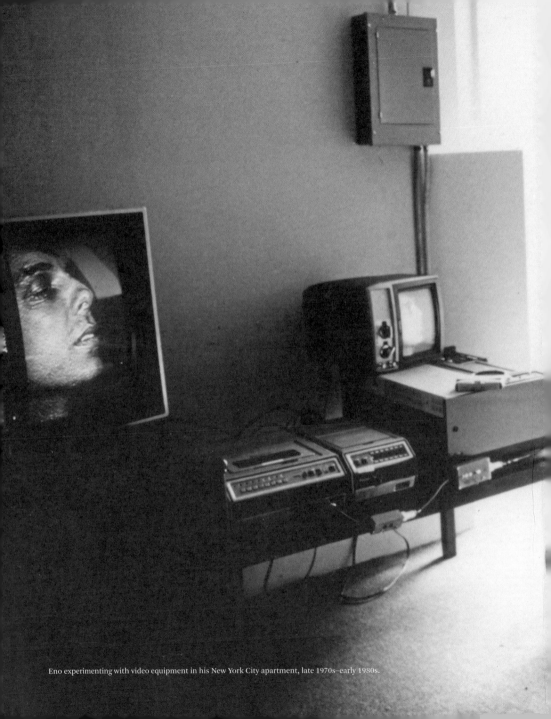

Eno experimenting with video equipment in his New York City apartment, late 1970s–early 1980s.

BRIAN ENO
VISUAL MUSIC

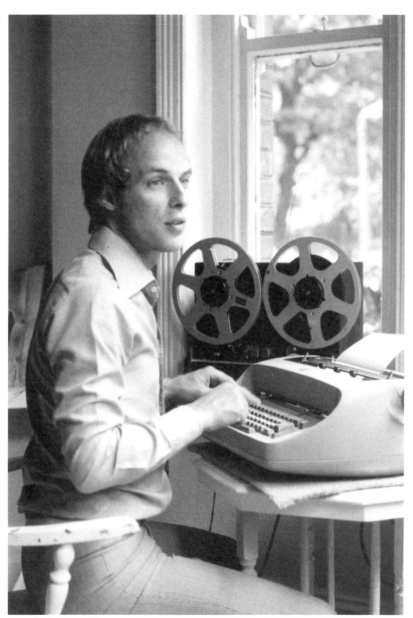

Eno in the studio, late 1970s.

BRIAN ENO
VISUAL MUSIC

By Christopher Scoates

With contributions by Roy Ascott, Steve Dietz, Brian Dillon, Brian Eno, and Will Wright

CHRONICLE BOOKS
SAN FRANCISCO

Brian Eno would like to thank the many people who have helped bring these works to life, in particular Tom Bowes, Michael Brook, Gabriella Cardazzo, Rolf Engel, Roland Blum, Frank Meyer, Juan Arzubialde, Jose Smith, Marlon Weyeneth, Dominic Norman-Taylor, Paul Collister, and Nick Robertson.

This book is accompanied by an excerpt from *CAM (Canada, Amsterdam, Milan)*, 1983–84, a previously unreleased composition by Brian Eno. The original composition was of indeterminate length and versions of it were included in many of his exhibitions between 1983 and 1995. To download the music please visit www.chroniclebooks.com/BrianEno and scratch below for code:

First Chronicle Books LLC paperback edition, published in 2019.
Copyright © 2013 by Christopher Scoates.
Foreword "Extending Aesthetics" Copyright © 2013 by Roy Ascott
Essay "Gone to Earth" Copyright © 2013 by Brian Dillon
Lecture "Perfume, Defense, and David Bowie's Wedding" Copyright © 1992 by Brian Eno
Essay "Learning from Eno" Copyright © 2013 by Steve Dietz
Interview with Brian Eno Copyright © 2013 by Will Wright and Brian Eno

Page 412 constitutes a continuation of the copyright page.

Library of Congress Cataloging-in-Publication Data

Names: Scoates, Christopher. Aesthetics of time.
Title: Brian Eno : visual music / by Christopher Scoates ; with contributions by Roy Ascott, Brian Dillon, Brian Eno, Steven Dietz, and Will Wright.
Description: First Chronicle Books LLC paperback edition. | San Francisco : Chronicle Books, 2019.
Identifiers: LCCN 2018031544 | ISBN 9781452169361 (alk. paper)

Subjects: LCSH: Eno, Brian, 1948—Criticism and interpretation. | Musicians as artists—England.
Classification: LCC N6797.E55 B75 2019 | DDC 709.2—dc23
LC record available at https://lccn.loc.gov/2018031544

ISBN: 978-1-4521-6936-1 (paperback)
ISBN: 978-1-4521-0849-0 (hardcover)

Manufactured in China.

MIX
Paper from responsible sources
FSC
www.fsc.org FSC™ C016973

Designed by Andrew Blauvelt and Matthew Rezac
Image retouching by Greg Beckel

10 9 8 7 6 5 4 3 2 1

Chronicle Books LLC
680 Second Street
San Francisco, CA 94107
www.chroniclebooks.com

This book is dedicated to Fiona, for her endless support and love.

— Christopher Scoates

CONTENTS

Ipswich Civic College
Untitled (yellow circle)
baroque (etceterart)
THE NATIONAL ANTHRAX. ARISE.
Untitled
Untitled (…)
NNNNNNNO

Winchester College of Art
Permutational Drawings (Square)
Permutational Drawings (Nodal)
. testing old wives.
simplepiece for two players.
2 projects for a painting.
readymade error paintings !
cities with multi-level transparent floors.
identikart.
film 3.
A positive Use of the Puddle.
series 1 (do nothing until a mistake is made)
series 2
first performance of 'do nothing until
* a mistake is made'*
.switch on tape recorder.
self-regulating drawing tactics.
Untitled (two performers)
SONGMAKING SYSTEMS
WHEN I RAISE MY HANDS YOU
* STOP DEAD.*
Untitled (British Standard Time)
the story so far
examining carefully the corners of my eyes

FOREWORD

EXTENDING AESTHETICS

ROY ASCOTT

Any attempt to locate Brian Eno's work within an historical framework calls for a triple triangulation, whose trig points in the English tradition would seem to be Turner/Elgar/Blake; in Europe, Matisse/Satie/ Bergson, and in the United States Rothko/La Monte Young/Rorty. This triple triangulation will quickly be seen as insufficient, however, since those based on Asian and Middle Eastern cultures will also be required. Soon it would become apparent that a precise or consistent location cannot be determined, except by the abandonment of triangulation in favor of a dynamic network model. Here we would need to adopt second-order cybernetics, the recognition that attempting to measure cultural location is relative, viewer dependent, unstable, shifting, and open-ended. This conclusion reminds me that Brian was the first of my students to understand that cybernetics is philosophy, and that philosophy is cybernetics.

However, this approach to an understanding of Eno's art would in itself fail to recognize his aesthetic of surrender and meditation, in which respect he seems to adopt a kind of Duchampian indifference, flowing from a process of removal of the Self from reflection, toward a quiet celebration of uneventfulness. If we take the high road to interpretation, we can say that his work exemplifies Plato's theory of forms: an approach to art that invests its creativity in the Ideal (in this case binary code), and affords the expression of the Particular in sound and image, a sort of *res extensa* that is both both/and and either/or. To stay with philosophy, we can recognize value in Bergson's insight, "We seize, in the act of perception, something which outruns perception itself." It is the specificity of that something that is recognized by those who are participants in Eno's art.

Here a distinction has to be drawn between the old order of music and art in which there are listeners and viewers, and the situation that now demands an active perception, what might be called *proception*, in the participatory process. We can recall McLuhan's dialectic of hot

and cold media, where hot is "too fast, too light, too loud" as Brian once described the Los Angeles media scene in a KQED interview. Cold is where it's at, if the viewer is to be engaged, calling for simplicity, ambiguity, open-endedness, and, specifically in Eno's work, a kind of variable repetition. Mind and matter, ontology and ecology, are in a state of indefinable extension, both analytically and numerically indeterminate. His dexterity in putting time in space and space in time is beyond numerical analysis, despite such rubrics as *68 Weeks Ambience*, *77 Million Paintings*, *48,000 Lumens*, and *400 Bodies*.

Finally, we cannot grasp the ambient identity of Eno's artwork without also recognizing the ambient identity of the artist himself. This demands knowing not only where to place him in the spectrum of roles across philosophy, visual arts, performance, music, social and cultural commentary, and activism, but in terms of personae, or as we say now, *avatars*. In the Groundcourse days, that is during the 1960s, when I first established a rather radical approach to art education in Britain (and which was emphatically the very antithesis, of course, of Groundhog days), identity, role-playing, and the variable persona were very much on the agenda, the goal of which was the construction of the Self. Throughout his career, not only has Eno explored identity, he has provided the context, employing light, sound, space, and color, in which each participant can playfully and passionately share in the breaching of the boundaries of the Self.

ACKNOWLEDGMENTS

CHRISTOPHER SCOATES

Brian Eno's career as an accomplished recording artist, musical pioneer, and producer is widely documented. His innovative studio and production techniques have been critiqued and discussed at great length in articles, interviews, and essays. He has written and published on a variety of subjects including ambient and generative music, music copyright, the studio as a compositional tool, and the role of the artist and of art. His interests range widely and his pursuits are not limited exclusively to music. He has written in opposition to the wars in Bosnia and Iraq and in 1996 he provided a window into his world with the publication of a year of diary entries as *A Year with Swollen Appendices*. He has given illustrated lectures on art, culture, evolution, science, serenity, and complexity theory. He serves on the board of the Long Now Foundation, which in a contemporary society accustomed to acceleration, instead promotes long-term thinking as a necessary cultural construct. Indeed, his polymorphous practice is marked by an inquisitiveness that is as incisive as it is wide-ranging.

Since the mid-1960s, Eno has pursued a career in the visual arts that has developed in tandem with his work as a musician. Not as distant in their conceptual approach as one might think, these parallel practices have often informed each other, but curiously, Eno's work as a visual artist has gone largely unnoticed. It is hardly surprising that he is better known for his musical output, given that it is far more easily distributed, marketed, and consumed; as Eno recognizes, "If you release an album, the chance is it will be available to the whole world and everybody within a couple of days. But if you show your work in an art exhibition, the audience would have to physically be there in order to see it."[1]

Eno's formal visual arts education provided the theoretical tools that have served him so successfully as both a musician and a visual artist. His approach to both art and music is a conceptually driven process integral to the work itself. This book explores the intersection of those dual practices. The essays and accompanying texts focus on the ways

in which Eno's approach to art making overlaps and flows seamlessly between both his art and music, and approach Eno's work from diverse perspectives that attest to the breadth of his inquiry. "The Aesthetics of Time" traces Eno's career from his early art school training with Roy Ascott at Ipswich Civic College to his latest installation at the Sydney Opera House as part of the Luminous Festival. The essay discusses his work against the backdrop of color organ music, cybernetics, Fluxus, structural and experimental film, and video and installation art. In "Learning from Eno," Steven Dietz examines the technological trajectory around Eno's new media works and argues the ways in which they have been important to the development of the field and current new media art practice. In "Gone to Earth," Brian Dillon contextualizes Eno's visual work and music through the lens of the British landscape tradition. In addition, an in-depth interview between Eno and game designer Will Wright traverses Eno's creative process, generative systems, sound, and his newest smartphone app, *Scape*. A transcription of Eno's 1992 three-part illustrated lecture, "Perfume, Defense, and David Bowie's Wedding," reveals Eno's thought process as a conceptually driven one that brings together diverse topics including the sense of smell, the amount of money spent on the defense budget, and the marriage ceremony of David Bowie and Iman in a brilliant synthesis of intellectual maneuvering.

Brian Eno: Visual Music would never have seen the light of day without the generosity and assistance of many people. The scope of this project and the thousands of research hours make it impossible to acknowledge each individual adequately. I'm wholeheartedly thankful to authors Steven Dietz and Brian Dillon for their insights and critical analysis of Eno's work. As leading contemporary critics, they bring a fresh perspective to it. The spirited and vigorous conversation between Will Wright and Eno was sparked by a friendship and working collaboration going back a number of years. As Eno's first major art professor, Roy Ascott provides a unique perspective on Eno's visual work, and I am indebted to him for sharing it in the foreword. Indeed, I'm extremely appreciative to all the contributors for their insights.

This volume is also enriched by the contributions of many photographers, archivists, individuals, and institutions that loaned or otherwise shared important documents. In Germany, both Roland Blum and Rolf Engel generously shared archives of photographic and ephemeral materials. Nick Robertson's photographs grace many pages in this book, which would be much poorer without them. Numerous other individuals and institutions who provided necessary materials

are recognized elsewhere in the photographic credits for this volume, and my sincerest thanks extend to each one of them.

I'd like to recognize my editor at Chronicle Books, Bridget Watson Payne, for taking on the project and supporting the book from the outset. Editorial Assistant Caitlin Kirkpatrick's attention to detail, eagle eye, and good humor was much appreciated throughout the complex proofing and galley stages. They are both part of the publisher's larger team that has shepherded this book to publication, and although all of them are not known to me individually, they have my gratitude. Enormous thanks go to Elizabeth Hanson, who volunteered countless hours on the research, development, and production of the book. Her dedication, commitment to quality, and attention to every detail kept the project moving forward and on track from the beginning. Elizabeth has gone above and beyond every step of the way. Many thanks to Karen Jacobson, whose skillful edits shaped my essay. Thanks to Gavin Lumsden and Alexandra Sage and their family for allowing me to stay at their beautiful London home every time I flew to the UK to work on the book. Rand Foster of Fingerprints Records graciously loaned Eno material from his inventory when it was difficult to locate elsewhere. And to Gary Heath, who sparked my interest in music as a young student in secondary school, I am eternally grateful.

What would I do without my go-to book designers Andrew Blauvelt and Matthew Rezac? When I was working on the initial proposal, there was no question that Andrew and Matthew would design the book. They are two extraordinary designers for whom I have the utmost respect and trust, established over many years of working together. Their exacting high standards, hard work, and relentless commitment have resulted in a beautiful book. A colossal thank you to my wife Fiona, who has been supportive, reassuring, and encouraging at every step along the way. She has shown an unshakable and steadfast perseverance, which has helped make this the best project it could be. Her sharp editorial eye and dedication to quality and clarity enhanced my essay immensely. Thank you!

Finally, this project would not have moved forward without the consent and blessing of Brian himself. His entire team has been a delight. Many thanks are due to Dominic Norman-Taylor, Nick Robertson, and Jane Geerts for their assistance and participation throughout the process. At every stage of the project, which has now been several years in the making, Brian has been collaborative, gracious, and supportive. This book would not have been realized without his generosity of time and spirit. I am truly honored by the opportunity to bring his extraordinary visual work to the wider audience it so deserves.

THE AESTHETICS OF TIME

PROCESS OVER PRODUCT: THE ART SCHOOL YEARS

CHRISTOPHER SCOATES

> Color directly influences the soul. Color is the keyboard, the
> eyes are the hammers, the soul is the piano with many strings.
> The artist is the hand that plays, touching one key or another
> purposively, to cause vibrations in the soul.
> —Wassily Kandinsky[1]

In Western thought, music, and in particular its attendant principles
of proportion and harmony, have informed an understanding of the
world since antiquity. Within the arts, the relationship between music
and painting has been understood as one based on the shared concerns
of composition, proportional relationships, and harmonic ratios. But it
was not until the nineteenth century—with the rise in scientific studies
on color, optics, and perception—that the connection between visual
and auditory stimuli took on greater currency. In the wake of research
by scientists and theorists such as Joseph Plateau, Michel Eugène
Chevreul, and Ogden Rood, the dialogue between painting and music
began in earnest. In his 1902 essay "Musical Painting and the Fusion of
the Arts," Camille Mauclair posited a correlation between the paintings
of Claude Monet and the musical compositions of Claude Debussy,
concluding that "chroma, harmony, value, theme, [and] motif" are
"employed equally by musicians and painters."[2] In 1912 the British art
critic Roger Fry, himself a member of the Bloomsbury group, coined the
term *visual music* to describe the abstract works of the Russian painter
Wassily Kandinsky.[3] Like many artists of the avant-garde, Kandinsky
was interested in synesthesia—a rare neurological condition that
produces a cross-sensory perceptual fusion, often between color and
sound.[4] He explored this synthesis in paintings, stage compositions,
and writings such as *Concerning the Spiritual in Art* (1911) and "On Stage
Composition" (1912).[5] For Kandinsky, a trained pianist and cellist,
the emotional power of music provided inspiration for abstract paint-
ings that used line, shape, color, and form to produce a concordance
between musical and visual tones (fig. 1).

Music, as an inherently abstract form, provided a potent meta-
phor for artists of the avant-garde in their search for an alternative
to prevailing modes of representation. Among them were the Czech
painter František Kupka; Paul Klee, whose paintings have often been
interpreted as graphic transcriptions of musical rhythm; and Francis
Picabia, who asserted that the rules of both painting and music should
be learned as follows: "If we grasp without difficulty the meaning and
the logic of a musical work it is because this work is based on the laws
of harmony and composition of which we have either the acquired

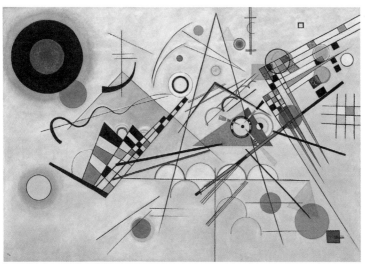

fig. 1

fig. 1
Wassily Kandinsky,
Composition 8
(Komposition 8),
July 1923, oil on canvas
55⅛ x 79⅛ inches.
Solomon R. Guggenheim
Museum, New York,
Solomon R. Guggenheim
Founding Collection,
by gift 37.262.

knowledge or the inherited knowledge . . . The laws of this new convention [painting] have as yet been hardly formulated but they will become gradually more defined, just as musical laws have become more defined, and they will very rapidly become as understandable as were the objective representations of nature."[6] For Piet Mondrian, the improvisational attitude of jazz was particularly significant, and its influence is evident in the dynamic rhythms and pulsating colors of *Broadway Boogie Woogie* (1942) (fig. 2).

While these painters invoked music as an important touchstone and created works that gave visual form to its syncopations and staccato rhythms, they remained rooted in the static, two-dimensional plane of easel painting. It wasn't until the latter half of the twentieth century that artists began to engage more directly with "real life" in their challenge to the conventions of art making. Turning to their bodies, the landscape, and everyday life to extend the parameters of aesthetic experimentation, they radicalized the relationship between the artist, the art object, and the audience. In this burgeoning effort to rethink artistic practice during the late 1950s and early 1960s, happenings and performance art came to the fore among a host of emerging forms that also included Fluxus, an international collective of artists noted for its work across the disciplines of visual arts, experimental film, literature, performance, and music. Fluxus mounted a critique of individual

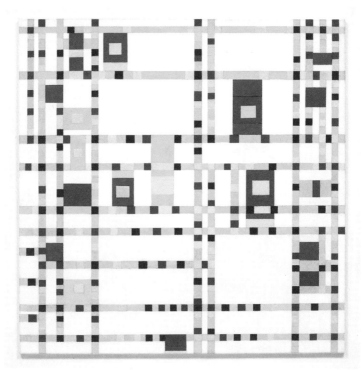

fig. 2

authority by proclaiming, "anything can be art and anyone can do it,"[7] rejecting the boundaries between painting and sculpture, photography and film, in favor of a more fluid approach that was quickly termed "intermedial."[8] It was against this backdrop that a young Brian Eno first enrolled in art school and began his formal art education.

> Art schools manage to balance themselves on the fence between telling you what to do step by step, and leaving you free to do what you want. Their orientation is basically towards the production of specialists, and towards the provision of ambitions, of goals, and identities. The assumption of the correct identity—painter, sculptor—fattens you up for the market. The identity becomes a straightjacket; it becomes progressively more dangerous to step outside of it.[9]
> —Brian Eno

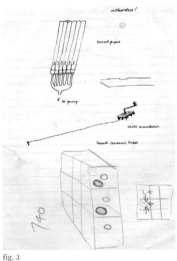

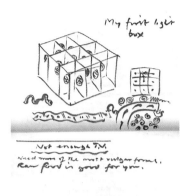

fig. 3
Page from one of Eno's notebooks with sketch of his first light box at bottom, mid-1960s.

fig. 4
Page from one of Eno's notebooks with light box sketch drawn retrospectively, 1990.

fig. 3 fig. 4

For more than forty years, Brian Eno has explored the complex relationship between light and sound, an interest that began long before he ever enrolled in his first art class. As a teenager he became fascinated by manipulating light and sound. His initial experiments with light used readily and cheaply available elements arranged in unusual and original combinations (fig. 3, 4). The best of these he went on to patent as a "light display unit" in hopes that it might rival the appeal of Astro Lamps, also known as Lava Lamps, a novelty item of recent British invention that could be found in pubs throughout England. These experiments with light were eventually abandoned, as Eno's attention turned to synthesizers and the manipulation of sound. Whereas the ability to distort and direct light was relatively limited, the possibilities afforded by synthesizers were much greater, and as the technology became more affordable and accessible, he embarked on what would become a career-long fascination with the medium.

Eno's formal arts education began in 1964, when he enrolled in a two-year foundation course at Ipswich Civic College, where several of his tutors would later encourage his early experiments with sound and light. Eno studied under the artist Roy Ascott, who was making groundbreaking artwork with the computer long before the Internet infiltrated every aspect of life. Ascott coined the term *telematic* to describe his practice, which used online computer networks as an artistic medium. He had established a radical and somewhat unorthodox approach to teaching

fig. 5
One of Eno's class
assignments from the
Groundcourse, Ipswich
Civic College, ca. 1965.

Course Tutor Lawrence Self.

Groundcourse 2

The problem for each group might be the invention of a game. This would
necessitate the creation of an enviroment within a determined and seperate
area. The structure would require a variety of materials. Light, colour,
sound, scent and texture, together with movement and change could be considered
as possible attributes. The function of the group in relation to this enviroment
might require the use of masks, costumes, voices, music as the game develops.

In "Man, Play and Games", R. Caillois. 1962.p.65. attitudes and impulses common
to "the unprotected realm of social life "and the" marginal and abstract world
of play" are listed as follows:-
The need to prove one's superiority.
The desire to challenge, make a record, or merely overcome an obstacle.
The hope for and the pursuit of the favour of destiny.
Pleasure in secrecy, make - believe, or disguise.
Fear or inspiring of fear.
The search for repition and symmetry, or in contrast, the joy of improvising,
inventing,or infinitely varying solutions.
Solving a mystery or riddle.
The satisfaction from all arts involving contrivance.
The desire to test one's strength, skill, speed, endurance, equilibrium, or
ingenuity
Conformity to rules and laws, the duty to respect them, and the temptation
to circumvent them.
And lastly, the intoxication, longing for ecstasy, and desire for voluptuous
panic.

The translator's introduction to the above work states - "Caillois"defines
play as free, seperate, uncertain, and unproductive, yet regulated and make-
believe. The various kinds of play and games are subsumed under four categories,
agon (compotition), alea (chance), minicry (simulation), and ilinx (vertigo).
Under certain conditions these rubrics are paired. For example, many Australian,
American Indian and African cultures illustrates the mimicry - ilinx complex
in their emphasis upon masks and states of possession. Ancient China and Rome
on the other hand, reflect the opposing principles of agon-alea in stressing
order, hierarchy, codification, and other evidence of the interaction between
competitive merit and the accident of "chance" of birth; Furthermore, games in
each of the four categories may be placed upon a continum representing an
evolution from paidie, which is active, tumultuous, exuberant, and spontaneous,
toludus, representing calculation, contrivance and subordination to rules.
(As the dominating value in the paidia impulse, children's games would predominate
in this category)".

Reading List.

CAILLIS, Roger: Man, Play and Games. Thames and Hudson 1962 3 9↘3
COHEN, John: Chance, Skill and luck. Penguin Books (No. A280)
DAIKEN, Leslie: Children's Games throughout the year Batsford 1949 39↘3
GROOS, Karl: The Play of Animals. D. Appleton and Co. New York. 1898
GROOS, Karl: The Play of Man D. Appleton and Co. New York 1901.
HESSE, Hermann: Magister Ludi. trans. into German by Mervyn Savill Holt. 1949
HUIZINGA, Johan: Homo Ludens. Roy Publishers. New York 1950
VON NEUMANN, J., and MORGENSTERN, O. Theory of Games and Economic Behaviour.
 Princeton 1944.
SCHLEMMER, Oskar and others: The Theatre of the Bauhaus.
 (edited and with an introduction by Walter Gropius. 1961

Museums and Exhibitions with Etherological Collections.

Horniman Museum London S. E. 23.
Donning Site. Cambridge.
Ipswich Museum.
Treasures from the Commonwealth exhibition, R... Piccadilly. London W.1.

 The Structure of the enviroment must be open. The game GO will be introduced

fig. 26

art, which he called the Groundcourse (fig. 5).[10] In his now famous 1964 essay "The Construction of Change," Ascott outlined the interdisciplinary nature of the course, which focused on process and method over product, and which drew together biologists, a behavioral psychologist, a sociologist, and a linguist.[11] This radical new way of teaching art was developed around cybernetic theories of systems of communication: the flow of information, interactive exchange, feedback, participation, and systemic relationships. He was one of the first artists and educators to discuss the possibility of using the computer to work collaboratively with others in remote locations. Through his writings and proposals, he was envisioning a global network of artists connected via electronic networks long before the advent of the World Wide Web.[12] Ascott had very clear ideas about the direction, outcomes, and objectives for those students who enrolled in the course. Prodding first-year students to scrutinize their preconceptions about art—"Art is Van Gogh"; "Art is what my teacher said it was to get me through my art exam"; "I am no good at colour"—was critical to Ascott's agenda for the course.[13]

Ascott established general areas of study for the first-year students and set out specific problems and exercises for them to address. They included the following:

Draw the room in reverse perspective. What information is lost?

Imagine you wake up one morning to find yourself a sponge. Describe visually your adventures during the day.

Make a sculpture in plaster of interlocking units, such that when a key piece is removed, the rest falls apart. Allot colors to separate pieces (a) to indicate the key (b) to facilitate reassembly.

Discuss visually the movements of a hungry, caged lion; then those of a frightened squirrel.

Invent two distinctly different animals, imagine them to mate, and then draw the offspring.[14]

The course concentrated less on the traditional products of art making, such as paintings and sculpture, and focused instead on process (fig. 6, 7). Ascott was fond of saying "that art that is art is not art—that art that is not art is art."[15] As part of the course, he had students engage in psychosocial-behavioral role-playing games that challenged their

fig. 6
A behavioral experiment
by a Groundcourse
student at Ipswich Civic
College, 1965.

fig. 6

instincts so that they began to rethink their preconceptions not only about art but about established patterns of the world as well.[16] Such a pedagogically innovative and experimental approach to teaching art proved to be a pivotal experience for Eno; as a young student whose expectations of art had now been turned inside out and upside down, he was given free license to think that anything was possible and that no subject was out of bounds.

In his first year under Ascott, Eno was challenged by a number of assignments that pushed him to think differently about the world and his personal environment. Expecting that art school was going to provide the opportunity to express his inner passions and talents, he quickly discovered quite the opposite, "As it happened, we couldn't have been more wrong. The first term at Ipswich was devoted entirely to getting rid of these silly ideas about the nobility of the artist by a process of complete and relentless disorientation."[17] Given his earlier experiments with light, one exercise that resonated strongly with Eno took place in a light-handling class in which students had to control the environment with lights, colored filters, lenses, and screens. Working with five other students, Eno built his first serious light project. He describes the accompanying illustration (fig. 8) as follows: "The pyramid field at the back of this picture is made from folded card. The lights were not turned on in this picture but what really happened was that there were coloured lights—red, green, and blue—around the sides of the pyramid field and these produced very elaborate patterns of colours where they

fig. 7

fig. 7
A behavioral experiment
by Groundcourse
students at Ipswich Civic
College, 1965.

fig. 8
Eno and his classmates
working on the "Game"
project, Ipswich Civic
College, 1966.

fig. 8

mixed. You can get a little bit of the effect from the fall of the white light on the surfaces, but with coloured light this is of course much more complex, as there are different mixtures of the three colours."[18]

The laboratory environment that Ascott developed stressed ideas and creative problem solving and was an ideal place for a curious young student like Eno, who remembers, "We were set projects that we could not understand, criticized on bases that we did not even recognize as relevant."[19] Nevertheless, the interdisciplinary approach of the Groundcourse laid an important foundation that paid dividends as Eno began to navigate his career path. He later recalled his art school years.

> I shouldn't glamorise Ipswich too much—a lot of it was a big mess and people didn't know what they were doing; but I had at least got used to the idea that *you were expected to be articulate*, and people would call you on it. You couldn't get away with just "art speak." You had to try, at least, to think out what you were doing. Ipswich made me become fascinated in the connection between the intellect and intuition. Normally these things are seen as disconnected; but I came out thinking that they were part of a continuum and that you had to know when to use them.[20]

26

In addition to Ascott, Eno's professors also included the painter Tom Phillips, who exposed the young student to philosophical texts by Ludwig Wittgenstein, novels by Vladimir Nabokov, and experimental recordings by David Tudor, La Monte Young, and Terry Riley. Eno respected Phillips as an instructor because he was demanding and rigorous. Eno recalls, "Tom had a rigorous approach to being an artist. I remember working on a painting for some time, and he looked at it in his skeptical way and said: 'It's rather slight, isn't it?' That discomfited me, but it didn't annoy me. His coolness was intriguing. Also I think I wanted that kind of rigour."[21]

It was through Phillips, who was as interested in music and literature as he was in the visual arts, that Eno was introduced to the idea that he could also make music. Under Phillips's tutelage, Eno listened to the work of Christian Wolff and John Cage. Together, they would make the trek to London to attend concerts, and Eno quickly became part of the experimental music scene, which was then a very small milieu.[22] Through Phillips, he was introduced to Cage's seminal work *4'33"* (1952), which consists of four minutes and thirty-three seconds in which the only sounds were those that emanated from the audience and theater environment while the musician sat silently. With his pioneering experiments with chance and the prepared piano, Cage championed indeterminacy in music and advocated a strategy that liberated sound from the composer's control. His influence has been widespread in twentieth-century experimental music, and his dictum that "everything we do is music"[23] paralleled what Eno was learning from Ascott and Phillips at that time. Eno states, "Cage, in particular was influential for me. In his case, composition was a way of living out your philosophy and calling it art. That was also the message that came over from Tom: if you wanted to be an artist there had to be a motivating force, which was more than simply wanting to add attractive objects to the world."[24] Eno would later compare his own approach to Cage's.

> John Cage . . . made a choice at a certain point: he chose not to interfere with the music content anymore. But the approach I have chosen was different from his. I don't reject interference; I choose to interfere and guide. . . . The music systems designed by Cage are choice-free, he doesn't filter what comes out of his mind; people have to accept them passively. But my approach is, although I don't interfere with the completion of a system, if the end result is not good, I'll ditch it and do something else. This is a fundamental difference between Cage and me. If you consider

yourself to be an experimental musician, you'll have to accept that some of your experiments will fail. Though the failed works might be interesting too, they are not works that you would choose to share with other people or publish.[25]

While embracing the lessons learned from Cage, Eno was also drawn to the methodologies and music of La Monte Young, Terry Riley, and Steve Reich. These American composers are widely regarded as the pioneers of the aesthetic and techniques of minimalism in musical composition. Many of their works were driven more by concept than convention and radically challenged traditional ideas of musical composition. Musical concepts of time, space, sound, and even the role and responsibility of the composer and the performer were subjected to critical scrutiny. Their compositions relied heavily on process and technique that followed strict rules, which inspired Eno. It was not uncommon for a composition to be repetitive or written using only a few notes, a small selection of instruments, or composed using just a few words.

Eno was particularly influenced by Reich's 1965 "It's Gonna Rain," which was one of the composer's first major pieces and a landmark minimalist work, calling it "probably the most important piece that I heard, in that it gave me an idea I've never ceased being fascinated with—how variety can be generated by very, very simple systems."[26] The entire tape recording for the seventeen-minute work was made by Reich in San Francisco's Union Square.[27] Brother Walker, an African American Pentecostal preacher, is speaking about the flood and the end of the world, and pigeons taking flight are picked up by nearby microphones. Reich captured the preacher saying, "It's gonna rain," which he repeated and looped throughout the piece.[28] He originally attempted to use two synced tape recorders to play the work, but due to the imprecision of the era's analog technology, the recording fell either ahead or behind in time. Reich would subsequently exploit this error—known as "phase shifting"—to explore new musical directions.

Eno would later discuss his reaction to Reich's work as thus: "A very interesting thing happens to your brain, which is that any information which is common, after several repetitions, you cease to hear. You reject the common information, rather like if you gaze at something for a long time, you'll cease to really see it. You'll see any aspect of it that's changing, but the static elements you won't see. . . . The amount of material there is extremely limited, but the amount of activity it triggers in you is very rich and complex."[29]

It was not just the combination of both the visual arts and music that was so important for Eno at this formative stage; the philosophical attitude that rejected virtuosity and product became crucial to his conceptual development. Both Cage's idea of "prepared randomness" and Reich's concept of "phase shifting" challenged Eno's very idea of music and stimulated his creative pursuits. On his jaunts to concerts with Phillips, Eno was being exposed to new, radical works and sounds that required no formal musical training but were pioneering compositions nonetheless.

It would be no surprise then, that during his second year of study at Ipswich, Eno wanted to find a way to incorporate the conceptual underpinnings of the music he was listening to and so began to rethink his approach to painting. He began by taking a "Cagean" attitude to creating new work. Just as Cage would prepare a set of instructions for a performance ("In a situation with maximum amplification [no feedback], perform a disciplined action"[30]), Eno began preparing specific directions for several people to paint a canvas: "I gave four people identical instructions of the type, 'Make the canvas such-and-such square, make a mark 14 inches from the top right-hand corner, and then measure a line down at 83 degrees and find a point here . . . ,' and so on. Each instruction built on the one before. If there was any error, it would be compounded throughout the picture. I ended up with four canvases that were clearly related but different from each other, and they were stuck together to make one picture"[31] (fig. 9).

At the time, the stance that art could be generated by ideas rather than emotions was revolutionary, and Eno was one of many artists who began using mathematical and linguistic systems to explore the ramifications of this approach. For Eno, this way of working spawned an entire series in which his authorial role was separated from its conventional relationship to an artist's gesture. Traditionally, the artist's gesture is a direct result of their thought process; by leaving the execution to others, he instead embarked on an exploration that would create an ever-widening gap between idea and execution. By the same token, the clarity of this process minimized the singular emphasis on the appearance of a work as a discrete object and instead explored the relationship between visual and textual modes of representation. Working around the same time, Sol LeWitt adopted a similar approach to drawing by following directions of his own invention. Rather than limiting the scope, a fixed set of instructions opened up the possibilities for a rigorous yet rich body of work. LeWitt would go on to expand his drawing to the scale

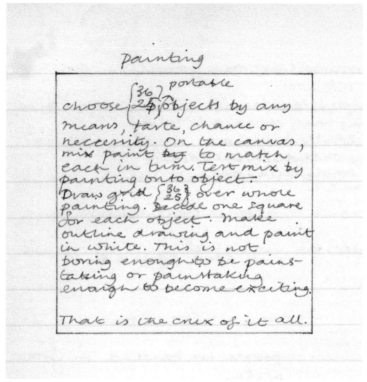

fig. 9

fig. 9
Page from one of Eno's notebooks with instructions for a painting, late 1969.

of architecture, enlisting assistants to complete the work in his belief that "the execution is a perfunctory affair. The idea becomes a machine that makes the art."[32]

During Eno's second year at Ipswich, he faced very different challenges in the Groundcourse. Instead of handing students a specific set of problems, Ascott required them to devise their own. For example, students were asked to create new personalities for themselves—"narrowly limited and largely the converse of what is considered to be their normal 'selves'"—and act them out for long stretches of time.[33] As part of the challenge, he required the students to design what he called behavioral "calibrators" that were used to determine the responses of their new personalities to events, materials, tools, and people (fig. 10).[34] As Eno explains, the students then charted the results, based on the behaviors that they had calibrated.

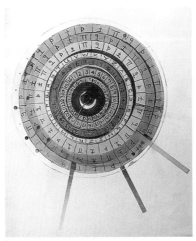

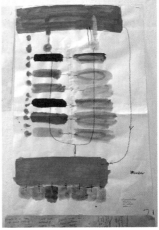

fig. 10
Calibrator for selecting
human characteristics by
a Groundcourse student,
Ipswich Civic College,
ca. 1963.

fig. 11
Mindmap by a
Groundcourse student,
Ipswich Civic College,
ca. 1963.

fig. 10

fig. 11

One procedure employed by Ascott and his staff was the "mind-map." In this project each student had to invent a game that would test and evaluate the responses of the people who played it. All the students then played all of the games, and the results for each student were compiled in the form of a chart—or mind-map. The mindmap showed how a student tended to behave in the company of other students and how he reacted to novel situations. In the next project each student produced another mindmap for himself that was the exact opposite of the original. For the remainder of the term he had to behave according to this alternative vision of himself (fig. 11).[35]

As he moved forward, process became Eno's conceptual filter. Between Phillips and Ascott, Eno was becoming completely enveloped in new and unorthodox ways of thinking about the world, visual ideas, and music. Eno became so enthused by the music he was hearing that he turned his attention to the use of tape recorders to make new work (fig. 12). Manipulating sound soon became more important than manipulating paint on canvas. So intent was he on finding new ways to make new sounds that he would haunt junk shops to find old tape recorders, "I thought it was magic to be able to catch something identically on tape and then be able to play around with it, run it backwards—I thought that was great for years."[36] It was during this period that he made his first recorded audio work using a metal lampshade as a bell-like sound

tapeloop. brian eno

basic equipment consists of three tape recorders,connected
by a single loop of tape passing thru all three heads. in
the diagram provided,recorders A and B are recording,while
recorder C plays back.Recording is made on two different
tracks,whilst C plays back both tracks simultaneously.

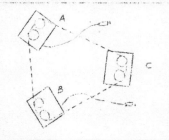

a noise made at a given time
(x)will record on both tracks
of the tape,and in different
places on it,and,after a d
delay(BC)will playback at C.
another delay(ABC)and there
will be a second playback.
the delay is directly depen-
dent on 1)distance between
machines,2)rotation speed of
tape.variance of these two
factors allows some degree of
control in this respect.

when a noise is played back at C,it is once again recorded
thru the microphones from A andB.due to acoustics and natural
echo of the environment,the recording made from such a play-
back will be of a different,more decayed quality.
theoretically,then,any noise made can be recorded and re-
recorded ad infinitum,which noise will incur a constant
decay in accuracy from the original.no sound is ever lost.

the apparatus may be used in a number of ways:it might
simply be erected,switched on and left to find and distort
incidental environmental noises,or,at the other extreme,it
might be used as a controlled and chronologically determined
mechanism;as an instrument in its own right.
it may be wired,by use of contact mikes,to 1)other instrum-
ents,2)to the moving parts of a building(such that the
inadvertent movements of the audience bacame the substance
for the piece)3)to the chairs on which an audience is
seated(the fart as art),4)to any external source(piccadilly
circus,clapham junction,ely cathedral,moving person),5)to a
stage floor upon which dancers were induced to move,such that
the sound of their own footfall became the rhythm to which
they danced.
the apparatus might physically enclose an entity - lecturer,
dinner-table,audience,centre of london,john cage,a bat,piano,
another tapeloop apparatus,and another.in these cases the
size of the enclosed entity determines the delay rate.
in conjunction with other pieces(eg. x for henry flint,drip-
event,distance,radio broadcast),or as a semi-determinate or
indeterminate signals mechanism.

 brian eno march 68

fig. 12

fig. 12
tapeloop., an early
tape recorder work at
Winchester College of
Art, 1968.

fig. 13
An early Eno sculpture
at Winchester College of
Art, 1967.

fig. 13

source; though it was the only input, looping it and playing it at various speeds created the suggestion of many bells. In this first experiment with recorded audio, Eno recognizes parallels to the far more sophisticated sound work that he composes today.[37]

In 1966 Eno continued his art studies by enrolling in a three-year fine arts diploma painting and sculpture course at Winchester College of Art in southern England. Coming from the experimental environment of Ipswich, Eno found the curriculum at Winchester far more traditional (fig. 13). The tutors at Winchester were more interested in producing painters who upheld the ideas of the academy and not artists who questioned them. Eno recalls, "When I went to Winchester it was all to do with product—the picture at the end. So at Winchester I was looking for anything that would keep me involved with process; it's hard to think of music, certainly, without thinking in those terms. The other idea about process was 'process within a community'—which again made music and 'happenings' appealing, because they involved rules and ways of tinkering with systems. Plus, there was an emerging trend within the arts that you could point to, in music, to prove that you weren't completely mad."[38]

Indeed, by the mid-1960s a blossoming of divergent happenings and performances hybridized theatrical, musical, sculptural, and literary forms of expression, reinvigorating the dissolution of traditional forms that had been initiated with movements such as Dada and futurism

fig. 14

earlier in the century.[39] Fluxus was particularly noted for its amalgamation of different artistic media and disciplines, and in 1966 the Fluxus artist Dick Higgins introduced the concept of *intermedia*, "For the last ten years or so, artists have changed their media to suit this situation, to the point where the media have broken down in their traditional forms, and have become merely puristic points of reference. . . . [T]hese points are arbitrary and only useful as critical tools, in saying that such-and-such a work is basically musical, but also poetry. This is the intermedial approach."[40] Speculating on the unbridled possibilities that such an attitude represented, one artist mused, "Imagine, perhaps, an art form that is comprised 10% of music, 25% of architecture, 12% of drawing, 18% of shoe making, 30% of painting and 5% of smell. What would it be like? How would it work? How would some of the specific art works appear? How would they function? How would the elements interact? That's a thought experiment that yields interesting results. Thoughts like this have given rise to some of the most interesting art works of our time."[41]

Eno began to look for other ways to spend his time and was quickly elected head of the student union, which gave him free rein to organize visiting lecturers and bring artists and musical performers to campus. The position came with great latitude, of which he took full advantage, recognizing this as an opportunity to supplement his education. He invited a roster of distinguished and esoteric guests from whom he

could learn, including his former tutor Tom Phillips; the experimental music composers Morton Feldman, Cornelius Cardew, and Christian Wolff; the virtuoso pianist and Wolff's sometime collaborator Frederic Anthony Rzewski; and the German-born painter, sculptor, and sound artist Peter Schmidt.[42]

Eno's continued audio experiments led to the creation of an avant-garde performance collective called Merchant Taylor's Simultaneous Cabinet, inspired by the experimental sound of the Velvet Underground (fig. 14). With Eno at the helm, Merchant Taylor's Simultaneous Cabinet was a highly conceptually driven group inspired as well by many of the experimental musicians that Eno had heard on his trips to London and by the artists he had brought to campus. Among the works they performed was *Drip Music* (1959), an event score by the artist George Brecht (fig. 15). Brecht was a key member of Fluxus who was well-known for his conceptual art and experimental music and would later study with Cage at the New School for Social Research in New York City. Brecht was an innovator who, along with many other artists—including Alison Knowles, Takehisa Kosugi, and La Monte Young—devised dozens of deceptively simple actions that were turned into event scores. These scores upended the relationship between the artist and the audience, emphasized the ephemeral and impermanent over the static and immutable, and highlighted the possibility of endless variation through singular repetition.

Drip Music (Drip Event)
• For single or multiple performance.
• A source of dripping water and an empty vessel are arranged so that the water falls into the vessel.
• Second version: *Dripping*.[43]

Eno later described in detail his own *Drip Music* event.

One of the best things I did in my art school days. George Brecht produced this thing called "Watermelon" or "Yam Box" or something like that. It was a big box of cards of all different sizes and shapes, and each card had instructions for a piece on it. It was in the time of events and Fluxus and happenings and all that. All of the cards had cryptic things on them, like one said, "Egg event—at least one egg." Another said, "Two chairs. One umbrella. One chair." They were all like that, but the drip event one said, "Erect containers such that water from other

containers drips into them." That was the score, you see. I did
two versions of that. I did a simple one which won an award, but
then I decided I wanted to do a big one. I made a ten-foot cube.
. . . On top of that I had a collector that collected water, then the
water would be disseminated through a whole series of channels
and hit little things and make noises as it went down. At the bot-
tom of this cube there was a wall a couple of feet high all the way
around, and the wall was covered with those things you get for
the children's painting books where you just put water on them.
So over the few days it survived—it was wrecked by vandals—the
water would drip, and it would splash onto these little pictures
which gradually came to life very slowly. But it was a very lovely
thing, it made the most beautiful delicate noise. I had the water
just dripping onto little cans with skins stretched across them
so that they made little percussive noises, little dings and tinkles
and so on, a very very delicate noise, and it was right by a river,
so the gentle bubbling of the river was in the background. But
that got wrecked, unfortunately. It was outside and I never even
got a photograph of it.[44]

Another work that Eno performed with the Merchant Taylor's
Simultaneous Cabinet was La Monte Young's 1960 piece *X for Henry
Flynt*. Like all Fluxus scores, Young's facilitated endless variations
within a narrow set of instructions: "a heavy sound (such as a cluster)
is to be repeated as uniformly, as regularly, and as loudly as possible a
relatively large number of times."[45] The repetition dictated by Young's
score was of lasting significance for Eno's work; while performing the
piece, he realized that it was impossible to hit the same cluster of notes
in the same way every time: "I did another one with an open piano
frame where I just used a big flat piece of wood, *Crash Crash Crash*. It
sounds horrible I know, but if you last ten minutes it gets very interest-
ing. My first performance of it lasted an hour and the second one an
hour and a half. It's one of those hallucinatory pieces where your brain
starts to habituate so that you cease to hear all the common notes,
you just hear the differences from crash to crash, and these become so
beautiful"[46] (fig. 16).

 There was *always* a variation—whether an imperfection or error—
due to the impossibility of repeatedly playing the same notes in the
same manner for the same length of time. The idea that "repetition
is a form of change" became an important compositional tool as well
as a new approach to listening.[47] The aesthetic attitudes that Eno was

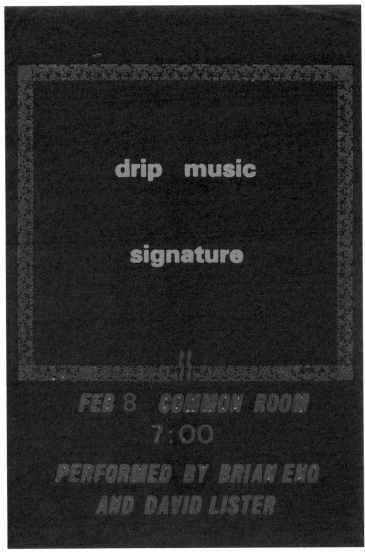

fig. 15
Event announcement,
Winchester College of
Art, 1968.

fig. 15

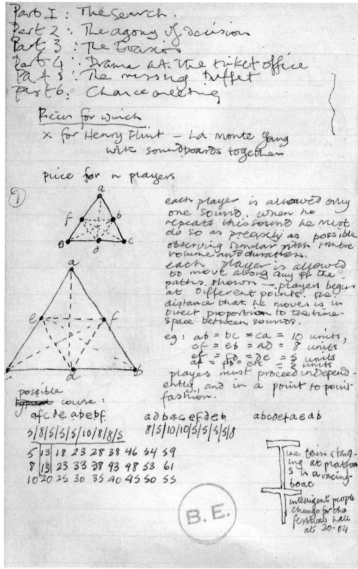

Part 1 : The Search.

Part 2 : The agony of decision

Part 3 : The Evasion

Part 4 : Drama at the ticket office

Part 5 : The missing buffet

Part 6 : Chance meeting

Piece for which

X for Henry Flint — La Monte Young
with soundboards together

piece for n players

each player is allowed only
one sound. when he
repeats this sound he must
do so as preascely as possible
observing similar pitch timbre
volume and durations.

each player is allowed
to move along any of the
paths shown — players begin
at different points. the
distance that he moves is in
direct proportion to the time-
space between sounds.

eg: ab = bc = ca = 10 units,
cf = eb = aD = 8 units
af = fd = De = 5 units

players must proceed independ-
ently, and in a point to point
fashion.

possible course :

afcDe abebf. aDbacefDeb abcDefaeDb

5/8/5/5/10/8/8/5 8/5/10/10/5/5/5/8

5	13	18	23	28	38	46	54	59
8	13	23	33	38	43	48	53	61
10	20	25	30	35	40	45	50	55

B.E.

Use train & thing-
ing at platform
5 in a racing-
boat

intelligent people
change for the
festival hall
at 30·04

fig. 16

38

learning from these performances also translated to visual work in which time, repetition, and composition took on increasing significance. Indeed, in those instances when he did produce paintings, Eno's role was more akin to that of a conductor, and the works that resulted were more akin to music, he says, "in the sense that they often had scores, quite often: a set of things that you had to do, just like in a piece of music. One of my pieces had a score which involved ways of dividing up the canvas into areas, by combination of measurement and randomness, and ways of deciding the colors that were to be used. This was done by numbering all the tubes of paint that I had, and devising a system that would decide the amount of each to be used. So the colors were basically arbitrary."[48]

Eno's tutors at Winchester did not always look favorably on such activities, and some questioned why he was enrolled as a painting student when his interests and creative output lay far beyond the narrow limitations circumscribed by the flat plane of the canvas. Within this traditional milieu, a sole instructor supported the approach that Eno had found so influential while at Ipswich, writing in a school report dating from the time.

> His involvement in Art has been an example to many other students, who have benefited from his enthusiasm and from Art Activities that he has sponsored and organised, and which otherwise would not have been available to the Fine Art Students. Much of what he does is not limited to painting as such, but much of what Leonardo da Vinci, Michelangelo, Marcel Duchamp, etc. did was not limited to painting as such. He is a most suitable and good student, and should undoubtedly be retained. The only reason to do otherwise would be that the course is inadequate, not the student.[49]

While Eno was eager to learn, the teaching of color theory and composition by some of the tutors seemed inconsequential and trivial, and was certainly no match for performances by Christian Wolff and the like. Eno's recollection of this period reflects the tension between the student and his tutors, "They thought I was an interesting character— but that I was taking up the place of someone who could be a proper painter. . . . I thought that art schools should just be places where you thought about creative behaviour; whereas they thought an art school was a place where you made painters."[50]

Untitled (yellow circle), ca. 1964–65

THE NATIONAL ANTHRAX.ARISE.

Untitled (...), ca. 1964–65

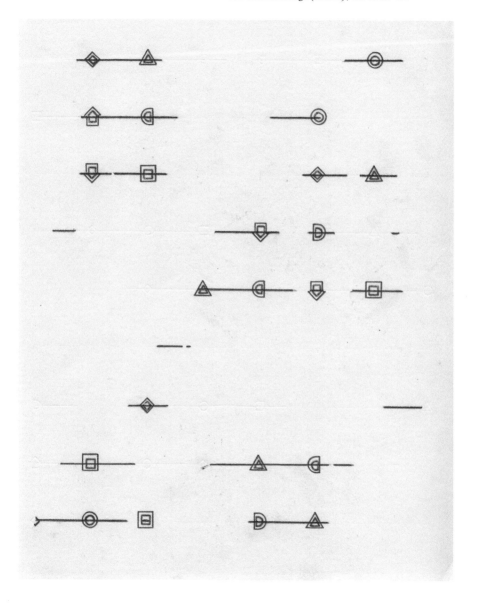

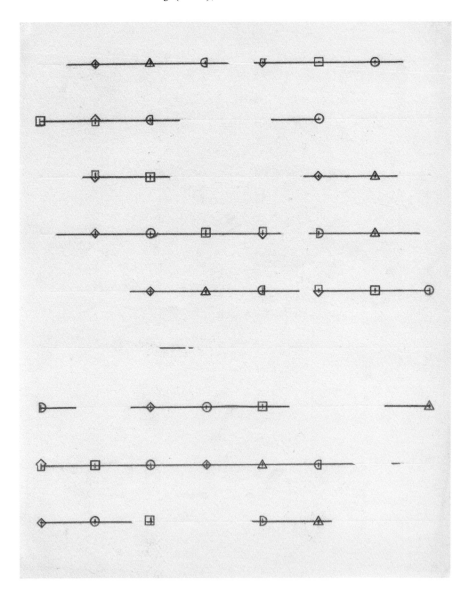

. testing ᴍᴍ old wives.

1.make mountains out of molehills
2.burn a candle at both ends.
3.judge a book by looking at the cover.
4.take a horse to water and make it drink.
5.ᴍᴍᴍ.paint the grass on the other side greener.

etc.etc.

simplepiece for two players.

two players playing identical
<u>tune</u> at moderato.Both play till
one makes a mistake.
At this point the second player
begins a second tune etc.etc.

6.9.68

2 projects for a painting.

.$(999,999^{999,999})$
.calculate the number of classes
of three numbers that could be
made using the numbers to one
million.

readymade error paintings !

buy four woolworth's original
oils,on same subject.

cities with multi-level transparent
floors.
new directions in shoe sole design.

identikart.

a felt painting with movable
self-adhering felt areas.

film 3.

make film with straight
aristotelian plot.
make another film on basis
of 'what could have happened
if....'
and another on basis of
'what could have happened if
not...'
show three films on adjacent
screens.

A positive Use of the Puddle.

carve a poem in reverse on
the soles of a pair of boots.
walk through puddles.11 11 67

series 1 (do nothing until a mistake is made), 1968

11.20 / 25.5.68

'do nothing until a mistake is made'

series 1.

method:

carbon paper is placed under a sheet
of graph paper,the carbon paper being
arbitrarily torn into small sheets.
a drawing is made on the top sheet
of carbon paper and removed.the same pieces
of carbon paper are then placed under
the next sheet in the pad(that is,the one
with the remnants of the first drawing)and
these remnants are again drawn over.a
predetermined amount of addition is allowed.
has affinities with tapeloop - gain and loss,
conservation of energy.

series 2,25 4 68 11.52

as in series 1(using torm carbon paper beneath
sheets)but this time filling in the gaps(mistakes)
on the last move made,and simultaaneously adding
one more move.

progeession: 5,5-3,5-3-1,5-5-1-4,

 5-5-7-4-2,5-5-7-4-2,0,

 5-5-7-4-7-0

$$5$$
$$\underline{5}-3$$
$$4-\underline{3}-1$$
$$4-4-\underline{1}-4$$
$$5-3-4-\underline{4}-2$$
$$4-3-4-4-\underline{2}-0$$
$$4-3-4-4-4-\underline{0}$$

21.4.68

first performance of ' do nothing until a mistake is made'
performed by myself over one hour in the afternoon .
 the performance was conducted as follows:
 1)the paper was stretched onto a board.
 2)mistakes (blemishes) on the paper were observed and
 these were attended to by covering them with an area
 of yellow.
 3)the points at which the tone of this yellow deviated
 from the norm was were attended to by means of an
 area of orange.
 4)it was found that each successive application of colour
 created an escalation in the number of mistakes,and
 thus the piece continued to fill the hour allotted
 to it (parkinson's law)

the second performance of the piece will be conducted on
this sheet of paper.

```
.switch on tape recorder.
.find wood,make a stretcher,sand
down its edges,strengthen it,cut
canvas to stretch over the wood,
stretch,prime.
.play recording back;measure tot-
al timelength,classify and call-
ibrate operations,and,if desira-
ble,noises.
.make a painting analoguing all
the recorded information.
.use the painting as an operati-
onal score for musicpiece.

.maintain low-definition of in-
formation - minimum verbalisms.
```

self-regulating drawing tactics.

1. a sheet of paper is mounted ready for
 drawing.
2. an area of carbon paper equivalent to
 the area of the drawing-sheet is torn
 up and strewn arbitrarily over the
 drawing sheet.
3. another sheet of paper,same size as
 the first,is placed such that it covers
 both the first sheet and the carbon
 paper.
4. drawing is performed on the top sheet.
5. the top sheet is removed and stored,and
 the carbon-marked sheet then becomes
 the top sheet for another similar oper-
 ation.the same carbon paper as before is
 used.
6. the carbon-marked sheet will exhibit the
 remains of the first drawing after it
 had passed thru the'carbon filter'.these
 remains are drawn over as precisely as
 possible,and further marks are made on
 tha paper in accordance with another
 conjunctive programme.(geometry)
7. repeat operations 5 and 6 ad nauseam or
 infinitum or absurdum..

```
.two performers
.coins are tossed
.winner takes all
```

```
the instruments are in turn
ground down and individually
cast into blocks of acrylic
resin.The blocks are given
young children.
Now the music begins...
```

```
make a list of all your interests(things you do)
make a list of all your non-interests(things
you don't)
shuffle each pack.
take a card from each and perform the following
combination,
```

```
painting as absurdity
ring modulator
gate amplifier
difference
errors patterns
```

SONGMAKING SYSTEMS

NUMBERING ONE.

TAKE CUES FOR THE NATURE OF THE MUSIC FROM WORDS I SING.

NUMBER TWO.

DECIDE SIMPLY ON A MOOD OR AN EVENT BEFOREHAND.

 FOR EXAMPLE?A SONG ABOUT A CAR FACTORY ,DESCRIBING
 IN DISCREET?FINITE AND AGREED)UPON
 STAGES THE PROCESS OF A CAR FACTORY.
 OR A SONG ABOUT A FUCK,OR ABOUT NOT
 GETTING A FUCK.
 OR A SONG ABOUT ANYTHING YOU LIKE BUT
 DESCRIBED IN THIS MANNER.

NUMERAL THREE.

A PIECE BASED SIMPLE ON THE POSSIBILITIES OF ONE PIECE OF
EQUIPMENT E.G. A FREQUENCY DOUBLER SONG OR A RING MODULATOR
PIECE OR A WAH WAH PIECE. YOU KNOW.

NUMMER FOUR.

WHEN I RAISE MY HANDS YOU STOP DEAD.

WHEN I LOWER MY HANDS YOU RENTER WITH SMETHING YOU HAVE NEVER PLAYED
BEFORE?REGARDLESS OF WHAT EVERYONE ELSE IS DOING.

IF YOU WISH A COMMON THEME MIGHT BE DECIDED BEFORE HAND.

IF YOU WISH SOMETHING MIGHT BE AGREED UPON) () ()

 KEY OR RHYTHM OR MOOD.BUT NOT TOO MUCH.

 KEEP IT INDETERMINATE?AND CONVINCING.

 AND DON'T ONCE FALTER.

A SONG THAT GOES A COMPLETE CIRCLE) (FADES OUT TO ITS BEGINNING.

THINK OF IDEAS FOR SONGS?(SYSTEMS OF SONGMAKING (AS WELL OK AS SONGS.

Untitled (British Standard Time), 1968

At each of the times indicated,a sound or
a collection of sounds is to be made.The
intervals between the beginnings of sequent
sounds increase in a geometrical progress-
ion.Performers may begin at any of given
times,and are free to curtail their active
participation at any time.A period of
silence must occur between one sound and
the next.

year	month	day	hour	minute	second
1968	02	29	24	00	00
1968	03	01	00	00	01
1968	03	01	00	00	03
1968	03	01	00	00	07
1968	03	01	00	00	15
1968	03	01	00	00	31
1968	03	01	00	01	03
1968	03	01	00	02	07
1968	03	01	00	04	15
1968	03	01	00	08	31
1968	03	01	00	17	03
1968	03	01	00	34	07
1968	03	01	01	08	15
1968	03	01	02	16	31
1968	03	01	04	33	03
1968	03	01	09	06	07
1968	03	01	18	12	15
1968	03	02	12	24	31
1968	03	04	00	49	03
1968	03	07	01	38	07
1968	03	13	03	16	15
1968	03	26	06	32	31
1968	04	19	13	05	03
1968	06	08	02	10	07
1968	09	15	04	20	15
1969	03	30	08	40	31
1970	04	22	17	21	03
1972	06	09	10	42	07
1976	09	11	21	24	15
1985	03	18	42	48	31
2002	04	16	13	37	03
2036	05	12	03	14	07
2104	07	02	06	28	15
2240	10	13	12	56	31
2512	03	30	01	53	03

and so on.

Times shown are British Standard Time;
Calculations are made on the assumption
that the Gregorian Calendar will remain
in use.The Gregorian Calendar errs by
one day in two thousand years,thus posing
a dilemma for performers of the distant
future.

brian eno.25.2.68.

progress report. 5.30 p.m. 6.5.68

the story so far:

our hero,bombastic brian the anti-retinal behaviourist,
begun painting on the canvas to the left of his electronic
covey;he painted a light thin red square of side twelve
inches less than the length of side of the canvas.he then
threw away the paint that he had employed in this operation.
proceeding to the canvas on the right side of his covey,
he repeated this operation.that is,he drew a square of side
twelve inches less than the length of side of the canvas.
what followed next will excite even the most dry retinalist.
HE ATTEMPTED TO MIX EXACTLY THE SAME COLOUR AND APPLY IT IN
PRECISELY THE SAME DENSITY AS HE HAD DONE IN THE FIRST OPER-
ATION.such a task was impossible.he was heard to mutter 'well,
that must be the interest of the piece'.
he returned,smiling,to the first canvas,and added another
square of the same area as the first,painting this fellow
with a green brush.Of course,you must have realized by now
that every colour he was using was composed of at least three
given tube-pigments,such as to make forgery almost impossible.
he repeated the green operation on the second canvas,and then
returned to the first,ruler and compass in hand.He drew arcs
from the the right hand corners of the squares,and constructed
lines from those corners to the lower bisector of the arcs.
perspicacious readers will have realized that this left ego
with a triangle,for which he arbitrarily selected a colour a
and coloured.he threw the colour away,and drew a line(on the
same canvas)from the bottom of his triange to the left-hand
corner of the left-hand square,noting the mid-point of this
line,and constructing a line from that point ot theright hand
corner of the left-hand square.he mixed a colour and coloured
the triangle resultant.forgetting all,he returned to canvas
2 and began to repeat this triangular activity.more news later.

examining
carefully
the
corners
of
my
eyes

stinging miles
of
labelled wheat

THE AESTHETICS OF TIME

MISTAKES AND RANDOM ERRORS: CHANCE, SYSTEMS, AND PROCESS

CHRISTOPHER SCOATES

> If you're in a panic, you tend to take the head-on approach because it seems to be the one that's going to yield the best results; of course, that often isn't the case—it's just the most obvious and—apparently—reliable method.[51]
> —Brian Eno

After graduating from Winchester College of Art, Eno pursued his musical ideas further and spent time playing in both the Portsmouth Sinfonia and the Scratch Orchestra (fig. 17). The Portsmouth Sinfonia was an orchestra founded in 1970 by the English composer Gavin Bryars along with a group of students at the Portsmouth School of Art. Eno joined the group as a clarinetist and produced its first two albums. The Sinfonia had an unusual entrance requirement, in that players had to be either nonmusicians or musicians who played instruments on which they were not trained.[52] Describing the Sinfonia's members, Eno notes, "the vast majority of these people can't play their instruments and yet they are definitely producing music." While they played the classics seriously, the resultant sound was often unexpected because they were untrained, as Eno observed: "there's a delay in terms of time and decay in terms of accuracy . . . you get this very lush feeling to the thing."[53] The Scratch Orchestra was founded in the spring of 1969 by Cornelius Cardew, Michael Parsons, and Howard Skempton, who would go on to become leading composers in the experimental music field, and like the Portsmouth Sinfonia, it had unorthodox prerequisites. While admission was open to anyone, traditional sheet music was banned in favor of graphic scores and an emphasis on invention. Both of these groups were made up of musicians with divergent skills whose performances were highly inconsistent and as a result unpredictable. Eno enjoyed playing with them because of his continued interest in chance, systems, and process, and their great relevance to experimental music.

Around the same time, Eno joined the nascent British art rock band Roxy Music, which at the time consisted of Bryan Ferry, Graham Simpson, and Andy Mackay, and provided a forum for continued experimentation. Using the entire recording studio as his instrument, Eno pioneered production techniques that became the band's trademark sound during the time he was associated with Roxy Music. During live performances, he initially worked offstage, operating the mixing desk and processing the band's sound with a synthesizer and tape recorders. Because of his importance to the band's distinctive synthesized sound, however, he quickly began performing onstage and played both keyboards and synthesizers for the release of its first two albums. After

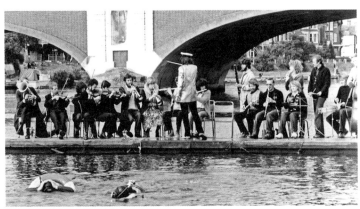

fig. 17
Portsmouth Sinfonia,
1979.

fig. 17

departing Roxy Music, Eno released several solo projects, including *Here Come the Warm Jets* (1973), *Taking Tiger Mountain (By Strategy)* (1974), and *Discreet Music* (1975), as well as two collaborative projects with Robert Fripp, *(No Pussyfooting)* (1973) and *Evening Star* (1975).[54]

Since his early teens, Eno has always kept impeccable notebooks (fig. 18, 19, 20). They are carefully dated and chronicle a wide variety of ideas, beginning with lecture notes made during his student days, and include sketches, lyrics, and production ideas for new albums. It was during work on the second Roxy Music album, *For Your Pleasure*, that Eno started taking notes on all aspects of the recording sessions, writing down his observations about the songs in their various states of completion and even the mistakes and random errors that occurred in the studio. From his time at Ipswich studying with Ascott, and his experience performing Fluxus scores, Eno recognized that mistakes and random errors could be productive if approached with the right mind-set. Such variables could potentially provide new and unanticipated directions if one found oneself in a creative cul-de-sac. Eno's observations and notes became a growing list of conceptual strategies and instructions that one might deploy if faced with a creative stalemate. Ideas such as this that minimized an artist's mastery were becoming increasingly prevalent. Eno was also aware of the *I Ching*, the classic Chinese text that was pioneered as a tool for musical composition by John Cage and was widely embraced by many artists (fig. 21). Cage turned to the *I Ching*—typically used for divination—as a means to incorporate chance operations. He consulted it with a series of questions in hand and used the answers to guide the development of his compositions.[55]

preferably compressed + limited

and make a copy of

Record a master tape of bland, not too variable music, probably a single instrumer Feed it thru a long delay echo system and chop it up thus.

the melody may or may not be related to the loop length

Continue repeating this process till there are a number of chopped tapes Rerecord all of them playing simultane- ously.

2; Treat each track differently (eg etc, echo, synthesize, drop octave)

MASTER A|B|C|D|E|A|B|A|B|A|B|C|D|E|A|B|E|F|G|E|F|G|B|C|D|E|F|G|

TRACK 1

TRACK 2 | |A|A|C|D|A|A|C|A|B|A|B|A|D|A|A|B|E|F|G|B|E|E|F|G|

B A B A B A B C D E A B E F G E F G B C D E F G

TRACK 3 A B C D A B C C A B C B A B C E A B C C A B C G

TRACK 4 *derived* A B C D A B C C

is there a way of fading changes.

~~cover~~ inc mixer

fig. 18

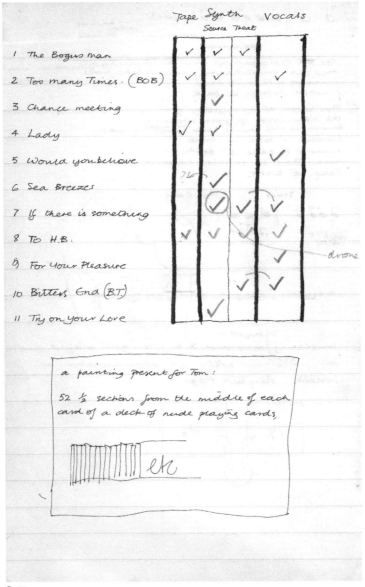

fig. 18–19
Pages from one of Eno's
notebooks with notes on
the Roxy Music recording
sessions, ca. 1971–72.

fig. 19

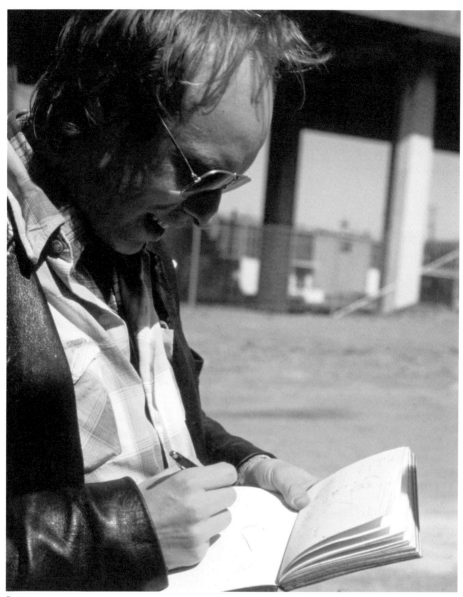

fig. 20

While at Ipswich several years earlier, Eno had been introduced to Peter Schmidt, a German painter and electronic composer with whom he had stayed in close contact. Schmidt had recently finished a series of sixty-four drawings based on readings of the *I Ching*, and the two decided to collaborate and publish their own set of creative instructions. Titled *Oblique Strategies* (1975), the set consisted of 115 white cards with simple black text in an austere black box (fig. 22, 23). The deck, bearing the subtitle *Over One Hundred Worthwhile Dilemmas*, contained such directives as the following:

Look closely at the most embarrassing details and amplify them.

You don't have to be ashamed of using your own ideas.

What would your closest friend do?

Emphasize the flaws.

Honour thy error as a hidden intention.

Take away the elements in order of apparent non-importance.

Unlike the Fluxus scores that Eno had used years earlier, which were essentially directives for performance, the *Oblique Strategies* cards were idea-generating tools and tactics designed to break routine thinking patterns. While born of a studio art context, *Oblique Strategies* translated equally well to the music studio. For Eno, the instructions provided an antidote in high-pressure situations in which impulse might lead one to default quickly to a proven solution rather than continue to explore untested possibilities: "*Oblique Strategies* evolved from me being in a number of working situations when the panic of the situation—particularly in studios—tended to make me quickly forget that there were others ways of working and that there were tangential ways of attacking problems that were in many senses more interesting than the direct head-on approach."[56]

In fact, while producing David Bowie's album *Heroes* (1977), Eno and Bowie used *Oblique Strategies* on the song "Sense of Doubt." They each picked a card but didn't reveal its content. "It was like a game," Eno recalled. "We took turns working on it; he'd do one overdub and I'd do the next. . . . As it turned out they were entirely opposed to one another. Effectively mine said, 'Try to make everything as similar as possible,' . . . and his said 'Emphasize differences.'"[57]

fig. 20
Eno sketching in his notebook, San Francisco, early 1980s.

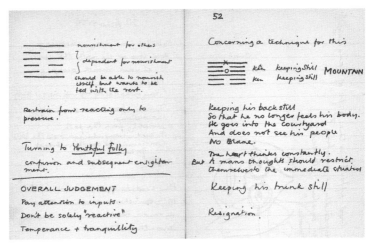

fig. 21

Schmidt and Eno collaborated on several more occasions. Schmidt contributed artwork to several Eno albums, including *Taking Tiger Mountain (by Strategy)* (1974), *Evening Star* (1975), and *Before and After Science* (1977). A few years later they began working on a painting illuminated by a special shifting colored light box. Schmidt had painted a large canvas with a red circle at its center, ringed with detailed imagery in vivid colors. The pair experimented with a lighting system in which primary colors would cross-fade from one to the next and found someone to build the necessary device. Eno described the result as an "animated painting" in which "the effect was spellbinding: as the colours changed, the big circle in the centre would move slowly from intense hot red to deep black to violet, and the different details in the intricate surround would appear and disappear in turn. The whole canvas became alive and deeply three-dimensional."[58]

During this time, Eno was introduced to the work of Stafford Beer and Morse Peckham, whose writings on cybernetics and biological systems, respectively, had an enormous influence on his philosophical approach (fig. 24, 25). While Eno had already been exposed to cybernetics as a student at Ipswich—Ascott's essay "Behaviourist Art and the Cybernetic Vision" cites Beer's work[59]—he became increasingly interested in the subject as a possible tool in the music studio. Beer was an international authority on operational research and management cybernetics (the science of control). Eno found Beer's 1972 volume *Brain of the Firm* particularly significant. The cybernetician defined

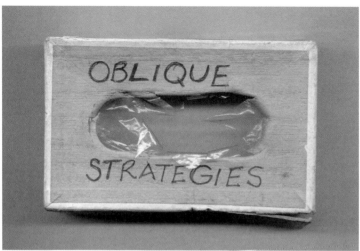

fig. 22

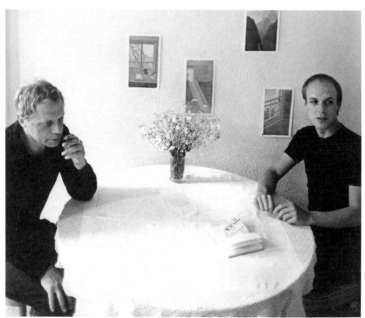

fig. 23

fig. 21
Notes from Eno's reading of the *I Ching*, April 1976.

fig. 22
Mock-up of original *Oblique Strategies* box.

fig. 23
Peter Schmidt and Brian Eno, ca. 1977, London.

fig. 24

Kahontek

if one accepts Morse Peckham's thesis that art acts as a bridging device between observed presents and projected futures, one also accepts that there should ∴ be a level at which the artwork from different media display similarities. At which level will this be? Stylistic — not often. Formal — rarely. Conceptual (i.e. in terms of the focus of attention of the artist) — yes! There are interesting parallels between the concerns of rock musicians and modern painters. It became a problem of painting to give the painting its own integrity — free of reference to external subject or object-matter This is a problem that seemed to have been solved quite easily in rock — almost as though it hadn't presented itself. Since rock has for a very long time been a studio-produced artifact not intended as a relic of live performance, a concomitant of this concern is to employ a rapidly devel-oping technology to produce something that would not happen by any other means. A gramophone record is a

fig. 25

fig. 24
Eno's notes about Morse Peckham and Stafford Beer and the evolution of behavior, 1975.

fig. 25
Eno's notes on the ideas of Morse Peckham, ca. 1973.

his "heuristic" approach as "a set of instructions for searching out an unknown goal by exploration, which continuously or repeatedly evaluates progress according to some known criterion."[60] Eno found this important in regard to his own idea that a musical composition or performance should not be structured by an organism or system that is expected or probable but by one that is instead a "responsive network of subsystems capable of autonomous behaviour"[61] (fig. 26). Beer's ideas challenged Eno to rethink the process of making music and to connect ideas from cybernetics to the studio environment and composition. Eno's 1975 album *Discreet Music* is an experimental application of these principles in which overlapping signals, varying rates of decay, and other strategies are used to create what he considers "generative" music created by a system (fig. 27). Beer's publication included many diagrams that mapped various systems, and Eno's album notably included a Beer-like diagram that outlined its recording process (fig. 28, 29).

Morse Peckham was an American scholar who published numerous books on biological theories of evolution and adaptation. Peckham is well known for his book *Man's Rage for Chaos: Biology, Behavior, and the Arts* (1965), in which he posits that an artwork is "any perceptual field which an individual uses as an occasion for performing the role of art

My own interest in a systems approach to ~~amking~~ making music arose from
my early experiences as an attempted painter. I had become disill-
usioned with painting in that all the possibilities it seemed to
offer were concerned with formal manipulation, and, at a time
when anything was possible formally, I felt sure that form was not
the main issue. In music, I was aware, a similar process was happen-
ing: any type of noise was by now acceptable concert material, so
it did not seem relevant to me to engage oneself ceaselessly in
the pursuit of new noises. My inclinations moved increasingly
towards ⋯ ⋯ ⋯ ⋯ ⋯ ⋯ st ipulating procedures by
which paintings could be /made, and then performing them. This was not only
interesting in itself, but it took the emphasis away from the
product and placed it instead on the process. I took the rather
doctrinaire view that what emerged at the end of the process was,
if not irrelevant, largely residual, and that its only value
would be that it in some way referred you back to the process.
This is not a view, incidentally, that I have since carried into
music. The following are two of the procedures I used to generate
paintings. I have cited tham because they are the antecedents of
of the type of procedures I subsequently used to make music.

.four painters working in isolation from one another are
given identical sets of instructions and identical square
canvasses. The instructions are of this type: 'draw a line
from the centre of the canvas to a point two inches from the
top left hand corner of the canvas. Draw a perpendicular from
a point midway along this line until you hit the left hand
edge of the canvas. From that point of incidence...' and so
on. There were enough of these instructions, all of which
were contingent on the previous one, to ensure that the
painters would arrive at a series of shapes which were not
quite identical. The instructions for how these shapes were
to be coloured were equally precise: for example, 'use
1 part of Monastral Green to 2 parts of Titanium white and
two parts of Prussian blue.' Again, one could rely on the
variability of measurement to produce slightly different results.
The four paintings taht resulted were joined together to form
a square and shown as one work. (1967)

.DETECTIVE PAINTING: A painting is made, and then hidden some-
where. The various clues as to its nature (paintrags, marks
on the wall, hearsay) are then used by a second painter who has
not seen the original to reconstruct the work. He knows, for
example, by the sequence of paintdrips on the floor, in what order
the paint was applied. He can ask witnesses whether his work
resembles the original, making allowances for the reliability
of their memories. When he is satisfied that he has reconstructed
the picture, the two works are joined together and hung. (1967-8)

I made many works from this kind of procedure before I
realized that what I was really moving towards was a performance
art - music.

This changeover was rather a surprise for me. Although I
had always been fascinated by it, I could ~~niether~~ *neither* play any
instrument (strictly speaking, I still can't) and nor could
I read or write music (ditto). But in the mid-sixties
something interesting was happening in music. Composers were
beginning to write work that did not use conventional notation
and did not require conventional skills. These pieces had a
procedural inclination very similar to those that I had been
using in painting, but in this case the performance was the
work - there was no residue. One of the first public performances
I gave was a piece by LaMonte Young called 'X for Henry Flynt'.

In this piece the performer is instructed to strike the same
chord repeatedly and at even intervals X times - the number being
stipulated before performance. The score does not make clear
whether each repetition ~~would~~ *should* be identical to the one before it,
or whether each should attempt to be an identical copy of the
first. I chose the latter course, using a very broad *40*-odd
note cluster on the piano . What this piece does, from
such an apparently humble proposition, is quite remarkable.
The ear is deceived: with each repetition it pays less and
less attention to all the common information and more and more
to the singularities. Thus one becomes crucially aware of the
accidental addition or omission of a note to the chord cluster;
differences in the amplitude of one chord to the next come to
assume major proportions, and the ear begins to 'hallucinate'.
This latter effect is especially interesting. After a while you
cease to be able to hear the sound as that of a piano - it
becomes trupets, bells, traffic noises, birds, bagpipes and
voices. This happens as a result of the buildup of shifting
ringing harmonics in the piano strings and the tendency of the
brain to focus increasingly on what is changing in the sound
rather than what is constant. By this means, we hear melodies
and rhythms among the beat frequencies that we would normally not
even notice. The piece is a prime example of an orientation
that has characterized much recent music: The idea of using
the listener's own perceptual mechanisms and ~~their peculiar~~
properties, *such as habituation* as the very basis of the piece.

fig. 26

fig. 26
An extract of a letter from
Eno to Stafford Beer,
ca. 1978.

101

fig. 27
The original tape record-
ers Eno used to record
his 1975 album *Discreet
Music.*

fig. 28
Diagram from Stafford
Beer's *Brain of the Firm*,
1970.

fig. 29
Diagram of Eno's infinite
tape loop system used
to make his 1975 album
Discreet Music.

fig. 27

perceiver" and cites the innovative ideas of John Cage to support his theory.[62] Peckham writes, "Art is rehearsal for those real situations in which it is vital for our survival to endure cognitive tension, to refuse the comforts of validation by affective congruence when such validation is inappropriate because too vital interests are at stake. . . . Art is the exposure to the tensions and problems of a false world so that man may endure exposing himself to the tensions and problems of the real world."[63] His theory that the arts are a "biological adaptation" rather than a purely cultural construct was significant for Eno, because it supported the place of systems within the artistic process.[64]

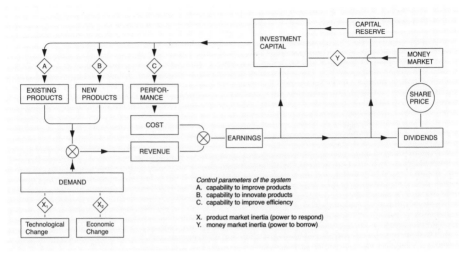

fig. 28

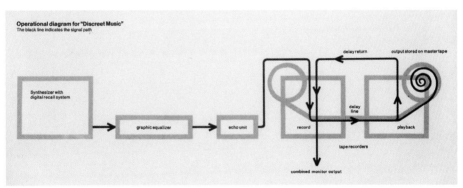

fig. 29

Oblique Strategies, 1974, collaboration with Peter Schmidt.

9.

SPECTRUM
ANALYSIS

61.

Consult
other
Sources • musical

 • otherwise

plot a graph of the piece

26

MAKE DIFFERENT
NUMERICAL LAYERS
OF BEATS AND
TREAT AS SANDWICH
FILLINGS

20.

TAKE AWAY
ELEMENTS IN
ORDER OF
APPARENT
IMPORTANCE

Distorting time
 ∮ wow + flutter
 ~~slowing / speeding~~
 ~ stretching/contracting
• altering sequence
 • reversing

listen in total
darkness or in
a large empty room
very quietly.

25

IMAGINE THE
MUSIC AS A
MOVING CHAIN
OR CATERPILLAR.

TAPE.
YOUR
MOUTH

DO WE NEED
HOLES ?

12.

mechanicalize
something idiosyncratic
or humanize
something free of error.

62.

Simple
Subtraction

EMPHASIZE
REPETITIONS

13.

Don't be frightened
to display your
talents

Oblique Strategies, 1974, collaboration with Peter Schmidt.

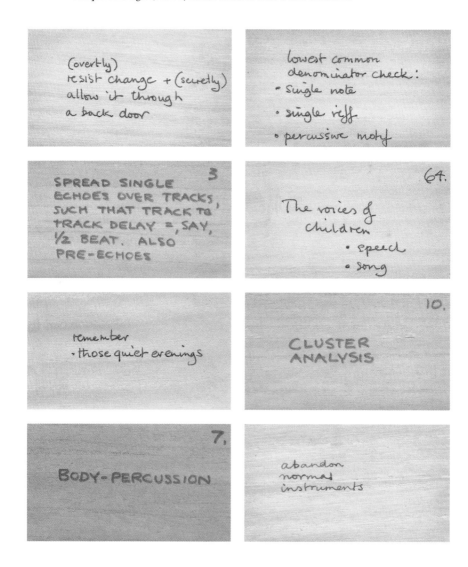

(overtly)
resist change + (secretly)
allow it through
a back door

lowest common
denominator check:
- single note
- single riff
- percussive motif

SPREAD SINGLE ³
ECHOES OVER TRACKS,
SUCH THAT TRACK TO
TRACK DELAY = SAY,
½ BEAT. ALSO
PRE-ECHOES

64.

The voices of
children
- speech
- song

remember
- those quiet evenings

10.

CLUSTER
ANALYSIS

7.

BODY-PERCUSSION

abandon
normal
instruments

5

GHOST ECHOES:
ECHO ONLY SEGMENT
OF SIGNAL ABOVE,
SAY, 4000 Hz

destroy. nothing
 ○ the most
 important thing
 ○ everything

11.

IF A THING
CAN BE SAID,
IT CAN BE
SAID SIMPLY

15.

CHANGE
INSTRUMENT
RÒLES

reverse the tape

Change the lyrics
if necessary

Oblique Strategies, 1974, collaboration with Peter Schmidt.

wow and/or
flutter

60.

check
tuning

convert a
melodic element
into a rhythmic
element ∘ pulses ∘echoes
 ∘ gates

— Define an area
as "safe", and use
it as an anchor.
(STOCK?)

63.

hydrophonic

∘ sources
∘ treatments

assemble some
of the instruments
into a group + treat
the group

look most closely
at the most
embarrassing details
and amplify them

19.

TAKE AWAY
ELEMENTS IN ORDER
OF APPARENT
NON-IMPORTANCE

REVERSE ALL
and listen closely

23.

USE
non-musicians

feedback
recordings into
an acoustic
situation

17.

HONOUR THY
ERROR AS A
HIDDEN INTENTION

22.

(ORGANIC)
MACHINERY

14.

EMPHSIZE
DIFFERENCES

Take a break

THINK OF
THE RADIO

Oblique Strategies, 1974, collaboration with Peter Schmidt.

21.

MAINTAIN A
GRAPHIC BALANCE

WHAT
GOES ON ?

1 Shut the
door and
listen from
outside.
2. put in earplugs

8.

ARE THERE
SECTIONS?
CONSIDER
TRANSITIONS

24.

FILL EVERY
BEAT WITH
SOMETHING

Consider different
fading systems

cross / echo / false / pow
intro

4

SPLIT SIGNAL VIA
FILTER WITH DIFF-
ERENT BANDS ON
DIFFERENT TRACKS.

2

OVERLAY
HARMONY
CASCADES,
DESCENDING AND
RISING OVER CON-
SECUTIVE OCTAVES

SIMULTANEOUS 1
MELODIES
AT DIFFERENT
SPEEDS, IN TIME

analyze
colour changes +
grading

USE FEWER NOTES 6.

HOW WOULD 18.
YOU HAVE DONE
IT?

intentions
- credibility of
- nobility of

REMOVE 16.
SPECIFICS, OR
CONVERT TO
AMBIGUITIES

Oblique Strategies, 1975, collaboration with Peter Schmidt.

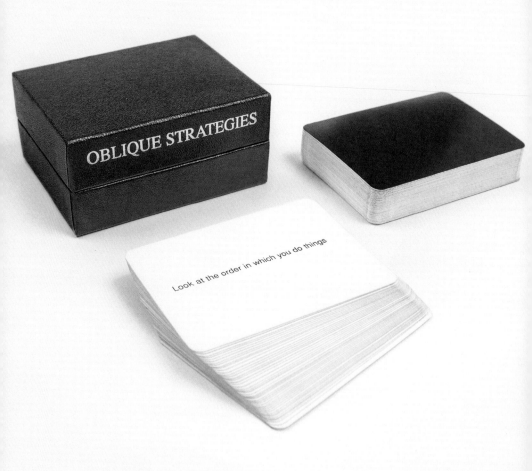

THE AESTHETICS OF TIME

COLOR CHANGE: EXPERIENCING LIGHT AS A PHYSICAL PRESENCE

CHRISTOPHER SCOATES

fig. 30
Nam June Paik, *Magnet TV*, 1965. 17-inch black and white television set with magnet, 28⅜ x 19¼ x 24½ inches. Whitney Museum of American Art, New York; purchased with funds from Dieter Rosenkranz 86.60a-b.

It always surprises me that in most galleries there are few provisions for people who might want to stay for longer than a cursory glance. The assumption is that people visit galleries like sightseers—a quick glance, read the label, and then you're away. You aren't expected to stand in front of one painting for very long before you move on to the next thing. My shows aren't like that—partly because there isn't a "next thing." I want to encourage people to stay in one place for a while.[65]
—Brian Eno

In 1978, Eno left England and moved to New York shortly after the release of *Music for Airports.* The critically acclaimed album established Eno at the forefront of experimental music, and introduced the idea of ambient music to a mass audience who embraced a radically new approach to listening. In New York, he continued to expand the range of his artistic language by bringing together his sonic and visual investigations. Over several bodies of work, he began to experiment with video as a way of playing with perceptual phenomena such as light, scale, and mass. Video was at the epicenter of a new art movement by the time Eno landed in New York. Many of the artists working with the medium were also involved in conceptual art, performance, and experimental film. From an academic perspective, too, the importance of video art was assisted in no small part by the publication of Gene Youngblood's *Expanded Cinema* in 1970. It was the first book to consider video as a serious art form and was influential in establishing the larger field of media arts, which the author perceived as an "intermedia" discipline that was "nothing less than the nervous system of mankind."[66]

Eno's inspiration for these early works was the city skyline and the building facades in his neighborhood. Soon after purchasing his new video camera, he set up a series of experiments shooting directly out of the window of his Lower Manhattan apartment.[67] Without a tripod to balance the camera, he placed it on the window ledge and pointed it toward the opposite building. Because of the camera's curved design, he had to place it on its side. When he turned on the TV to view the image, Eno realized that the recorded picture was rotated. He said, "I turned the TV—the size of a washing machine—onto its side, and there, on the screen, was something I'd never seen before. It was like a painting, but it changed. The sideways-on screen was an essential part of this: it took the TV out of narrative space and into picture space."[68]

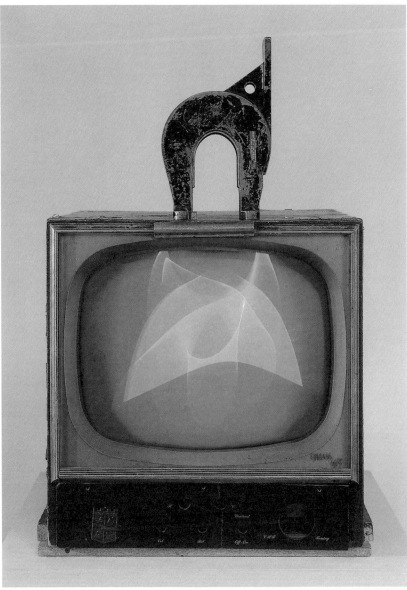

fig. 30

fig. 31
Installation view
of *2 Fifth Avenue*,
Contemporary Arts
Museum, Houston, 1981.

fig. 32
Exhibition poster for
2 Fifth Avenue, Hallwalls
Contemporary Art
Center, Buffalo, New
York, 1980.

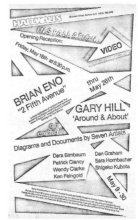

fig. 31

fig. 32

Despite considering video art "completely unmemorable," Eno found himself among a growing community of artists using video and television as a creative medium.[69] Many artists found video more appealing than film, in part because the technology provided instant playback capabilities and video cameras came with built-in features that facilitated modifying and editing the image. While video art shared with film the moving image, it focused for the most part on processes specific to the medium, dispensing with actors, dialogue, narrative, and other plot devices. The Korean artist Nam June Paik, who is widely regarded as a pioneer in video art, was active in Fluxus from its inception and as such maintained a studio practice that synthesized visual arts, music, performance, and eventually television and video.[70] His earliest experiments with the nascent medium involved using magnets to distort and manipulate the flow of the broadcast image across the television screen, thus creating loops and patterns of infinite variation (fig. 30). Peter Campus, another pioneer, deliberately distorted the image by sending video signals through a mixer to create *Double Vision* (1971). Joan Jonas's seminal work *Vertical Roll* (1972) intentionally used the "vertical hold" as a formal device to reframe and distort the image. By the late 1970s, however, video was less concerned with image manipulation and distortion and became increasingly focused on real-time explorations of conceptual propositions.

Eno shot his videos from his apartment window; without benefit of intervention such as editing, panning, or changing focus, he recorded what was in front of the camera for an unspecified period of time. The

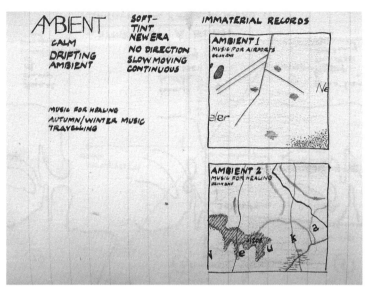

fig. 33
Notebook drawings for
album covers *Ambient 1:
Music for Airports*, and
the unrealized *Ambient 2:
Music for Healing*.

fig. 33

first series became *2 Fifth Avenue*, a linear four-screen installation sub-
sequently shown at museums and alternative spaces throughout the
United States (fig. 31, 32, and pages 142–43). The work's title was taken
from the address of the building across the street, and the music came
from his ambient album *Music for Airports*. In a simple but crude form
of experimental postproduction, the color controls of the monitors on
which the work was shown were adjusted to wash out the picture, pro-
ducing a high-contrast black-and-white image in which color appeared
only in the darkest areas. Through this simple process, Eno manip-
ulated color as though painting, observing, "Video for me is a way of
configuring light, just as painting is a way of configuring paint. What
you see is simply light patterned in various ways. For an artist, video
is the best light organ that anyone has ever invented."[71] With time as
a major underlying theme, Eno's visual works are no different in their
aesthetic intentions than his music.

 Music for Airports was composed, in part, by recording individual
notes on separate tapes that were then looped into different lengths.
The album partially owes its rich texture and varied repetition to the
layered collage of notes that—when run simultaneously—fall into
different configurations depending on the lengths of the individ-
ual tracks. The composition was prompted by Eno's experience at a

fig. 34 fig. 35

German airport, where he found the surrounding noise at the terminal anxiety-producing and was determined to create an alternative ambiance constructed from music. Eno stated, "Ambient music must be able to accommodate many levels of listening attention without enforcing one in particular; it must be as ignorable as it is interesting."[72] In contrast to conventional canned music, which erases the distinctions between the idiosyncrasies of specific environments and replaces it with homogenized pabulum for mass consumption anywhere, Eno's ambient music is instead concerned with site-specificity, as reflected in the album title[73] (fig. 33). It is no surprise then that *2 Fifth Avenue* was exhibited as a four-monitor work in the Marine Air Terminal of New York's LaGuardia Airport (fig. 34). If for John Cage music could be created using random and ordinary sounds from the environment, for Eno the environment could be created in the music.

The video portraits of the Manhattan skyline continued the following year in a new series, *Mistaken Memories of Mediaeval Manhattan* (1980–81) (fig. 35 and pages 145–51). With the camera now located in his new thirteenth-floor Broome Street apartment, Eno made a series of seven video paintings with a total running time of forty-seven minutes. Once again, necessity dictated that he reposition the camera from the conventional landscape orientation to a portrait format, turning it on its side to capture in real time the living image of the city. A technical

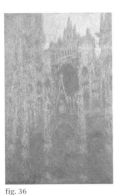 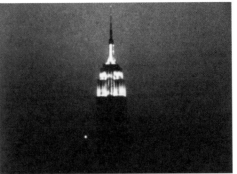

fig. 36
Claude Monet, *The Portal of Rouen Cathedral in Morning Light*, 1894, oil on canvas, 39½ x 25⅝ inches, The J. Paul Getty Museum, Los Angeles.

fig. 37
Andy Warhol, *Empire*, 1963, 16mm film, black & white, silent, 8 hours 5 minutes.

fig. 36 fig. 37

problem caused by damage to the tube that converts the optical image to an electrical signal lent the works an unexpected impressionistic tone, compounded by rain and clouds moving across the skyline. The works' muted light and atmospheric sensibility recall Monet's paintings of Rouen Cathedral, in which the artist depicted the edifice under different temporal and seasonal conditions, reflecting subtle atmospheric changes (fig. 36). Although he did not anticipate the problem, Eno had been well trained by Ascott and others to embrace random accidents and errors, and this case was no different. Rather than jettisoning the damaged camera, Eno instead worked with what he referred to as a "unique paintbrush" for many more months.[74]

Like Warhol's film *Empire* (1964), each video in Eno's *Mistaken Memories of Mediaeval Manhattan* series consists of one continuous, unedited shot. Warhol's silent black-and-white footage of the Empire State Building at night has a running time of eight hours and five minutes (fig. 37). As Catherine Russell has written, "In its durational aesthetic, 'nothing happens' in the film because 'nothing happens' in the quotidian realm of the referent."[75] Warhol films such as *Empire*, with its fixed camera position and temporal dimension, would have a resounding influence on experimental filmmakers, who "reworked his long-take, fixed camera aesthetic into what came to be known as structural film."[76] Eno's videos explored many of the same formal qualities, revealing an aspect of the city that is rarely recognized, "New York at street level is a busy city, but . . . it's actually a very slow city at sky level."[77] Both Warhol's and Eno's works turn time into an aesthetic gambit as the camera captures imperceptibly passing clouds and changing shadows. Neither could be considered eventful, and neither has story nor plot, but the temporal dimension of both works calls

119

these very concerns into question as a rebuttal of the inherently narrative conventions of cinematic time. The single long-take shot dispenses with edits and, in so doing, dispenses with illusory time, upon which cinematic narrative is constructed. In the work of both Warhol and Eno time is not illusory but concrete—experienced in the duration of the work.[78] For Warhol, using slow motion—that is, projecting the film at a slower frame rate than that at which it had been filmed—facilitated this investigation and rendered the nonevents captured by film even more imperceptible. For Eno, turning the video camera on its side represented a shift from narrative to pictorial space, and with it came an attendant shift in time. These early videos were created in response to the question, "What type of image would not presuppose the time and attention characteristically accorded a narrative structure?"[79] Here, as in *2 Fifth Avenue*, time becomes mutable and elastic.

P. Adams Sitney coined the term *structural film* in 1969 and would subsequently elaborate the concept in the 1974 publication *Visionary Film*. In the work of filmmakers such as Stan Brakhage, Paul Sharits, and Michael Snow, Sitney discerned four characteristics typical of this shared cinematic practice (yet seldom all found in a single film): a fixed camera position, the flicker effect, loop printing, and rephotography off the screen.[80] Later critics would add to this debate, contributing to the theorization of structural-materialist cinema as an alternative practice. Malcolm Le Grice, both a theorist and a filmmaker, expanded Sitney's analysis to include an emphasis on celluloid as a material, the projection as an event, and duration as a concrete dimension.[81] By emphasizing material and temporal aspects, Le Grice argued, these filmmakers subverted cinematic illusionism. For Le Grice, the recognition of time as film's "primary dimension" was "equivalent to the abandonment of deep, illusory perspective in painting," and as such this materialist practice was also a minimalist one.[82]

Eno's video series incorporated music from *On Land*, the fourth and final album in his ambient series, which would be released in 1982. For Eno, *On Land* is about "the idea of making music that is in some way related to a sense of place—landscape, environment."[83] The music for these video painting installations is played at comparatively low levels so that at times the sound may be subsumed by the noise of the surrounding environment, swallowed by people talking or cars driving past. Eno has spoken frequently about the influence and theories of the French composer and pianist Erik Satie, who coined the term *furniture music* in 1917. The term described the live performance of background music that blends and mixes with the sound in the room.

We must bring about a music which is like furniture—a music, that is, which will be part of the noises of the environment, will take them into consideration. I think of it as melodious, softening the noises of the knives and forks at dinner, not dominating them, not imposing itself. It would fill up those heavy silences that sometime fall between friends dining together. It would spare them the trouble of paying attention to their own banal remarks. And at the same time it would neutralise the street noises which so indiscreetly enter into the play of conversation. To make such music would be to respond to a need.[84]

In his ongoing investigations of non-narrative imagery, Eno traveled to Canada to visit Michael Brook, a musician friend who was helping run the Charles Street Video lab in Toronto. The lab was established to encourage artists to experiment with video, and Eno wanted to somehow jettison the moving image and simply use the architecture of the TV as an apparatus to control the color, form, and density of the light it transmitted.

I began to think that I could use my TVs as light sources rather than as image sources. My thinking went like this: TV was actually the most controllable light source that had ever been invented—because you could precisely specify the movement and behaviour of several million points of coloured light on a surface. The fact that this prodigious possibility had almost exclusively been used to reproduce figurative images in the service of narratives pointed to evolution of the medium from theatre and cinema. What I thought was that this machine, which pumped out highly controllable light, was actually the first light synthesizer, and that its use as an image-retailer represented a subset of its possible range.[85]

Eno began by making a very simple color video in which the entire screen was filled with one color and contained within it a second, smaller color field—a kind of rudimentary "electronic Mark Rothko" in which the colors fade softly into one another. By using foam core to create a long, simple lens or tube that fit perfectly around the colors on screen, Eno hoped to control and project the light onto another surface. As with his first video works in which he serendipitously turned the TV sideways to correct the camera's position, here he turned it on its back to facilitate attaching the makeshift lens. With the TV on its back and

fig. 38
Video stills from the
Crystals installations.

fig. 38

tubes attached on top, the internal light source was projected upward like a flashlight, and the whole was transformed into a stand-alone light sculpture with a singular presence. For Eno, the presence of this "internally illuminated ziggurat" was far more interesting than what he had originally planned, "This unusual object . . . had the presence quite unlike anything else I'd seen. The light from it was a tangible, as though caught in a cloud of vapor. Its slowly changing hues and striking color collisions were addictive. We sat watching for ages, transfixed by this totally new experience of light as a physical presence."[86]

Eno titled these works *Crystals* (1983–85), reflecting a move to a more abstract language[87] (see pages 199–205). Each had a distinct color-field video with up to four concentric fields or layers of color paired with foam core structures mapped to the exact profile and shape of the color fields (fig. 38). The videos all had unique running times so that they ran asynchronously. For the first time with his installations, they were accompanied by stand-alone music. Eno had collaborated with the Canadian musician Daniel Lanois on a twenty-four-track piece that was cut into four separate mixes, each containing only six tracks. Eno explained, "I put each of the four mixdowns onto a cassette leaving a silence at the end of each, then cut a random chunk of that silence out, so that each cassette ended up a different length. I then turned

them over and put the mixes onto the other sides. So now I had four cassettes of different lengths, which I played back on four auto-reverse players. The four layers of music juxtaposed with each other in different relationships, so that an ever-changing music accompanied the ever-changing ziggurats."[88]

The separate mixes played simultaneously yet out of sync, creating an auditory asynchronous experience that paralleled the visual one. If recorded sound is "essentially a static experience, remaining identical to the last performance in every detail," this approach was a strategy to return the static to its original mutable condition.[89] For Eno, this installation introduced generative music as a "working concept" because an infinite set of arrangements and configurations of sound could be heard differently over time, rather than reproduced repeatedly.[90] While Eno's interests focused on art and music, generative systems were the subject of research in numerous fields of science, including cybernetics, cognitive science, and linguistics. In the late 1950s and the 1960s, the American linguist Noam Chomsky developed a theory of linguistic competence in which he argued that language has an infinite set of sentence combinations, which became known as "generative grammar." He wrote, "A fully adequate grammar must assign to each of an infinite range of sentences a structural description indicating how this sentence is understood."[91] Chomsky believed that when one learns a language the "linguistic competence" attained gives one the possibility of generating an infinite combination of words to form grammatical sentences that one has never heard before.[92] Working with Lanois, Eno created a system of musical phrases that reintroduced variability to musical composition by establishing a generative grammar.

A subsequent generation of *Crystals* was constructed with the concentric walls of the lens structures built to the same height and topped with a sheet of colored Plexiglas. With the light of the video projecting onto the colored sheet, it produced an outline of the foam core below. Where the foam core touched the Plexiglas, a dark line appeared, producing an indexical shape from the tube below. Eno realized that if he also cut the structures to varying lengths, the lights from the tubes would mix and produce different colors where they intersected. By subtly changing the distance between the tube and the Plexiglas surface, and by replacing the foam core with more malleable materials such as cardboard and cut paper, Eno was able to sculpt the light and create more intricate and complex abstract compositions. By also editing the videos to slow down the color transitions, he could make it almost impossible to detect the gradual shifts from one color to the

next. The different planes and tilted angles of the ziggurat forms subtly challenged the act of seeing; becoming meditations on individual perception, as well as on the aesthetics of time and the conventions of art.

Eno's combinations of light, color, and music recall the work of the early twentieth-century American educator and color theorist Maud Miles, who described *color music* as a new art form that was created not with traditional paint on canvas but with colored lights, "The truest parallel that I can conceive between direct light rays of color and music would be to lay aside all attempts to represent objects either in a natural or conventional way, in using the color. To simply use the color as music, might prove genuinely new art."[93] For Eno, the *Crystals* light works marked the first time that color was completely disassociated from form. As pure light, color could be experienced in its simplest state, without the need for objects that might be "referential, and possibly limiting." The *Crystals* come close to achieving Miles's vision of a color music in which visual and auditory stimuli are perceived as inseparable, and as such also suggest the synesthetic experience of color as music and music as color.

Eno's experiments with television as a "light synthesizer" devoid of representational or narrative syntax echo Paul Sharits's work with film some ten years earlier. Sharits was key to the development of structural film, and his multiple-projector installation *Shutter Interface* (1975) is the apogee of what Sitney termed structural film's "flicker effect." Four 16mm projectors aligned in a row run looped films that consist of nothing other than color-filled frames interspersed with a single black frame to create the flicker. With varying running times, looped films, and overlapping projections, the installation creates a mix of hues in a seemingly infinite immersive lateral filmstrip (fig. 39, 40). By eliminating all imagery in favor of single-color frames, Sharits explored celluloid as a material in much the same way that Eno used the television for its inherent light properties. Sharits, who called these works "locational" because they were installation based rather than theatrically presented, emphasized the material and durational aspect of the cinematic apparatus, "Two or more films, on projects with loop devices, may be projected indefinitely, suggesting a continuum without beginning, middle or end. The films are all out of phase/sync and therefore a multitude of variational states of interactions between them is set in (potentially perpetual) motion."[94] For Sharits, the fades and dissolves were "'active punctuation' for the 'sentences' being visually enunciated" and in their variable syntax recall a Chomskyan notion of grammar.[95]

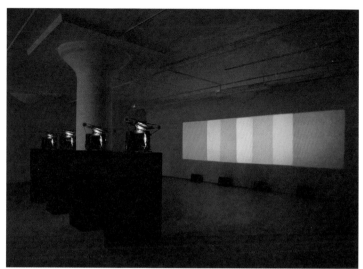

fig. 39

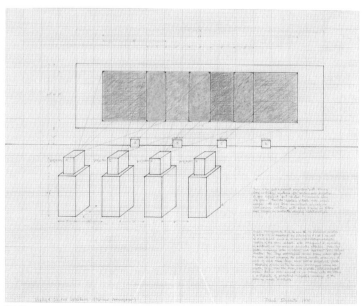

fig. 40

fig. 39
Paul Sharits, *Shutter Interface*, 1975, 4-screen 16mm loop projection with four soundtracks.

fig. 40
Paul Sharits, *Study 4: Shutter Interface* (optimal arrangement), 1975, ink and colored pencil on paper, 18 x 23 inches.

fig. 41
Robert Irwin, *Untitled*,
1969, acrylic lacquer on
formed acrylic plastic,
53 inches diameter x
3 inches deep. Museum
of Contemporary Art
San Diego, Museum
purchase.

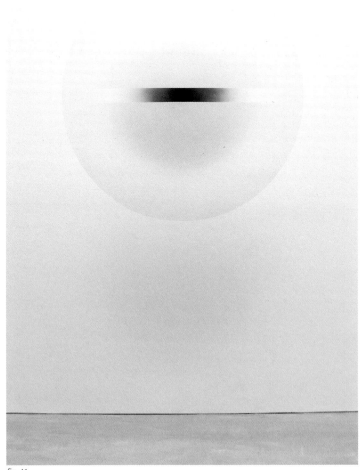

fig. 41

The exploration of perceptual phenomena echoes the interests of the Light and Space artists of the 1960s and 1970s, such as Larry Bell, Robert Irwin, and James Turrell. These artists were eager to move beyond the confines of a limited canvas in favor of more expansive perceptual phenomena. Irwin's "disc" paintings from the late 1960s exemplify this strategy as they blur the boundaries of both painting and sculpture (fig. 41). Like the *Crystals*, these works are a fascinating interplay of light, shadow, illusion, and environment. Irwin would go so far as to abandon an object-based practice altogether, saying, "What appeared to be a question of object/nonobject has turned out to be a question of seeing and not seeing, of how it is we actually perceive or fail to perceive 'things' in their real contexts. Now we are presented and challenged with the infinite, everyday richness of 'phenomenal' perception . . . one which seeks to discover and value the potential for experiencing beauty in everything."[96]

Works such as this render one keenly aware that what one does affects what one sees and what one sees affects what one does. At first, one might assume that the ziggurat forms are missing something, not unlike an empty display case, but as one moves around them, the remarkable effects of light and color become apparent. The properties of a light work do not belong to the work alone; their color, shape, and surface effects are contingent on the spatial and temporal conditions of observers as they experience the work. In their minimalist expression, the *Crystals* typify Eno's approach, using conventional materials in entirely unconventional ways in order to create a new and unexpected experience and mode of engagement. These works further express his desire to move from a traditional static painting to a three-dimensional light box that offers the viewer a sense of both ambient and direct vision, echoing his earliest experiments with "animated paintings" with the artist Peter Schmidt.

In the midst of his ongoing series *Crystals*, Eno returned briefly to single-channel video to make another suite of video paintings in 1984. In its representational impulse, *Thursday Afternoon* recalls *2 Fifth Avenue* and *Mistaken Memories of Mediaeval Manhattan*. The work—a collection of seven video paintings featuring Eno's friend Christine Alicino—was commissioned by Sony Japan and was accompanied by a new musical composition of the same name (fig. 42 and pages 167–75). Each is shot with a different treatment, and in each the subject is recorded in different contexts and states of being. The images are tightly framed, capturing the model in various states of undress, at times submerged in water and seemingly unaware of the camera's fixed gaze. Despite the

return to a representational mode and the choice of a figurative subject in slow motion, the seven videos continue Eno's investigation of temporal experience and engagement. For the first time in his video work, the paintings were presented in the same vertical, portrait format in which they were shot. At the time the image's vertical orientation would have been counter to the conventions of the narrative television format, thus resonating with Eno's view of the TV as "a picture medium rather than a narrative medium."[97]

Eno wrote, "These pieces present a response to what is presently the most interesting challenge of video: how does one make something that can be seen again and again in the way that a record can be listened to repeatedly? I feel that video makers have generally addressed this issue with very little success: their work has been conceived within the aesthetic frame of cinema and television (an aesthetic that presupposes a very limited number of viewings) but then packaged and presented in a format that clearly intends multiple viewings, the tape or disc."[98] In Eno's work, as in that of the video artist Bill Viola, who has translated the aesthetic of structural film to the medium of video,[99] time is the dominant dimension. Much of Viola's work centers on the structures of perception, nowhere more evident than in his 1986 video *I Do Not Know What It Is I Am Like*, in which the camera functions as a surrogate, carefully observing the world under its electronic gaze as reflected in the close-up of an owl's eye. In Viola's 1996 work *The Messenger*, a figure is revealed as it slowly rises to the surface of an inky pool of water (fig. 43). Time is foregrounded and extended, as the figure slowly breaks the surface, takes a breath, and slowly sinks below the surface again.

Similarly, Eno uses slow motion to confuse the perception of time and narrative structures, seemingly collapsing the boundaries between photography and video. He explains this thought process.

> So long as video is regarded only as an extension of film or television, increasing hysteria and exoticism is its most likely future. Our background as television viewers has conditioned us to expect that things on screens change dramatically and in significant temporal sequence, and has therefore reinforced a rigid relationship between viewer and screen—you sit still and it moves. I am interested in a type of work which does not necessarily suggest this relationship: a more steady-state image-based work which one can look at and walk away from as one would a painting: it sits still and you move.[100]

fig. 42

fig. 43

fig. 42
Brian Eno, *Thursday Afternoon*, 1984.

fig. 43
Bill Viola, *The Messenger*, 1996, color video projection on large vertical screen mounted on wall in darkened space, amplified stereo sound, 25 x 30 x 32 feet.

fig. 44
Oskar Fischinger, still from *Motion Painting No. 1*, 1947, 35mm, color, sound.

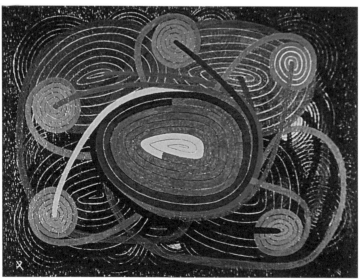

fig. 44

In fashioning what one might call an ambient video, Eno has created a radically different experience of the moving image.

Natural Selections was commissioned in 1990 for Milan's La Triennale, a design museum that focuses solely on contemporary architecture, design, music, and media arts. At the time, Eno was feeling restricted by the limited scale of the television as a vehicle for his work. There was no question that it was a very sophisticated lighting instrument and one that was easy to control; it also provided an unlimited range of colors. But the challenge it presented was one of size. How could its images be projected on a more environmental scale?

The work of Oskar Fischinger provides an insightful parallel to Eno's dilemma. Trained as a draftsman and engineer in his native Germany, Fischinger owned his own animation company from an early age, made more than fifty animated short films, and painted hundreds of canvases. He combined his two loves, music and graphic arts, by creating abstract film works that he called "visual music" (fig. 44). Inspired by the work of Walter Ruttmann, he experimented with colored liquids, wax, and clay, which he used to create abstract forms and shapes in his animations.[101]

Fischinger is often cited as the grandfather of visual music, music video, and motion graphics, but can also be seen as the forerunner of immersive environments.[102] Using painted glass slides, and multiple projectors and screens, he projected abstract imagery on multiple surfaces to create all-encompassing environments (fig. 45). Fischinger believed he was creating a new art form that would merge all the arts; he called this concept *Raumlichtmusik* (space light music). Fischinger stated: "Of this Art everything is new and yet ancient in its laws and forms. Sculpture—Dance—Painting—Music become one. The Master of the new Art forms poetical work in four dimensions. . . . Cinema was its beginning. . . . *Raumlichtmusik* will be its completion."[103]

La Triennale's windows were the site for *Natural Selections*, allowing passersby to view the installation from a nearby garden at night. The site was an immediate challenge because Eno was not simply installing work in a gallery. For the first time in his career, he was forced to think about the installation in large-scale architectural terms and turned to a software program that allowed him to work on an environmental scale.[104] On the outside of the building at night, he projected large-scale images of butterflies. With several unused projectors, and a large empty wall inside the museum, he was driven to create a second work on the interior and started to plot a new projection using the leftover slide mounts (fig. 46 and pages 215–20).

fig. 45

fig. 46

fig. 45
Oskar Fischinger.

fig. 46
Eno's hand-painted
slides for *Natural
Selections*.

As a onetime rock musician, he was well aware of the lighting designers who created psychedelic shows for bands such as Jefferson Airplane, Pink Floyd, the Soft Machine, Jimi Hendrix Experience, and the Velvet Underground. Using overhead projectors and transparent containers filled with colored oils and water, along with color wheels, stage-lighting gels, slide and film projectors, mirrors, and various other items to create wildly colorful kinetic abstractions, they produced audiovisual extravaganzas that were projected onto the bands. Known as "liquid light," these light shows were created using very basic materials and little technology.

Glenn McKay was an American pioneer in the field.[105] He was greatly influenced by the counterculture guru Ken Kesey's infamous large-scale "Acid Test" parties, which often involved the music of the Grateful Dead along with a light show, strobe lights, fluorescent paint, and LSD. McKay went on to develop some of the most elaborate light shows of the psychedelic era (fig. 47). It would not be unusual for him to use five hundred hand-drawn slides for a forty-five-minute show. Using rear-screen projections and up to ten slide projectors, oil-dish projectors, overhead projectors, and motorized color wheels, McKay produced highly textured and colorful imagery that included moving biomorphic forms.[106] The British artist and designer Mark Boyle also experimented with projected light and immersive taped-sound environments in the 1960s (fig. 48). Boyle already had a recognized art career in the cultural underground before he began organizing full-scale performances at venues across London.[107] Against a backdrop of prerecorded audio, he mixed chemicals and projected the resulting physical reactions onto screens while the performances took place.

This experimental lineage was extended in *Natural Selections*. Eno covered the glass from the slides with correction fluid, so that he could "draw" into them with a fine-pointed instrument.[108] The incorporation of colored gels added another layer to the minuscule scratched drawings, which became monumental when projected at hundreds of times

fig. 47
The Jefferson Airplane
performing at The Family
Dog Ballroom, San
Francisco, June 13, 1969,
with light projections by
Glenn McKay.

fig. 48
Mark Boyle and Joan
Hills /The Sensual
Laboratory, *Son et
Lumière for Earth, Air,
Fire & Water*, 1966.

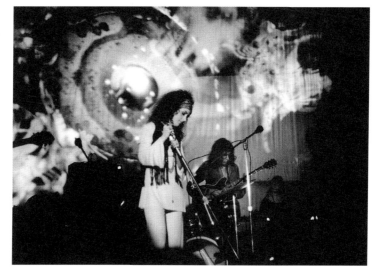

fig. 47

the original size. Eno was no longer limited to thinking about his work as a collection of small, discrete objects but could begin to think in terms of environments on an architectural scale. With this installation, he embraced a site-specific approach that would reach its logical conclusion in his *Quiet Club* series.

An important reference for the *Quiet Club* is Kurt Schwitters's *Merzbau*, one of the landmarks of twentieth-century art and an inspiration for many installation artists (fig. 49).[109] Schwitters's lifelong project transformed a portion of his family home into a labyrinthine series of abstract grottoes, becoming a place where he could make art that was not separated from the life he led.[110] Schwitters wrote in 1920, "My ultimate aspiration is the union of art and non-art in the Merz total world view [*Merz-Gesamtweltbild*]," and his *Merzbau* served as the ultimate expression of this idea.[111] For Eno, what began with *Natural Selections* as a response to a particular environment became in the *Quiet Club* the creation of total environments (see pages 236–77). Prompted by his Milan installation, he began working on complete room environments dedicated to the mood of contemplation. No longer limited to sound and light projections, these spaces, much like the *Merzbau*, were envisioned as extensions of everyday life while offering a refuge from its stresses. Eno wanted to create quiet places where one could reflect— something akin to a public park, church, or quiet pub.

fig. 48

fig. 49

fig. 49
Kurt Schwitters,
Merz Building, 1933.
Destroyed (1943). Room
installation, color, paper,
cardboard, plaster, glass,
mirror, metal, wood,
electric lighting, several
materials, 393 x 580 x 460
centimeters.

fig. 50
La Monte Young and
Marian Zazeela, *Dream
House: Sound and Light
Environment*, 1993–.
MELA Foundation, New
York.

fig. 50

One of the things I enjoy about my shows is that they produce a type of behavior I haven't seen before—lots of people sitting quietly watching something that has no story, few recognizable images, and changes very slowly. It's somewhere between the experience of painting, cinema, music, and meditation. I've noticed two things: If you make something that is the right slowness, people are very happy to slow themselves down to meet it. And if you accompany that with music which is the right quietness, people are happy to quiet themselves down to listen to it. I dispute the assumption that everyone's attention span is getting shorter: I find people are begging for experiences that are longer and slower, less "dramatic" and more sensual.[112]

La Monte Young and Marian Zazeela's hypnotic *Dream House* (fig. 50) provides a more contemporary parallel to Eno's *Quiet Club*. Their sound and light environment, first realized in 1969, was originally conceived to accommodate musicians, who would inhabit the space and play music twenty-four hours a day.[113] The installation was meant to exist in time as a living organism with a life of its own.[114] Zazeela, a visual artist, designed the light projections, while Young's compositions played throughout a twenty-four-hour cycle. Visitors were expected to relax and recline on pillows while the music and light enveloped them. Like Eno, Young emphasized, "Time is so important to the experiencing and understanding of this work that *Dream House* exhibitions have been

specifically structured to give visitors the opportunity to spend long intervals within the environment and to return perhaps several times over the span of its duration."[115]

Eno's environments were initially called *Places*, numbered sequentially by location *(Place Number 12, London)* but soon thereafter became known as *Quiet Clubs* (1986–2001). The ongoing series incorporated audio elements, including the ziggurat light sculptures, but also employed materials such as vermiculite, tree trunks, fishbowls, ladders, rocks, and even specially constructed tables and chairs with false perspective to create quasi-domestic environments (see pages 238–77). Eno wrote the following: "I was encouraged [by] the unexpectedly calming effect these shows seemed to have on people. These shows were always very slow-paced, but nothing was ever completely still. This minimal amount of change seemed to be very welcome—on a line between cinema and painting, these works existed quite a lot closer to the painting end than to the cinema end."[116] The *Quiet Clubs*, which cycle continuously and asynchronously, are not conceived to create illusion or destabilize perception. Instead, one is invited to step into an environment that highlights the way in which light and sound operate as both subject and perceptual medium. Eno has continued to explore these ideas in an ongoing series of installations, including *New Urban Spaces Series #4: "Compact Forest Proposal"* (2001), created for the San Francisco Museum of Modern Art's landmark exhibition *010101: Art in Technological Times*.[117]

In 1997 Eno created a generative, sound-only installation for London's White Cube. Mapping out a one-mile radius around the gallery, he selected specific locations to record the ambient sounds and noises, the voices of people walking by, the busy London traffic, and the pealing of nearby church bells.[118] At each site, he also recorded himself singing a single long note. Back at his studio, a variety of software programs were used to stretch, compress, and otherwise manipulate the raw sounds, and the final mixes were transferred to disks. Within the gallery, CD players with two speakers were installed on each of the four walls, and the unique disks with eight distinct tracks were played in a random sequence (see pages 306–07). Played and remade continuously, Eno's urban symphony of sounds rewards listening to its ever-changing landscape. He says of this work, "I was thinking of the sound less as music and more as sculpture, space, landscape, and of the experience as a process of immersion rather than just of listening."[119] For Eno, as for Cage before him, music needs neither beat, pulse, nor harmony.

Classical music works around a body of "refined" sounds—sounds that are separated from the sounds of the world, pure and musical. There is a sharp distinction between "music" and "noise," just as there is a distinction between the musician and the audience. I like blurring those distinctions—I like to work with all the complex sounds on the way out to the horizon, to pure noise, like the hum of London. If you sit in Hyde Park just far enough away from the traffic so that you don't perceive any of its details, you just hear the average of the whole thing. And it's such a beautiful sound. For me that's as good as going to a concert hall at night.[120]

The antecedents for this work can be found in the innovative work of the French composer, engineer, musicologist, and acoustician Pierre Schaeffer. Schaeffer is renowned for his achievements in experimental music and pioneered the form of avant-garde music known as *musique concrète*.[121] *Musique concrète*, or "real music," refers to music based on recordings of everyday sounds, a form that does not depend on harmony, rhythm, or tempo to create a melody. Schaeffer's first broadcast work was the seminal *Étude aux chemins de fer* (1948), which was a revolutionary montage of sounds recorded at a Paris train station. The work incorporated the sounds of steam locomotives, conductors' whistles, and train cars rattling across the tracks. Back in his studio, Schaeffer would play and manipulate the sounds by reversing, looping, and decreasing the speeds of his recordings to create the final piece.

Within the antiseptic walls of the gallery, named White Cube in acknowledgment of the pristine generic spaces in which contemporary art is consumed, Eno's introduction of everyday environmental sounds could be seen as a subversive gesture directed toward the conventions of art.[122] At the same time, the work's site-specificity countered the nonspecific environment represented by the white cube. Within a gallery setting, the recontextualized sounds—often heard but rarely listened to—blur the edges between music and nonmusic.

White Fence, 1979 (video stills)

00:00:02

00:02:02

00:04:02

00:00:42

00:02:42

00:04:42

00:01:22

00:03:22

00:05:26

00:06:14

00:08:14

00:10:26

00:06:50

00:08:54

00:10:58

00:07:18

00:09:30

00:11:26

White Fence, 1979 (video stills)

00:11:50

00:13:18

00:14:58

00:12:22

00:13:54

00:15:34

00:12:54

00:14:26

00:16:06

00:16:38

00:18:26

00:19:58

00:17:22

00:19:02

00:20:38

00:17:54

00:19:38

00:21:18

141

2 Fifth Avenue, 1979 (video stills)

Mistaken Memories of Mediaeval Manhattan (Dawn), 1980–81 (video stills)

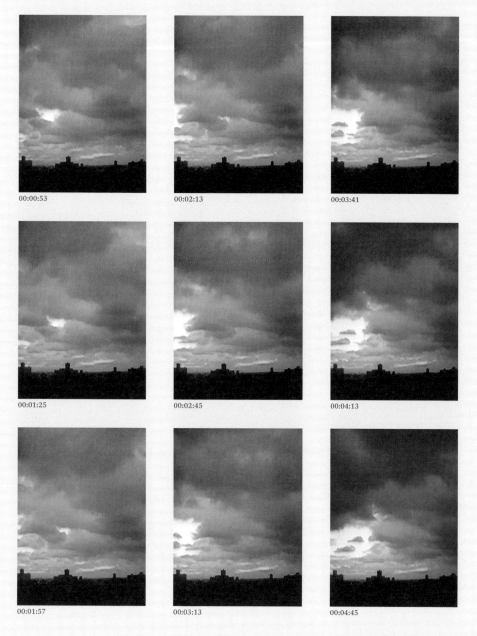

Mistaken Memories of Mediaeval Manhattan (Menace), 1980–81 (video stills)

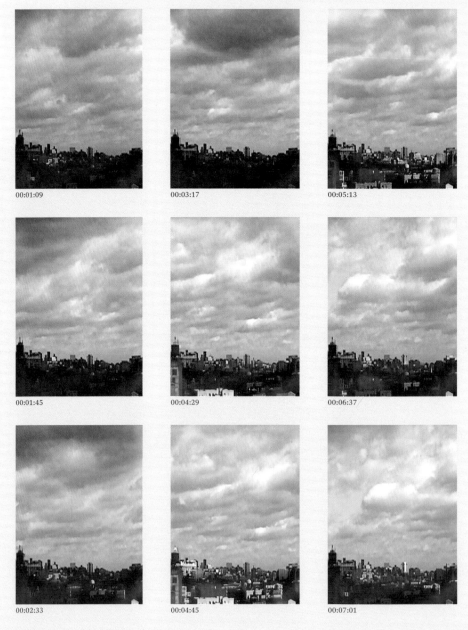

00:01:09

00:03:17

00:05:13

00:01:45

00:04:29

00:06:37

00:02:33

00:04:45

00:07:01

Mistaken Memories of Mediaeval Manhattan (Towers), 1980–81 (video stills)

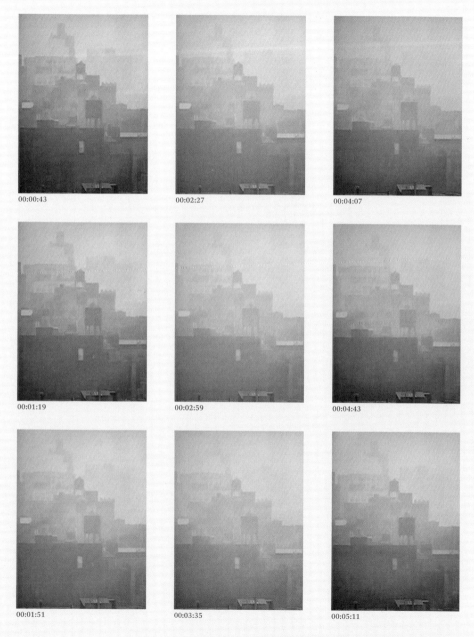

00:00:43

00:02:27

00:04:07

00:01:19

00:02:59

00:04:43

00:01:51

00:03:35

00:05:11

Mistaken Memories of Mediaeval Manhattan (Menace), 1980–81 (video stills)

00:00:40

00:03:52

00:07:16

00:01:44

00:04:56

00:08:16

00:02:52

00:06:24

00:09:20

Mistaken Memories of Mediaeval Manhattan (Empire), 1980–81 (video stills)

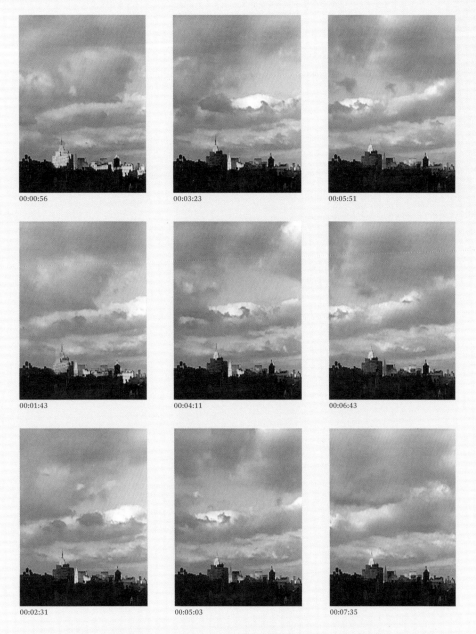

Mistaken Memories of Mediaeval Manhattan (Appearance), 1980–81 (video stills)

00:00:23

00:00:51

00:01:23

00:00:31

00:01:03

00:01:31

00:00:43

00:01:11

00:01:43

Mistaken Memories of Mediaeval Manhattan (Lafayette), 1980–81 (video stills)

Portraits (Manon, Patti, Alex, Janet, Sophie), 1981 (video stills)

00:01:05

00:00:48

00:00:56

00:01:33

00:00:56

00:01:32

00:01:49

00:02:12

00:02:28

00:00:59

00:00:43

00:01:31

00:01:19

00:02:07

00:01:55

Portraits (Manon, Patti, Alex, Janet, Sophie), 1981 (video stills)

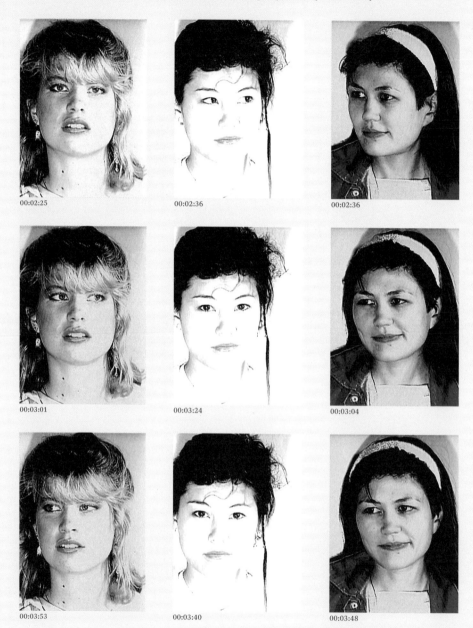

00:02:51

00:02:27

00:03:19

00:03:15

00:03:43

00:03:43

East Village (Blue), ca. 1980–82 (video stills)

00:00:04

00:01:56

00:03:36

00:00:40

00:02:28

00:04:12

00:01:20

00:03:04

00:04:40

East Village (Magenta), ca. 1980–82 (video stills)

Evening View Over East Chinatown (Views out of focus—Parisian phase),
ca. 1980–82 (video stills)

00:00:07

00:03:27

00:06:51

00:01:15

00:04:39

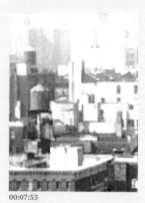
00:07:55

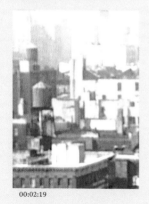
00:02:19

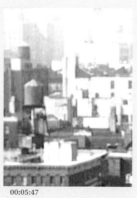
00:05:47

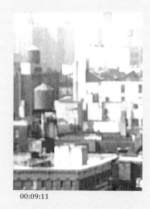
00:09:11

The Williamsburg Bridge (Mediaeval View), ca. 1980–82 (video stills)

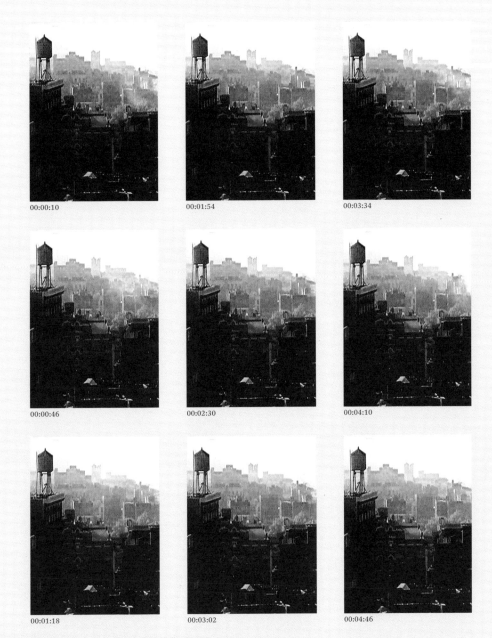

00:00:10

00:01:54

00:03:34

00:00:46

00:02:30

00:04:10

00:01:18

00:03:02

00:04:46

Beach (Two Parts), ca. 1980–82 (video stills)

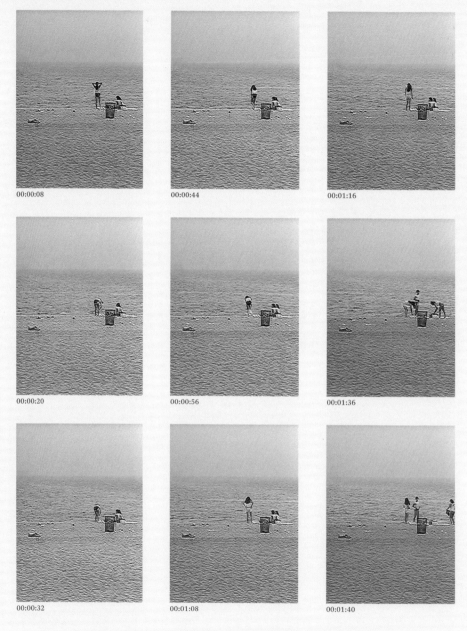

00:00:08

00:00:44

00:01:16

00:00:20

00:00:56

00:01:36

00:00:32

00:01:08

00:01:40

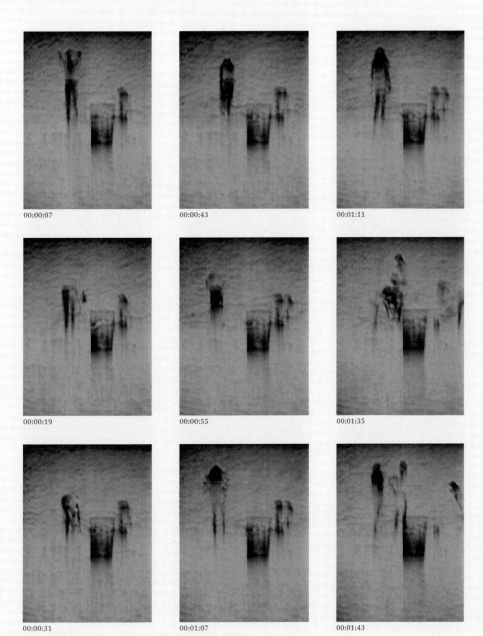

00:00:07

00:00:43

00:01:11

00:00:19

00:00:55

00:01:35

00:00:31

00:01:07

00:01:43

Slow Waves, ca. 1980–82 (video stills)

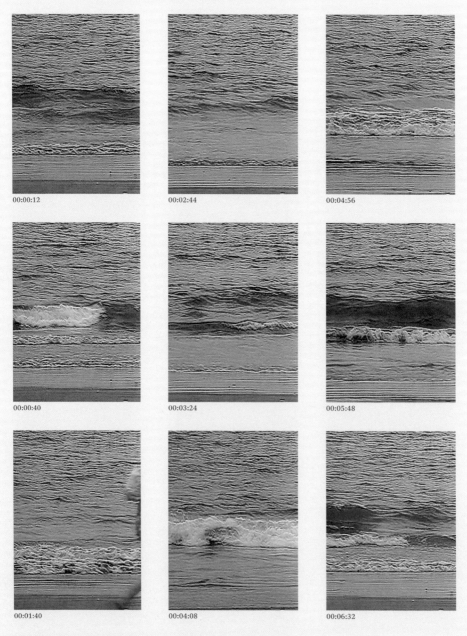

00:00:12

00:02:44

00:04:56

00:00:40

00:03:24

00:05:48

00:01:40

00:04:08

00:06:32

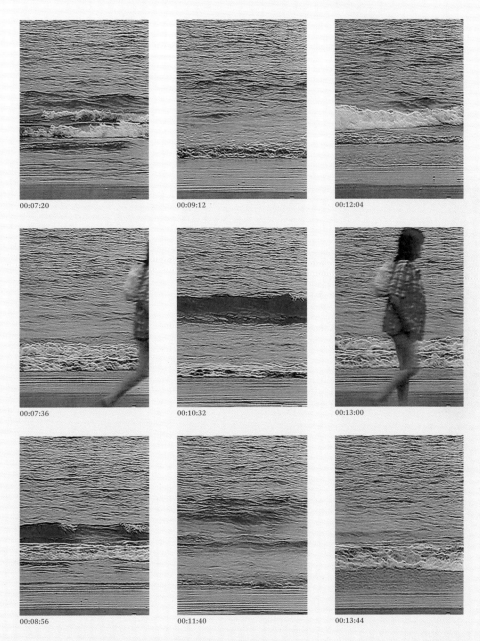

00:07:20

00:09:12

00:12:04

00:07:36

00:10:32

00:13:00

00:08:56

00:11:40

00:13:44

163

Slow Waves, ca. 1980–82 (video stills)

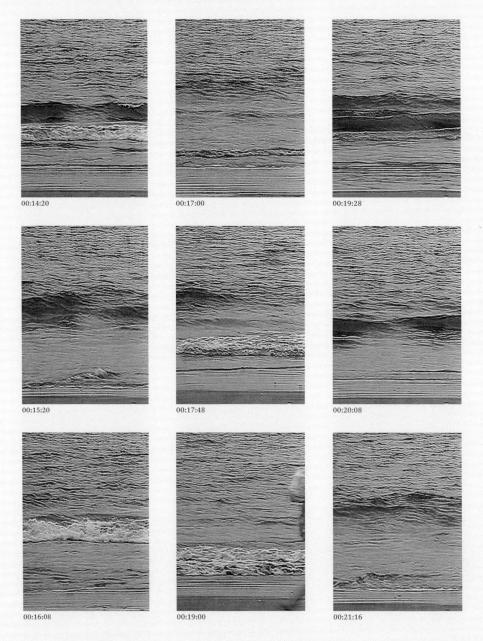

00:14:20

00:17:00

00:19:28

00:15:20

00:17:48

00:20:08

00:16:08

00:19:00

00:21:16

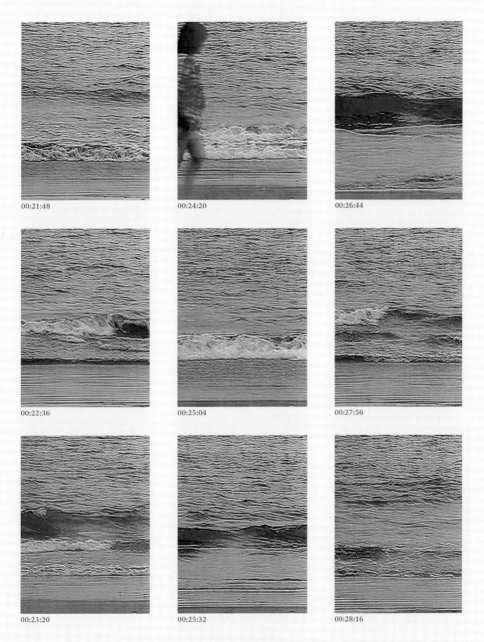

00:21:48

00:24:20

00:26:44

00:22:36

00:25:04

00:27:56

00:23:20

00:25:32

00:28:16

Thursday Afternoon (seven video paintings of Christine Alicino), 1984 (video stills)

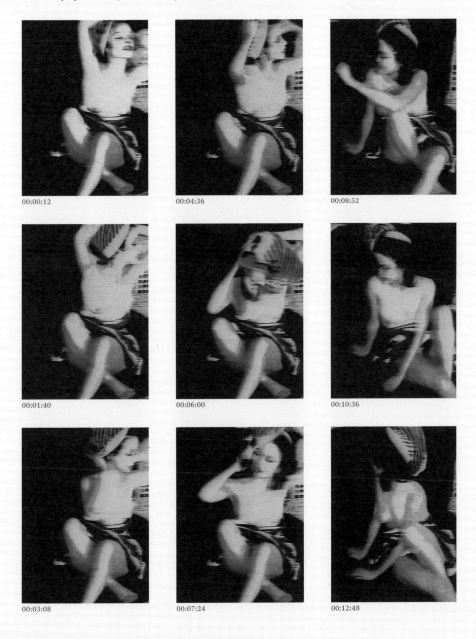

Thursday Afternoon (seven video paintings of Christine Alicino), 1984 (video stills)

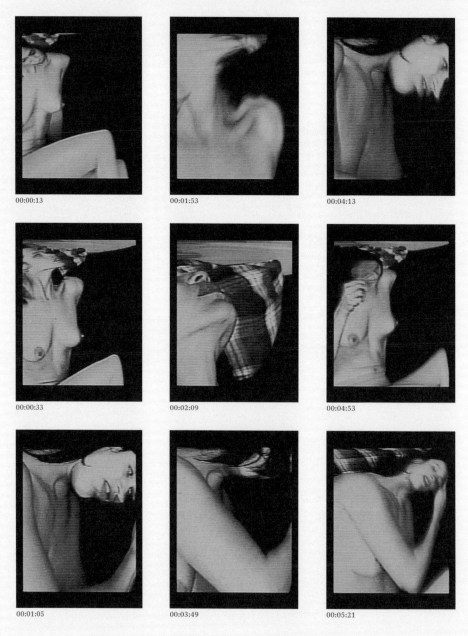

00:00:13

00:01:53

00:04:13

00:00:33

00:02:09

00:04:53

00:01:05

00:03:49

00:05:21

168

Thursday Afternoon (seven video paintings of Christine Alicino), 1984 (video stills)

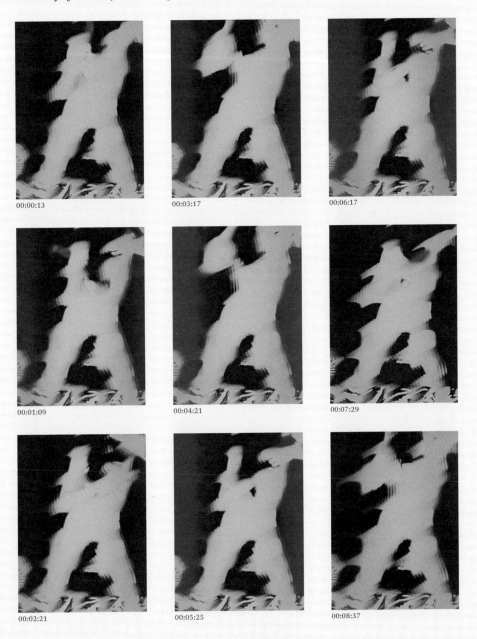

Thursday Afternoon (seven video paintings of Christine Alicino), 1984 (video stills)

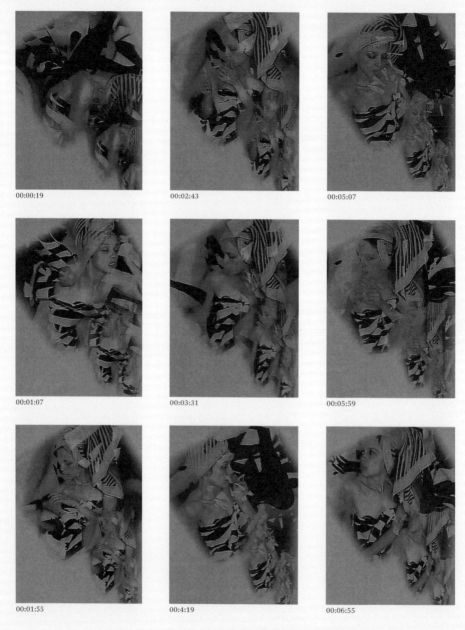

Thursday Afternoon (seven video paintings of Christine Alicino), 1984 (video stills)

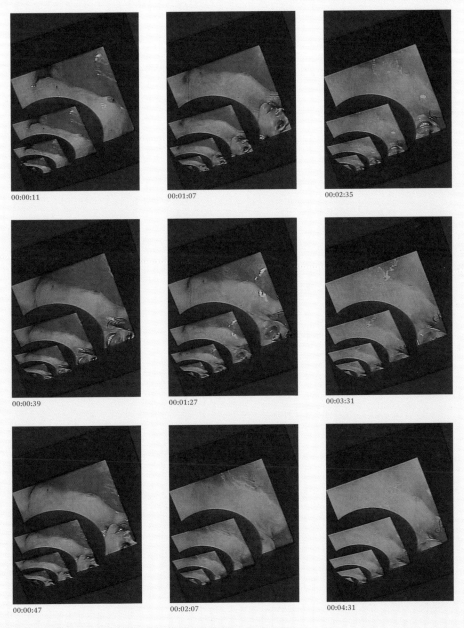

00:00:11

00:01:07

00:02:35

00:00:39

00:01:27

00:03:31

00:00:47

00:02:07

00:04:31

Thursday Afternoon (seven video paintings of Christine Alicino), 1984 (video stills)

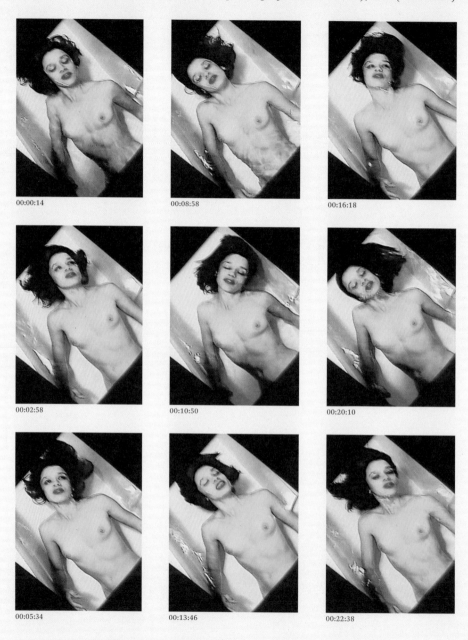

00:00:14

00:08:58

00:16:18

00:02:58

00:10:50

00:20:10

00:05:34

00:13:46

00:22:38

Thursday Afternoon (seven video paintings of Christine Alicino), 1984 (video stills)

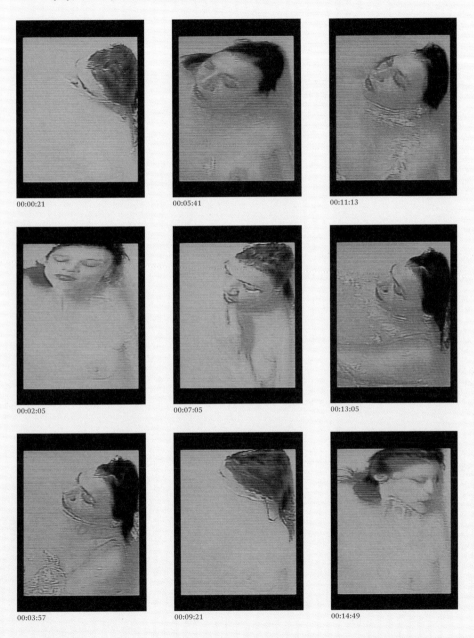

00:00:21

00:05:41

00:11:13

00:02:05

00:07:05

00:13:05

00:03:57

00:09:21

00:14:49

Christine, ca. 1980–83 (experimental video treatments for *Thursday Afternoon*)

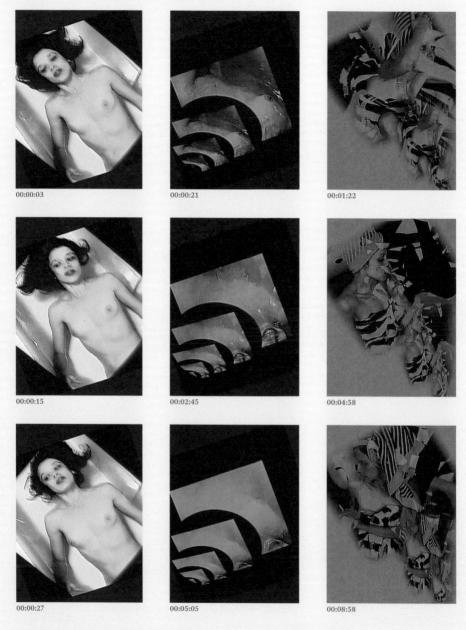

00:00:03

00:00:21

00:01:22

00:00:15

00:02:45

00:04:58

00:00:27

00:05:05

00:08:58

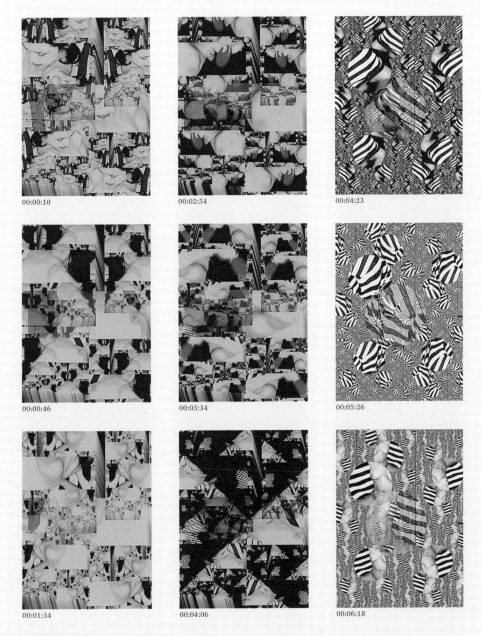

00:00:10

00:02:54

00:04:23

00:00:46

00:03:34

00:05:26

00:01:34

00:04:06

00:06:18

Nude Turning (Four Parts), ca. 1980–83 (experimental video treatment)

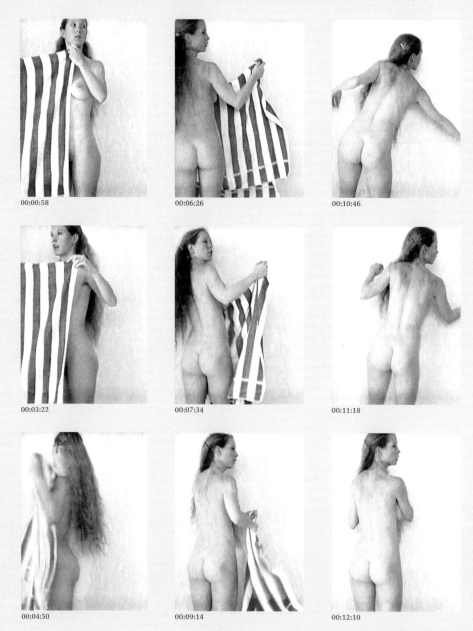

00:00:58

00:06:26

00:10:46

00:03:22

00:07:34

00:11:18

00:04:50

00:09:14

00:12:10

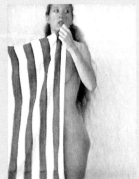

00:01:29

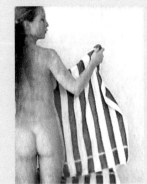

00:04:41

00:09:29

00:03:25

00:06:29

00:10:45

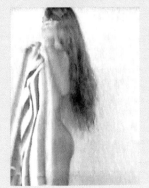

00:03:39

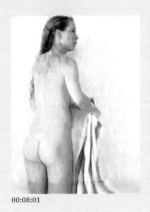

00:08:01

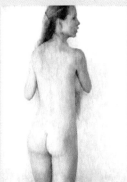

00:11:45

Beach #1, ca. 1980–83 (enhanced video experiment)

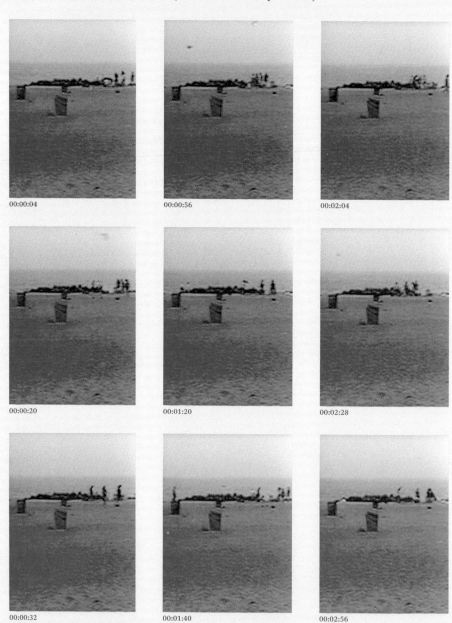

Reflections, ca. 1980–83 (enhanced video experiment)

00:00:23

00:01:15

00:02:07

00:00:39

00:01:31

00:02:23

00:00:55

00:01:51

00:02:39

Panel in the Sun with Dove and Night Frog (Three Sections), ca. 1980–83
(experimental video treatment)

Broadway *(Sunday Morning)*, ca. 1980–82 (experimental video treatment)

00:00:08

00:02:28

00:05:00

00:00:56

00:03:24

00:05:44

00:01:44

00:04:12

00:07:00

East Towards Delancey (Midday), ca. 1980–82 (experimental video treatment)

Spring Street (Saturday, May 1983), 1983 (experimental video treatment)

GONE TO EARTH

BRIAN DILLON

Here, weather is all:
To live, in the teeth of it,
As the birds do,
With a little always left over
For celebration.
(Michael Hamburger, "In Suffolk")

Let us begin at some apparent remove from the music, art, and thought of Brian Eno, in hope of describing a spiral back to his work and the vision of landscape that is to be seen and heard there, with its competing urges to theoretical lucidity, experimental rigor, pop-cultural bravado, and moments of frank nostalgia. In his vagrant and melancholic essay-fiction, *The Rings of Saturn* (1995), W. G. Sebald undertakes a journey on foot through the landscape and history of Suffolk, the eastern county of England where he had worked and taught since 1970. Sebald, or rather his half-imagined stand-in, finds himself in a state of convalescent near stupor. He sets out in the dog days of the summer of 1992 to walk a territory that is at once familiar and estranging. Its disorienting flatness and sudden shifts in time and space cause him to confuse visions of wildness with views of military and industrial ruins, and his own delirious state with the biographies of this region's famous and obscure inhabitants—among them the poet and translator of "The Rubaiyat of Omar Khayyam," Edward FitzGerald, whom at length he follows to the village of Woodbridge. It is a landscape, like much of England, charted and scored by modernity and still apt to plunge the peripatetic narrator into romantic dreams and reveries—a ghostly territory, alive with the past and visions of a technological future, whether plausible or quite imaginary.

In the eighth of Sebald's chapters—it seems more accurate, despite his wandering, to think of them as fugues or variations on a steady state of meditation or reflection—he arrives at Woodbridge as night falls and finds a room at the Bull Inn. It is less than half a mile from where the village fronts the river Deben and the rigging of numerous yachts chimes bell-like against metal masts. Sebald retires at once and listens to the sounds immediately about him, "The room to which I was shown by the landlord was under the roof. The clinking of glasses in the bar and a low murmur of talk rose up the staircase, with the occasional exclamation or laugh. After time was called, things gradually quieted down. I heard the woodwork of the old half-timber building, which had expanded in the heat of the day and was now contracting fraction by fraction, creaking and groaning. In the gloom of the unfamiliar room,

my eyes involuntarily turned in the direction from which the sounds came, looking for a crack that might run along the low ceiling, the spot where the plaster was flaking from the wall or the mortar crumbling behind the panel."[1] Closing his eyes, Sebald has the impression that he is in a cabin aboard a ship on the high seas, the building rising and falling with the waves. He lies awake until dawn, then dreams about Edward FitzGerald. When he rises, late, he sets out eastward from Woodbridge to Orford and the sea, "[A] good four-hour walk. The roads and tracks pass through dry, empty stretches of land which, by the end of a long summer, are almost like a desert."[2] As he approaches Orford Castle, heading for the strange expanse of Orford Ness, the sky darkens and a sandstorm whips up around him, obscuring everything, "Even in my immediate vicinity I could soon not distinguish any line or shape at all."[3]

We'll have occasion later to rejoin Sebald as he nears the desolate military hinterland of the Ness and discovers the lost town of Dunwich along the coast, touching as he goes on points of interest in the landscape that have explicitly or implicitly been recalled in Brian Eno's music. For now I want simply to note the unexpected conjunction of two near contemporaries who have memorialized this territory: the one avowedly, while sunk in its history and mystique, the other more or less obliquely, seeming to conjure memories of it as if from a constant (though, over time, apparently deepening) well of poetic and cartographic images, not to mention of course its sounds both natural and not. Woodbridge is famously the village in which Eno grew up; the Bull Inn is just a twenty-minute walk across playing fields and the village cemetery from the council house at 21 Queens Avenue to which his family moved when he was born in 1948. Nearby are the sites where during the Cold War hundreds of American pilots and troops were stationed, turning this otherwise sleepy East Anglian town into an oddly cosmopolitan place. This is where while growing up, Eno could hear the latest musical imports from the United States long before others of his generation. Once the connection has been spotted, it is superficially easy to find Sebaldian motifs in the stories of his childhood that Eno has told interviewers over the past four decades. His parents met in Belgium at the end of the Second World War; his mother, Maria, was Flemish and had spent time in a German labor camp. His uncle, Carl Otto Eno, had been a cavalryman in India in the 1930s, and now led an eccentric life surrounded by seventeen cats, a tame jackdaw, and "swords and flags and suits of armour and skeletons and old instruments." It was Carl who introduced him to modern art, and specifically to the paintings of Mondrian that convinced Eno, around the age of ten, that he must be an artist.[4]

As Eno has also noted many times, he was born into a family of postal workers, specialists of a sort in communication and its networks. Like his father and uncle, his grandfather too had been a postman, and in retirement had taken up as a hobby the repair of church organs, "My grandfather lived in a deconsecrated chapel—a chapel that a priest had committed suicide in, to be exact. . . . It was a rather spooky place, with lots of creaky stone tiles. And he had filled it with all kinds of incredible things; he was rather like a rural version of Lieutenant General Pitt Rivers, who started the Pitt Rivers Museum in Oxford; he just collected things. He had great bundles of Zulu spears sitting around; or you would go around a dark corner and there would be a Japanese suit of armour. It was an incredible place for a child; and everywhere, there were keyboard instruments."[5] One thinks immediately of such figures in Sebald's fiction as Major George Wyndham Le Strange, who, secluded in his manor at Henstead, "would wear garments dating from bygone days which he fetched out of chests in the attic as he needed them," or of the poet Michael Hamburger, surrounded at his Suffolk house with towers of manuscripts and his apple harvest.[6]

But although such details have been told and retold in interviews and biographies, and suggest a now-vanished type of semirural English life in the middle of the twentieth century, it is not immediately apparent that they are at the heart either of the version of landscape, or of rural English memory, that Eno seems at times to share with a writer such as Sebald—or of the specific relations between his music, art, and a version of English landscape that I want to suggest provides one route through his work, both musical and visual. Rather, Eno's Suffolk—and by extension his English landscape, and by further extension his very idea of landscape—is at first glance or listen a curiously unpeopled sort of place. His landscape is overlain by theories, maps, and images of elsewhere, but which nonetheless breaks the surface here and there in his music with remarkable specificity of reference or recall, in sounds and lyrics, or simply in song and album titles. This suggests that one of the various types of artist he has been is an English landscape artist. That is putting it too crudely, of course, because it is the fact of his abstracting himself from the landscape that in both his music and the visual art is most striking—the way real places, whether near at hand in England, or in various exotic locations, or even on the moon, give way to a governing concept of place, to its merest suggestion or to a strategically or compositionally useful notion of place. For a time at least, Eno conceived of some of his music as summoning up "imaginary landscapes"; but it is not a term to which he has adhered with any

rigor—perhaps precisely because his interests are more abstract and his frame of reference, in terms of place, more specific.

Eno's music, when it touches as it frequently does on topographical themes, be it in sound or image or verbal suggestion, seems to shuttle between subjecting landscape to systematic derangement and giving in to the seductions of memory or longing, allowing the artist not only to invoke the places of his Suffolk youth by their names, but to summon the flatness and desolation of the place, its liminal situation and aspect, and the specific sounds of its weather or wildlife. And the same ambiguity obtains in his videos and installations, if not exactly at the level of specific recall of real places. Eno's earliest video piece, *2 Fifth Avenue* (1978), treats the New York skyline as an opportunity for a meditation on light and weather, subsequently expanded in duration and scope for *Mistaken Memories of Mediaeval Manhattan* (1980–81). And if his later video and installation work is not precisely attuned to landscape as such, it certainly pursues something of the same relation between conceptual and technological systems, and the aesthetic and meditative tendencies of the music. Works such as *Pictures of Venice* (1983), *Crystals* (1983–85), and the more recent *77 Million Paintings* (2006) still treat digital or televisual sources as ways into something very close to the languid disorientations of the music of the 1970s. They are still, that is to say, dedicated to a kind of romanticism. Eno is a prime instance of a type of English artist—a type he allows us to better define with regard to the work of others; he is, we must say, a "romantic conceptualist."

•

Consider, by way of introduction to the field of Eno's topographical engagement, the profusion of spatial, natural, and maritime references in his early solo albums and in the relatively few instances since the mid-1970s when he has returned to singing—a practice for which he has since at times expressed some nostalgia though apparently (and in a telling way of putting it) he could after a certain point no longer find a place for it in his music. It is possible to trace a certain imagery of barrenness, verging alternately on abandonment or bliss, and couched often in terms of riverine or seaside vistas, to his first solo album, *Here Come the Warm Jets* (1973). Though we might also want to note that these motifs are already partially in place on the first two Roxy Music records, as also on *Stranded*, the album the band made directly after Eno's departure, and which he has more than once declared his favorite of their recordings. Much of *Here Come the Warm Jets* is given over to a

knowing and sleek perversion of the lyrical surrealism inherited from the previous decade by many rock artists of the early 1970s. Eno has admitted a debt to Syd Barrett's lyrics for the first Pink Floyd album and on his few subsequent solo recordings. Songs such as "Baby's on Fire" and "Blank Frank" confect a campy grotesque that is partly a comically Anglo take on the familiar rock strategies of mock-psychedelic oddity and bizarrerie, some of it avowedly influenced by writers such as William Burroughs. All of which in Eno's case we have to set alongside his repeated assertions that his lyrics, even at this early stage in his career, were written more for their rhythms and texture than meaning.

All of that said, there is a strain of darkling pastoral on at least one track. "On Some Faraway Beach," the opening song on the second side of *Here Come the Warm Jets*, drifts in slowly with an elegant though slightly uncertain and staggering piano motif, taking some minutes before Eno's vocals appear, with their laconic invocation of the narrator dying "like a baby" at the sea's edge, submerged in shifting sands, though also in the next verse transported to a nameless plateau, "with only one memory. A single syllable." The song, sandwiched here between the lurching oddity of "Driving Me Backwards" and the mania of "Blank Frank" (on which guitarist Robert Fripp viciously reanimates a classic Bo Diddley riff), is a brief placid glimpse of an aesthetic and a set of imagery that would recur with increasing frequency in Eno's vocal work. His subsequent album, *Taking Tiger Mountain (By Strategy)*, would invoke a different array of landscape scenes; derived as he has said from a series of postcards depicting a Chinese revolutionary opera of the same title. Here the plane of the landscapes hinted at what seems determinedly flat, painterly, or photographic; as for example, in the background to the enigmatic events that seem to have transpired in the bay of "China My China," a song that appears lyrically to light on scenes depicted across a disparate and detailed canvas, a composition made of ordered and discrete elements, "You see, from a pagoda, the world is so tidy."

It's on *Another Green World* (1975) that the lyrical tendency toward dissolving into, rather than scanning across, a landscape properly returns. It is possible, I suppose, to take the album's title quite literally and hear in these fourteen pieces a description not merely of an imaginary landscape but a notional planet, more or less Earthlike—Edenic, perhaps, in the environmentalist mode of much science fiction of its era, but traversed too by sinister trajectories. *Another Green World*, however, is some distance from the sci-fi imaginary that informed much of the progressive rock then being made by Eno's contemporaries—its musical palette is more austere, its lyrical evocations considerably

more oblique and suggestive. More crucially, in place of a thoroughly or even minimally imagined world it affords fragmentary glimpses of certain ways of negotiating the spaces or territories at which it hints. The opening three tracks—"Sky Saw," "Over Fire Island," and "St. Elmo's Fire"—seem to posit an airborne, perhaps cartographic, perspective—one has the sense of complex machinery describing uncertain arcs above and among elemental, meteorological phenomena. And the impression of technology massed against or in exploration of the sensory morass of this world returns in "Golden Hours," with its precise evocation of a consciousness fading out even as it focuses, via that technology, on flux and mutability, "The passage of time is flicking dimly upon the screen. / I can't see the lines I used to think I could read between." By the end of the record, all is drift and dissolving, whether in a literal state of being "Becalmed" or again on "Everything Merges with the Night" and "Spirits Drifting," a sense of ecstatic falling away, out of measurable time and space and into a state of blissful being between. The same condition of stillness verging on extinction would recur in a song such as "By This River" and two years later on the album *Before and After Science*.

But the most compelling tracks on *Another Green World*, the pieces that most complexly propose a certain vision of landscape and the musical and visual systems that may be arrayed before it, are those that refuse any easy lyrical conjuring of an imaginary landscape, but seem themselves to enact a movement across or though it. In "In Dark Trees," "The Big Ship," and "Sombre Reptiles"—all three depend on rhythm tracks that suggest at once forward propulsion and a steady or at least repetitive state—minimal ancillary rhythms and snatches of melody arrive like details that one latches onto in an otherwise uniform landscape. For sure, the titles are useful here, and there are visual corollaries one can reach for in the cinema of the same era; it is hard to listen to these pieces and not think of the riverine drift through forest or jungle in *Fitzcarraldo* or *Apocalypse Now*. Regarding "In Dark Trees," Eno made an explicit link back to woodland excursions in his youth, "I can remember very clearly the image that I had which was this image of a dark, inky forest with moss hanging off and you could hear horses off in the distance all the time, these horses kind of whinnying, neighing."[7] But the sense here is surely of the drift itself rather than the drifter, of movement tracked across a minutely altering field without reference to a perceiving, let alone interpreting, consciousness. The view unfolds as in the revelation of a painted scroll, but in this case the landscape is empty—there are no localized scenes on which to fix the gaze, no narratives hinted at by even

the most minimal lyrics—merely the elaboration of a musical and visual frieze whose points of interest are obscure at best.

In an interview with *Artforum* in 1986, Eno put it thus: "My feelings about landscape do have a lot to do with [the music]. There is a point in making a piece where I suddenly get a sense of where I am—in landscape terms. I can begin to sense the geography, the light, and the climate. After that it normally flows quite easily. An aspect of this landscape concern is to do with the removal of personality from the picture. You know how different a landscape painting is when there is a figure in it. Even if the figure is small, it automatically becomes the focus—all questions of scale and depth are related to it. When I stopped writing songs I took the figure out of the landscape."[8] *Another Green World* is among other things a dramatization of this evacuation of the landscape, and what replaces the consolidating or grounding figure is a repetition that cedes without warning to certain evocative details, "It seems necessary to me that the music must be generally constant but specifically unpredictable. Watching clouds form, change, and dissolve is a good analogy: the overall nature of the experience is consistent but the details of it are unpredictable."[9]

The link back to Eno's earliest experiments with tape loops, with systems that allow for a degree of unpredictability within repetition, is clear, and here cast exactly in terms of landscape. What is striking, though, in Eno's own descriptions of the relationship or relay between system and surprise, or between figure and ground, is the extent of unease involved—it is not simply a matter of placid, abstracted drift with occasional vistas of emotionally heightened content, but of a kind of topographical panic. In his biography of the artist, David Sheppard recounts a story that Eno liked to tell of a holiday in Scotland in the summer of 1974, "During a long, solitary hillside walk he had become severely lost. Increasingly anxious in the gathering gloaming he stumbled on a bank of wild flowers and was suddenly overcome by their unexpected spectral beauty. This, he reasoned, was evidence of desperation sharpening the aesthetic sense."[10] The anecdote is teasingly romantic (specifically, Wordsworthian) in its scenography and detail—but it maps precisely onto Eno's developing musical practice.

●

Eno's ambient works from the 1970s onward are the fullest expression of the conception of his music as both invested in an idea of landscape and itself productive of a certain type of space and time of listening.

The primal scene out of which he imagined that music is well known, but worth repeating here. On the evening of January 18, 1975, Eno was struck by a taxi and though not very severely injured spent the ensuing weeks incapacitated. In the sleeve notes to his *Discreet Music*, released later that year, he claimed that his occasional collaborator Judy Nylon had brought him a recording of eighteenth-century harp music, and left it playing when she left. Unable to get out of bed and raise the volume Eno lay listening as the music was quietly interfered with by the hum of traffic outside his apartment. In Sheppard's biography Nylon tells a slightly different version of this anecdote; she and Eno had deliberately manipulated the volume of the music so that it balanced with the sound of rain outside. In either case, Eno had apparently "discovered" a type of music, or a type of listening, which was on the verge of vanishing, and of a piece with its environment. In reality of course Eno's ambient work is of a piece with compositional and recording strategies that he had already explored both on his solo albums and on the recording he had made with Robert Fripp, released in 1973 as *No Pussyfooting*. The idea of a music whose structure is largely beyond the composer's or musician's control also had its origins in his immersion in the works of the minimalist composers of the late 1960s. The very idea of a music to which one could adjust one's attention was in part a wry repurposing of the reality of Muzak—a project that had its clearest fulfillment on Eno's *Music for Airports* (1978)—and an acknowledgment of Erik Satie's *musique d'ameublement* or "furniture music."

But ambient is also marked by another origin, or a set of origins that overlap and make for an especially rich and suggestive series of evocations of real, not imaginary, landscapes. First, there is Eno's stated intention of producing a music that approached the condition of landscape. This is how he formulated it in the notes to *On Land* (1984): "The idea of making music that in some way related to a sense of place—landscape, environment—had occurred to me many times over the years preceding *On Land*. Each time, however, I relegated it to a mental shelf because it hadn't risen above being just another idea—a diagram rather than a living and breathing music. In retrospect, I now see the influence of this idea, and the many covert attempts to realise it, running through most of the work that I've released like an unacknowledged but central theme. This often happens; you imagine a territory rich in possibilities and try to think of how you might get to it, and then suddenly one day you look around and realise that you have been there for quite a long time." The ambient albums pursue, at one level, the sense on *Another Green World* of the music *as* landscape,

complete with a more or less stable ground and fleeting or unexpected phenomena that, just to state it very literally for a moment, function like impressions of atmosphere or weather. But these are landscapes too that as it were leach into the space of the listener, transforming that space and turning the listener, albeit fleetingly, into the very subject—the solitary romantic walker, we might say—that Eno had been at pains to remove from the frame.

There is however a third stratum: Eno's specific if not exactly elaborated references to and evocations of, in the eight tracks that comprise *On Land*, real places and half-recalled events in the Suffolk landscape. They do not all have to do with places in the county of Eno's birth; the opening track is "Lizard Point," with its sense of sound drifting across land and sea and its title's reference to a point on the Cornish coast. The prevailing mood is of a landscape in which sound behaves strangely; clues emerge in pieces such as "The Lost Day" and "Shadow" as to the presence of water, of wildlife, of a certain marshy *platitude*. Voices, or what might be voices, drift and settle like fog; birdcalls, or what might be birdcalls, sound like ghosts of the rhythm tracks on *Another Green World*. The specificity of reference starts to accrete as the record progresses. The sleeve notes to the original release make the links explicit. Eno recalls the territory named by "Unfamiliar Wind" (Leeks Hill), "Leek's Hill is a little wood (much smaller now than when I was young, and this not merely the effect of age and memory) which stands between Woodbridge and Melton. There isn't a whole lot left of it now, but it used to be quite extensive. To find it you travel down the main road connecting Woodbridge and it lies to your left as you go down the hill." And on "Lantern Marsh" Eno writes, "My experience of it derives not from having visited it (though I almost certainly did) but from having subsequently seen it on a map and imagining where and what it might be." The real Lantern Marsh is at the northern end of the shingle expanse of Orford Ness, a territory, according to the Ordnance Survey map today, crossed by power cables and pylons and given over to a bird sanctuary owned by the National Trust. The Ness (the word derives on account of its shape from the Old Norse for a nose) is a famously desolate flatness used as a testing ground by the military during both world wars and the Cold War. It was used to test radar and later components of atomic weapons. Eno, we have to assume, would, like most Suffolk residents in the postwar years, have been well aware that certain experiments had taken place, and were still going on there. Much of *On Land* feels distinctly *irradiated*. This is the territory that Sebald walks in *Rings of Saturn*.

For a long while I stood on the bridge that leads to the former research establishment. Far behind me to the west, scarcely to be discerned, were the gentle slopes of the inhabited land; to the north and south, in flashes of silver, gleamed the muddy bed of a dead arm of the river, through which now, at low tide, only a meagre trickle ran; and ahead lay nothing but destruction. From a distance, the concrete shells, shored up with stones, in which for most of my lifetime hundreds of boffins had been at work devising new weapons systems, looked (probably because of their odd conical shape) like the tumuli in which the mighty and powerful were buried in prehistoric times.[11]

There is one more reference in *On Land* to this ruinous territory. "Dunwich Beach, Autumn 1960" is another of Eno's liminal compositions, evoking as it does a place along the coast from Orford that is if anything even more haunted. (Sebald fetches up here too, and reflects lugubriously, "We simply do not know how many of its possible mutations the world may already have gone through, or how much time, always assuming it exists, remains. All that is certain is that night lasts far longer than day."[12]) Dunwich was once a thriving port and town with shipyards, fortifications, a merchant fleet, and a dozen churches, all of which fell, over centuries, into the sea as the land eroded. The last, All Saints, slipped over the cliff edge in 1919. By the late nineteenth century, the place was already a kind of sub-Gothic tourist attraction, an emblem of nature's and time's victory over human endeavor. In 1897, Henry James visited it on a tour of notable places in England, and wrote: "I defy anyone, at desolate, exquisite Dunwich, to be disappointed in anything. The minor key is struck here with a felicity that leaves no sigh to be breathed, no loss to be suffered; a month of the place is a real education to the patient, the inner vision. The explanation of this is, appreciably, that the conditions give you to deal with not, in the manner of some quiet countries, what is meagre and thin, but what has literally, in a large degree, ceased to be at all. Dunwich is not even the ghost of its dead self; almost all you can say of it is that it consists of the mere letters of its name."[13] If landscape for Eno was a matter of discovering "a quiet place," there are few so quieted, and at the same time disquieting, as Dunwich.

●

All of this, of course, is implicit rather than avowed in Eno's music, and we could hardly say that ruinous melancholy is the dominant mode of

his work. But the resurfacing of the historic territory in which he grew up is just one instance of a preoccupation with landscape—landscape as idea, as process, as image, and as sound as well as remembered reality—that ghosts his music and art. How best, then, to situate Eno's topographical preoccupations? In 2002, the art critic Jörg Heiser identified a strand in the art of the previous three decades, heightened in recent years (and only more so since Heiser named it), toward what he called romantic conceptualism—a tendency that consists not only in the persistence of subjective or affective traces in conceptual art, but in a productive relay between emotional valence, which may even include such disreputable emotions as nostalgia, and austere or rigorous conceptual intent. As Heiser puts it, "why should a spectator not be able to find a piece 'mentally interesting' and emotionally rich? Why would an 'emotional kick' inevitably deter from perceiving the Conceptual? Could it not be quite the opposite: that charging a concept with an emotional investment, or subjecting emotions to a Conceptual approach, might focus rather than distract?"[14] Heiser adduces a wide range of canonical artists and works—for example, certain films of Andy Warhol's such as *Kiss* (1963); Bas Jan Ader's 1971 film *I'm Too Sad to Tell You*, in which the artist openly weeps before the camera; the covert romanticism of Robert Barry's interventions in landscape; and the patently autobiographical works of Sophie Calle and Felix Gonzalez-Torres.

If the tendency exists, it seems that it has flourished among English artists, filmmakers, musicians, and (to a lesser extent) writers in the past decade or two. Its richest expression has been in a frank though conceptually nuanced return to the English landscape; its history, its seductions, its ruination, its future. We may think for example of the films of Tacita Dean, whose elegant 16mm films have depicted for example a set of concrete acoustic early-warning devices of the 1930s on the Kent coast at Dungeness (a geological twin to Eno's and Sebald's Orford) and in ravishing detail the home and garden of Sebald's friend Michael Hamburger. In film, Patrick Keiller's rough trilogy of *London* (1994), *Robinson in Space* (1997), and *Robinson in Ruins* (2010) have essayed a richly researched and visually laconic survey of the depredations of capital and the military on the English city and countryside in the late twentieth century. For Keiller as for Eno there are aesthetic and emotional surprises to be discovered in the static view of landscape. Details such as the play of light on stone or concrete, or the sounds of wind and birdsong, take on an almost visionary strangeness in a territory mapped and strictured by the modern. Over the past decade the record label Ghost Box, whose artists are clearly indebted to Eno's

early ambient works, has contrived a kind of fictional mid-twentieth-century Britain composed of near-forgotten acoustic remnants: the soundtracks of public-information films, the landscape-obsessed popular science fiction of the 1970s. In literature, the rise in the past decade of a "new nature writing" has at its most daring (as in the works of Robert Macfarlane) sought to revisit traditional views of landscape through the conceptual filter of the land art of the 1960s and 1970s. And in a lesser celebrated field of cultural criticism, a self-declared "hauntological" turn, dedicated to the unearthing of buried cultural and political relics in the neo-liberal present, has involved a surprising investment in landscape as the site of the most startling insights—the critic and theorist Mark Fisher, for example, returning precisely to the East Anglian territory that subtends so much of Eno's music.[15]

It is possible—indeed, necessary, given the degree to which his work is routinely understood chiefly in terms of its avant-garde musical debts—to situate Eno in this wider context of a resurgence of English romanticism, in the context of bodies of work that are at the same time determinedly contemporary in terms of their media or the conceptual strategies they bring to bear on seemingly traditional material. Eno has been reticent about declaring himself part of any such move—understandably so, as what I have been calling his romantic interest in landscape is more obviously a matter of a subjective set of biographical and topographical resources than anything like a programmatic "return" to landscape. But the lineage remains true, the essential rootedness of his work is in real places as well as imaginary and a matter of the texture of his music and art, as well as stated references or titular invocations of place and time.

This romanticism is as much an aspect of his most successful video and installation work as it is a feature of his ambient recordings. *Mistaken Memories of Mediaeval Manhattan*, for example, shares much with the conceptual underpinnings of the music he had made in the half decade that preceded it; a reliance on the process to make the work as it were of its own accord, an attraction to minutely varying impressions within an overall structure that hardly varies. (We should recall too that *On Land* supplied the soundtrack to showings of *Mistaken Memories* in many or most of its showings.) But it also denotes a vision of the city that is close to the combination of rational structures and emotional impressions that mark that music. It is a combination that has not ceased to be made visible in Eno's art. Its purchase is both on the past, on subjective echoes of the past, and, as on the early records, on a notion of the future. Like much of the work made, knowingly or

otherwise, under the rubric of a romantic conceptualism, Eno's is (surprisingly, given his lack of interest in his own artistic past) of the future anterior, of what will or what might have been. Here, finally, is how Eno put the matter in 1983: "Like the music that accompanies them, the films arise from a mixture of nostalgia and hope, from the desire to make a quiet place for myself. They evoke in me a sense of 'what could have been,' and hence generate a nostalgia for a different future. It is as though I am extracting from this reality (the one that my camera is pointed at) the seeds of another. . . . My assumption is that by giving it attention it will be nourished and will thus be seen to exist."

Eno's visual art since the 1980s has seemingly evolved at some distance from romantic conceptualism, and from the particular English version of it that I'm positing here. But that's not to conclude that we cannot trace a continuation of his version of landscape in his subsequent work—instead, perhaps, we should say it persists as a trace or memory. It is there, for example, in the TV-lit fields of *Pictures of Venice*, which are after all at some level heirs to a long history of displaced English artists taking it on themselves to represent the city, its reflections, and skyscapes. There are ghosts too, surely, of the map-like forms conjured on the ambient records in the abstract or near-abstract forms that have dominated much of Eno's work since then. And perhaps more ambitiously in terms of their involvement in the gallery environments where they have been shown, Eno's installations—and the *Quiet Clubs* that he began in the 1990s to propose around them—have the effect of immersing the viewer in fields of color, light, and imagery that approach the condition of the "imaginary landscapes" the music once posited. At the same time, the artist's interest in landscape has expanded to encompass, at its most elaborate, the planet itself and our investment in it. Eno's involvement with the Long Now Foundation and its ambition to foster extremely long-term thinking is of a piece with the sense that in his ambient music the landscapes conjured were both ancient and futuristic: that the slow changes wrought in the static view were occurring over immeasurable spans of time. As with the view of the Manhattan skyline, the unfolding landscapes and cityscapes of light in the video work, and the invitation to imagine landscapes or vistas of time, so too with the traces of postwar Suffolk, which emerge among Eno's records, videos, and installations as austerely remembered clues to his artistic genesis.

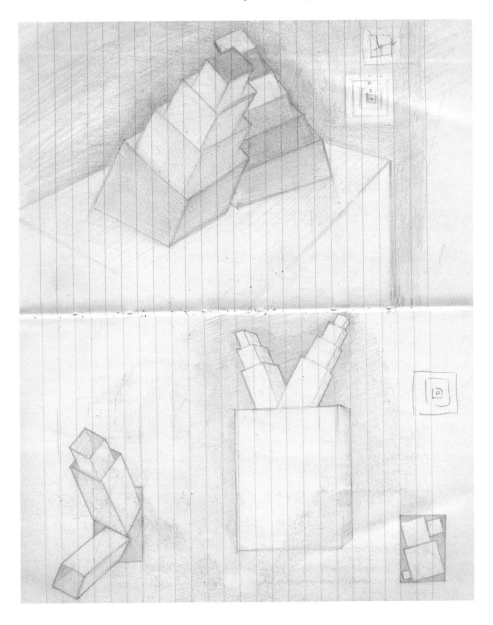

Crystals, 1984 (notebook drawings)

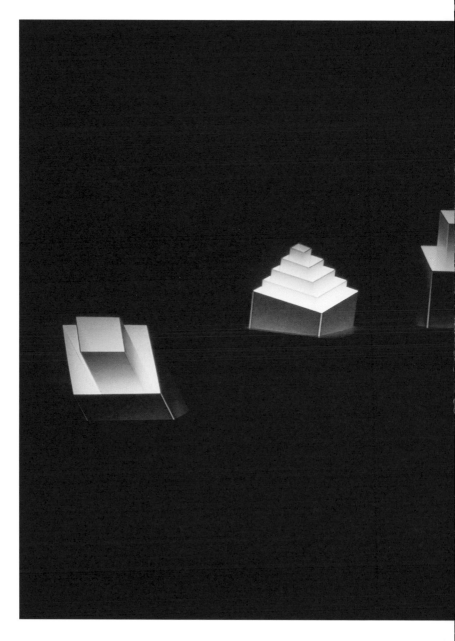

Crystals, Cologne, West Germany, 1985

Pictures of Venice, 1983–85 (notebook drawings)

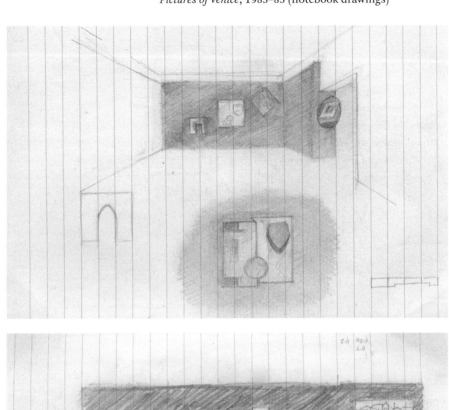

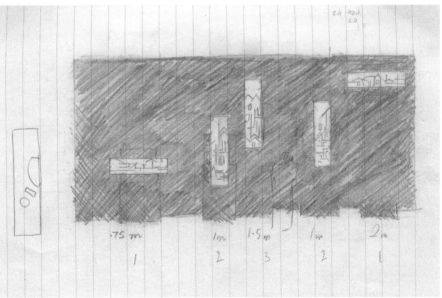

TOP: Eno building a light box, 1988.
BOTTOM: *Pictures of Venice*, Venice, Italy, 1985.

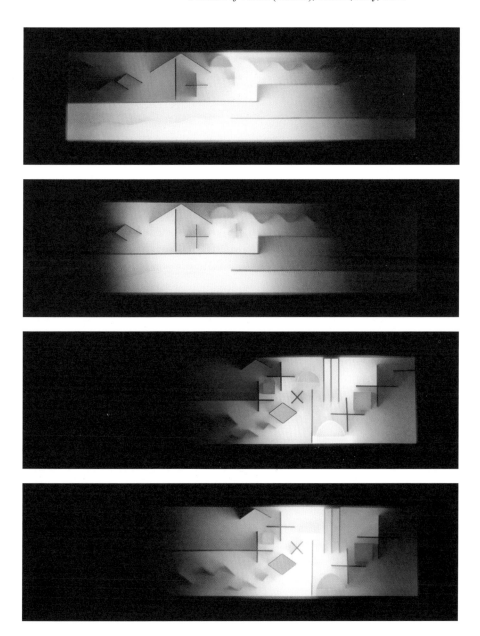

Pictures of Venice, Venice, Italy, 1985

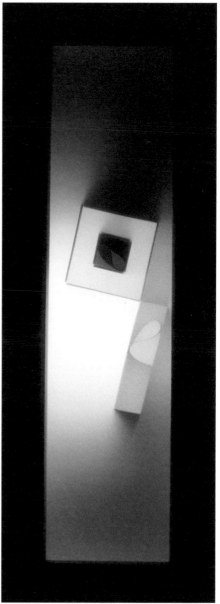

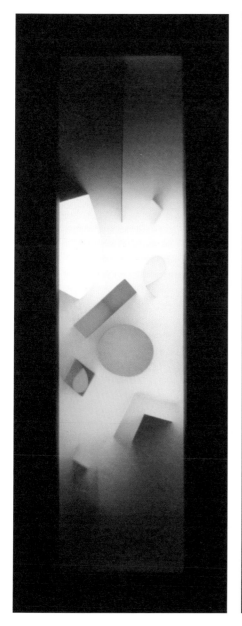
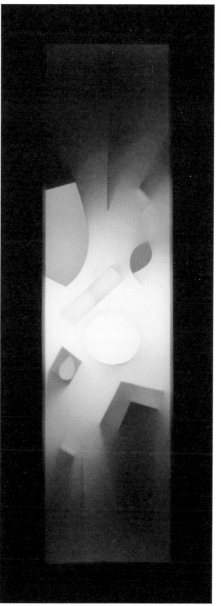

Natural Selections (Eclipses, Mutations, and Living Data), Milan, Italy, 1990

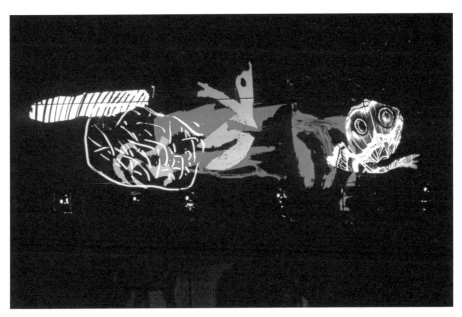

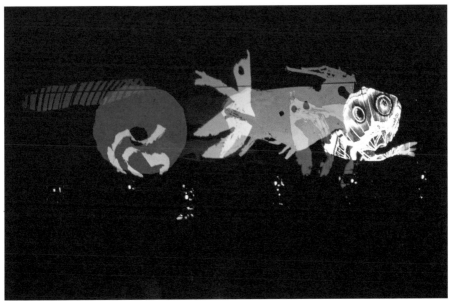

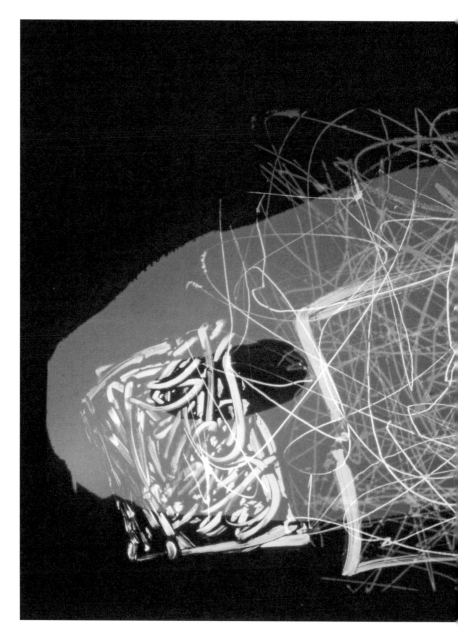

Natural Selections (Eclipses, Mutations, and Living Data), Tokyo, Japan, 1990

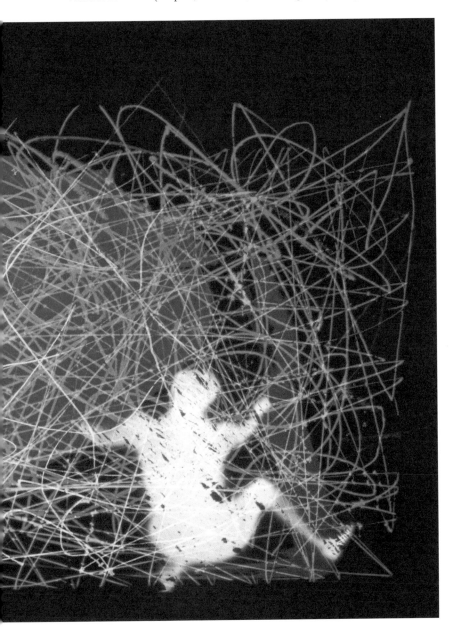

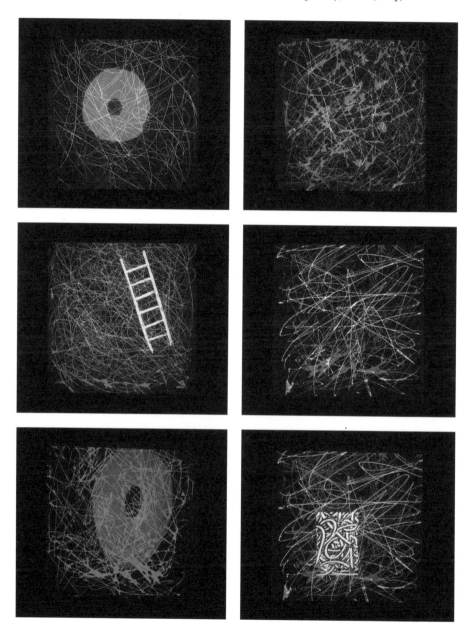

3 # PERFUME, DEFENSE, AND DAVID BOWIE'S WEDDING

PERFUME

Thank you very much for coming, I hope you didn't get too wet out there.

I started thinking about smell in 1965. I had made a collection of fifty little bottles and in each I had an aroma that particularly excited me, reminded me of something perhaps. My little collection of perfumes in their fifty bottles: wax, naphtha, black currant leaves, juniper wood, gasoline, motorcycle dope, sat on my shelves for several years, thirteen years in fact. I would occasionally take them out as one might take out a diary and read entries that one had forgotten and be reminded of times and places. In about 1978, in a very unlikely and neglected part of London, I found an old pharmacy. It had about two hundred to three hundred different essential oils and absolutes in it. I was more interested in the names than anything else: heliotrope, frangipani, styrax, labdanum, things that I had never really heard of before. And over the next few months I bought about one hundred bottles of these. Well, when you have one hundred bottles of oils fairly soon you start mixing them together. In doing this I found something very interesting, something that I subsequently discovered is at the root of perfumery, which is that it's possible to mix two recognizable smells into one smell that is no longer recognizable. And perfumery really is to do with courting the edges of unrecognizability with creating things that are evocative and nameless at the same time, that call up strong sensations, but which are never specific. This fascinated me, this sense of being able to make something new, something very unfamiliar from things that might be quite familiar, initially. And I continued experimenting and became a little bit more sophisticated in my experiments. I bought some glassware so that I could accurately measure quantities so that I could repeat certain combinations. I started to notice, too, that some materials were in themselves ambivalent; they didn't have just one nature, they were complex and confused in their nature. For instance, a synthetic called methyl octane carbonate smells simultaneously of violets and motorcycles. It's used in Dior's Fahrenheit.

Orris butter, which is a complex fat derived from the roots of irises, is faintly floral in small quantities, but obscenely fleshy in large quantities, like the smell between buttocks. Civet, which is a derivative from the anal gland of the civet cat, is very sexy until you can recognize it—and then it's repulsive.

What became apparent after a little bit of experimentation was that there were no reliable maps for perfumes. It's quite different from color, for example. Color had several different ways of being described: hue, saturation, brightness. And with color it was possible to, for instance, visualize a particular milky green and to say it might be jade, or pale turquoise, *eau de nil*, it was possible to locate it in a color space that probably most other people would be able to understand. It's almost impossible to do that with smells; they are not described by any system of that kind. And the landscape of smells is really only describable by comparison. So for instance the chemical calomel smells like flint, if you strike flint, or like an electric fire when you first switch it on. Vetiver smells like roots or earth. But there is no structure within which you can say, that you can describe the relationship of, for instance, calomel to vetiver. They exist separately and the sensation of them cannot be conveyed to anybody else, except by them smelling it. My first theory about my big contribution to perfumery, the contribution I never made and will never make, was to invent a mapping system for smells—I was very surprised that nobody else had done it. I bought the few available books on the subject and they varied from mysticism to science, and at both ends of that spectrum the descriptions told you nothing about smell. I decided that I would try to make a map out of the world of smell. And the way I would do this was by trying to create a picture of families of smell. I had noticed, for example, that strawberries and egg yolks smelled similar, that certain kinds of horsehair mattresses and a brewery is a similar smell. I started trying to make a map of these families of smells to see whether I could relate them together. I gave up. I gave up very quickly, in fact, because I realized that the complexity of the map

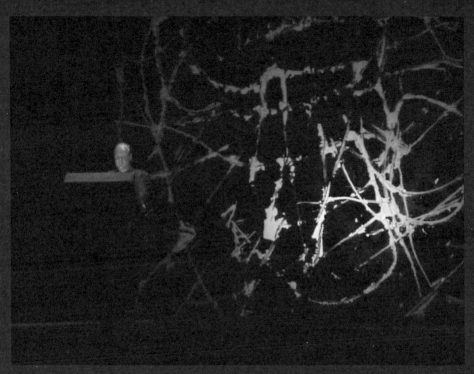

was such as to make it incomprehensible anyway and it was not a map that could be described in a simple number of dimensions; it was a multi-dimensional map, it was unvisualizable. I wasn't particularly concerned because what I really liked doing was playing with smells, and that's what I went back to doing: mixing things up and then dabbing them on anyone who would lend me a patch of skin. In the meantime, of course, I was working with music.

Music, on the surface, is a quite different medium. It has a complete language; it's called notation, musical notation. That language is entirely useless to me and almost useless to most of the musicians I work with. It's a language that is very good at describing all the things we are not interested in. It describes, for instance, pitch—in discreet and finite steps. It describes rhythm in

what seems to my benighted vision a rather simple way. And it describes timbre, in an extremely simple way. It describes timbre in terms of clarinet, violin, cello, and a few other distinct islands of sound. I entered music via electronics and electronic music doesn't have islands of sound, it has a continuum of sounds. The term electric guitar as a notation on a score is meaningless because an electric guitar is a different sound according to whoever is playing it. The term synthesizer is even more meaningless. Most of the playing on synthesizers is even more meaningless, but here was a field of human activity that a lot of people were actively involved in, and for which there was no language. If you walked into a recording studio—and still if you walk into a recording studio—what you see people doing is working with sound. Not working with the traditional elements of music so

much, but working with sound, that's why we have those huge consoles with all of those controls on them—all of those controls are to do with modifying sound, sculpting and painting with sound. This is really something new, it's not a possibility that anybody had before the advent of electronics. Unfortunately, musicologists looking at what we're doing say "well, everything they're doing has been done by 1830," and perhaps in terms of melody, harmony, structure, it is an old-fashioned pursuit, but my feeling is that if you don't see innovation where you are looking then perhaps you are looking in the wrong place. The musicologists have no language for the thing that we are doing and consequently don't notice it. I started thinking that actually music was in a very similar condition to perfume; it had this language, this archaic language, which describes another kind of music, another way of working with music.

But the current condition of music is very similar to the current condition of perfumery. It's all to do with guesswork, hunches, and empirical response. You can put things together and see how they work, you can try out combinations, evoke new sensations, but you can't really describe what you've done. The only adequate description is the experience of the sound itself. So, now I was dealing with two areas of my life that were unmappable, uncertain, confused, unstable, and empirical. All of the elements of those areas, although they might have names, were shifting, were evolving. For instance, in perfumery the name coriander meant one thing in the coriander I bought in Paris, but quite a different thing on the one I bought in London. So I came to think that coriander describes a fuzzy space in my smell experience, an approximate area rather than a specific thing—just as synthesizer describes a fuzzy space in my sound experience.

In January, I was invited to Brussels to talk to some businessmen and politicians from the EEC about the future of culture. I had thirty minutes to do it in. I couldn't assume that we necessarily shared the same assumptions about what future or culture might mean, so I thought it was important to begin my talk by looking at those questions.

I said, "Culture is everything we don't have to do. We have to wear clothes in this climate, but we don't have to evolve Levis and Yves Saint Laurent. We have to eat, but we don't have to evolve nouvelle cuisine, Szechuan cooking. We have to, perhaps, get our hair cut, to keep it out of our eyes (it's not a problem in my case), but we don't have to have hairstyles." A great deal of the things that humans do are stylistic, are quite beyond the needs of survival. What's interesting is that we don't know of a human group that is able to master the most basic aspect of survival that doesn't engage in stylistic behavior. As soon as people can feed themselves, it seems, they start making choices about how they decorate themselves, how they prepare things, how they present themselves to each other. It seems to be something that we're very involved in; it's not just an add-on, it seems to be biological. I asked the question of the politicians: "Why do you think we do this? What's the value of it?" Of course I answered the question as well. I said, let's look at something a little less complex perhaps than a Picasso or a Rembrandt, let's look at a haircut. Why do we have one kind of haircut rather than another? What happens to you when you choose to get your hair cut in a particular way? What you're really doing is saying to yourself I want to be the kind of person who has this kind of haircut. It's rather a complicated and interesting construction. For instance, I want to try being the kind of person who has long, shaggy hair that flies in the wind. I'd love to try it, actually. Or on the other hand I want to try being a feminine man, or I want to try being a woman with a very masculine haircut. When you do something like that you don't do something that only sits on the top of your head, you make choices about the kind of person you would like to be and the kind of behavior you would like to aspire to. Let's look at another cultural item, say a *Rambo* film. I choose *Rambo* because I assume we have all seen all of his movies, even though none of us would admit to it. When you go to a *Rambo* film you look at a world, it's quite a simple world, it's a world where there is a very easy distinction between right and wrong and it's very clear who is on which side. It's a world

where certain types of response to situations are promoted, explored, and offered as adequate or inadequate. If you go and watch that film, if you accept the assumptions of it, which you may not, but if you do what you do for a while is engage in that world, you imagine yourself in that world and you check your sense of the hero's action to the situation. You discover whether you find that appropriate, whether it makes a message for you, whether this is your picture of the world, whether this is the way you would deal with the world. In that sense a cultural artifact is a kind of simulator: it's a way of engaging in a situation without having any of the risks of real engagement. This is very important, because engagement without risks allows us to engage fully. Of course we are going to have risky engagements in our lives, we are not short of them, but in an insulated cultural space we're capable of making rather wild choices and seeing what happens to us. If it was wrong, it will grow back. In the meantime, we discover what it is like being the kind of person who would have that kind of haircut. So I said to the businessmen that I saw culture as a space for experimenting with other behavioral possibilities.

Then the other question was the future of culture. Well, what's the past of culture first? A classical view was very hierarchical. There were many cultural objects, but they were very clearly organized. Dante, Shakespeare, and Goethe would be at the top, Beethoven, people like that. Pygmy singers, walking stick carvers, Balinese gamelan players, Prince. (Actually, another Pygmy singer. Sorry.) They would be considered marginal, of marginal cultural value. In the hierarchy of cultural objects that the classical art historian would look at there would be very little doubt in his or her mind about which ones were at the center of the story and which ones were at the edges. The job of an art historian was to connect these together, to tell that story—the history of art—*the* history, as if there were only one. The art historian lined up these cultural objects and told a story of progress of some kind or another. The picture of this power line, this cultural power line, was that proximity to it carried with it connotations of

longevity and value, ultimate value. The valuable objects were the ones closest to that line, the less valuable objects were the ones further from it. So, as in this diagram, though there would be a field of events only some of them were important and there was a good consensus about which ones they would be and some wrangling about what the rankings might be within those. So the history of the history of art is really the history of people defending one or another line that they drew through what they saw as the center of culture. Central to this idea is that behind it all there is an intrinsic value and that this value shades away as it goes to the edges. As it goes to the edges we are faced with things that are more casual, more ephemeral, less well evolved, less finished, generally to be taken much less seriously. At the center of the line we have the thing called "Art" with a capital A, which is the position of greatest power and greatest energy. Art (capital A) was seen as a quality that certain things had. The question "Is it art?" of course, is still occasionally asked. The question "Is it art?" assumes that things are, or are not, art. It assumes that art is a quality that resides in some things and not in others. What I said to the people in Brussels was that this view, more than anything else, is what has changed in this century. Ever since Marcel Duchamp put a urinal in an exhibition the message has been that an artist is somebody who creates the occasion for an art experience. This is rather different from the classical message. The classical message is the artist is someone who puts art into something. He takes this object, this lump of stone, and he hacks it about until what is left is art. This "stuff," whatever this "stuff" is, flows through him and into it. This is still the picture I think that most people hold in some way or another. Duchamp made a very deliberate, and deliberately arbitrary choice of the urinal. He chose something that was commonplace, deliberately irreverent, stylistically uninteresting, and most importantly quite arbitrary, and he put it in an art gallery and he dared people to have an art experience with it. I had an art experience with it, actually, myself—but that's another

story. Actually, this is all another story, really. The change that happened when Duchamp did this is that some people started to think, yes, art is not a quality that resides in things, but is the name of a transaction that I as an observer can have with something. If you accept this idea, and you accept the idea that the job of the artist is to provide an occasion for this to happen, however he does it, you've really opened up the notion of what an artwork is. First of all there is no absolute condition, this microphone could be the occasion for an art experience for me for the next couple of minutes—let's hope it isn't, but it could well be—it need not be for you, and it need not ever be again for me, but it could have been for that time. A Mondrian painting could be the occasion of an art experience for a very large number of people for a very long time. If we accept this idea

of a transaction, art being the name of an experience, what happens is that the cultural pyramid that we saw in the classical view collapses completely. All that we can say is that some people like some things for longer than they like other things, and there are quite arbitrary reasons why that might be the case, cultural momentum for instance; if things get put in museums people see them, it's quite simple. There need not be some sense of greater intrinsic value that creates that momentum.

After my talk in Brussels, somebody said, "So do you take everything equally seriously? Is it all art to you?" And I said, "No, not at all. I make choices and I have preferences." But what is the case is that I cannot sustain a good argument for my preferences over anyone else's. I cannot justify one particular line drawn through the cultural

space, and I can't question any line that anybody else might draw. What I see instead of there being one line, many, many, many lines, lots of ways of looking at this field of objects that we call culture. Lines that we might individually choose to change every day; I might choose that line one day and another line another one. [Indicating the lines in the projection over his shoulder.] The objects in my lines, the concepts, the carved walking sticks, the Prince records, might change their value depending upon which story they become a part of. If I'm looking, say at the breakdown of focus in painting, the Prince record doesn't have much of a contribution to make there. If I am looking at the advent of sensuality in music it makes a big appearance. All of the items of culture in this new view of culture have negotiable value. They don't have one value any longer, they don't describe one point in the cultural space, they await changes. This connection making is really a form of storytelling. One line through our culture is a story about it; one set of choices you choose to make is a story about you. You choose these records, these cookery books, this kind of color paint, this kind of furniture; all of these are some kind of cultural experiment that you are making. They are experiments that you can change your mind about, they're flexible, you don't have to commit yourself to them in any permanent way, you can shuffle them—we all do a lot of shuffling. We're confronted with so many cultures, and so much of the past of our own culture, that it's impossible to any longer be doctrinaire in choices in them. We cannot any longer sustain this pyramid picture of culture. This has really given rise to a new personality. I call him the curator, but actually perhaps that's the wrong word—the storyteller might be better—and the storyteller is a much older word. A storyteller is someone who weaves together a perspective. I don't know if you've noticed in going to exhibitions in the last few years that the curator's name gets a bigger and bigger typeface.

I went to an exhibition in Berlin a few years ago, which said something in German, curated by a name that large [indicating the size of the text with his hands], with works by people that large [indicating with his hands the much smaller text of the artists]. And I thought that this was a very, very interesting idea that the person who made the choices should be credited as the person who created the work, the work being the whole of the exhibition. The whole of that exhibition was a cultural picture of some kind. I wondered who the other curators in our culture were. Well DJs, of course, and other spin doctors, editors, cameramen, journalists, models, futurologists, stylists. These are jobs that have in the past been seen as rather on the edge of creative culture, I would say, so the really creative people sat in the middle and these people on the edge tinkered with what they did and somehow presented it to the public. But I think that picture is changing now, I think those people who were considered marginal suddenly start to have a big role because the role of digesting, of creating possible packages from the huge plethora of stuff that is around, becomes a very, very important job. It becomes a job actually that we start to pay very well for as well. The storytellers really are saying here's a line that you could follow through our culture. Here's a possibility, here's a style you could adopt—and styles are terribly complicated now, they're not just haircuts, they involve all sorts of choices, and each of those choices has resonances. It's not in an aesthetic vacuum, it's not just something you do because you like it. "Because you like it" is a very complicated phrase; you like something for all sorts of reasons, and the task of putting together a, what was in the '80s called a "lifestyle," preoccupies us. The picture of this culture, then, is actually a lot like the picture of perfume and the picture of music. Instead of seeing a culture that is nicely organized and stable, where elements have their value and rarely change their value, we see a culture that is filled with objects that keep changing place and keep changing status, that interpenetrate, that take on different values depending on who's telling the story. We see a culture that offers as its primary material confusion and uncertainty, not stability and security, a culture where every space is fuzzy, where there are

no hard distinctions. That doesn't mean that we have to turn into new age hippies, it means that we make distinctions but we make them with a certain kind of irony. We make them knowing that they are not ultimately defensible, they don't translate into some kind of absolute language that everybody would in the end agree with if they had enough time to see our point of view.

This, funnily enough, was the classical view, the classical view was that in the end any reasonable person would like Bach. There were tragic stories of missionaries appearing in Africa with gramophones and trying this experiment. And the Pygmies made flowerpots from them and things like that, as any reasonable person would. But the assumption was that any reasonable person would finally agree on one way of describing the reality of culture—*the* reality of culture. This picture has really changed now, I think. We really don't expect to see books now that are called *The Art of the Novel*, *The History of Painting*. There isn't one of any of those things. There's *a* history of painting, and *another* history of painting, and yet *another* one, so it seems that what I discovered in perfume, and subsequently in music, I now come to believe is true of the whole of culture. The space is fluid. This has an effect on the way we think about the world. It predisposes us, I think, to not think in terms of *capital letter words*: Freedom, Justice, and things like that, as if they were identifiable and locatable items in the way that I described art earlier on. Instead of that we start to think, I believe, in terms of networks of confidence.

Think of something like the GATT talks, General Agreement on Trades and Tariffs; this is probably one of the most important discussions going on in the world today. It's the set of discussions that will determine how well trade interpenetrates, how we import and export, how we don't destroy each other's markets; it's a huge and very, very complex set of agreements. These agreements have no absolute basis, they're not reducible to any set of laws, or rules, or mathematics. They eventually are just agreements, they're statements of confidence of some kind

or another. A lot of the things that we do now are statements of confidence, all of our currencies are statements of confidence; they're not backed by anything. If you go to a bank with a twenty-pound note and say "I want to redeem this," you'll get four, five-pound notes. You won't get a bar of gold or something tangible. All of our currencies are backed by trust. This is a very interesting idea, I think, because it leads me to believe that the most important evolution that humans have been undergoing for the past two thousand years at least, is the gradual evolution away from absolutes and principles towards ephemeral confidences, networks of belief, understanding, and empathy. Empathy is the thing that we do really well. And empathy is, funnily enough, what underlines the GATT talks. Trust and confidence, strangely enough, underlines the stock market—and the art market. Those are markets of confidence, they're markets of structures of belief in the value of something. Value, of course, is negotiable and everybody knows that, that's why those markets fluctuate. It's confusing, perhaps, to live in a world that doesn't have any final rules, that doesn't hold out the hope that eventually reasonableness will persuade us all to one course of action. It's confusing to be faced with a situation where perhaps there isn't one final, philosophical language that we will all speak in the end, but quite the opposite: there's an increasing proliferation of languages, which interpenetrate, which cross over one another, which interfere with one another. It's confusing because we never know whether we are right, all we can do is make experiments, make guesses, see how they work out, try to describe this space we have created to somebody else, try to inhabit it, see if it works, change bits of it.

Of course there are lots of ways of retreating from that: nostalgia, mysticism, paranoia, survivalism, those are all ways of shutting out the problem of dealing with uncertainty, of dealing with confusion. The way of dealing with it, I suppose, is to learn to improvise, to be alert, to watch for these changes that are always happening in the flux that we call culture—modern culture—to

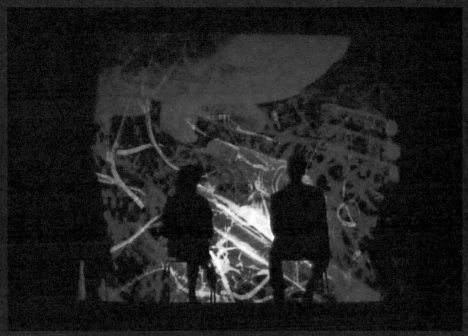

act on hunches rather than on principle. It's a different kind of future, it's very chance-y, it's very exciting, and in that future is the biggest struggle that we've seen for a long time, the struggle between fundamentalists, people who don't want that future, and who don't believe in it, and who desperately want to prevent it from happening, and people who we might call pragmatists—I don't know of a better word. The fundamentalists I call "rootists." Rootists are people who think that they'll find the roots in the end. I am a nonrootist in that I don't think that I will. Well, the end of this part of the talk is that I've stopped expecting a future where perfume will find its place in a neat system of classification. Instead, I'm waiting for everything else to become like perfume. Thanks. [End of part I]

DEFENSE

[Addressing the individuals seated on stage.] Thank you. Thank you for coming. Thanks.

This section of the talk is about defense. Defense is nothing like perfume. Whatever the world that I tried to describe just now, the world of flux and change, of things in motion, instability, uncertainty, defense wants the opposite world. Defense is the way that we try to stabilize the world, we try to prevent the perfume world from happening. I want to ask the question: "What is defense defending us against? Why do we spend so much money on it?" I read the other day that the annual budget of the World Health Organization is equivalent to two and a half hours of defense spending. Fifty-five percent of Britain's research and development money goes to defense. We obviously take this very seriously—even more seriously than the Royal Opera House, actually, which only gets 50 percent of our

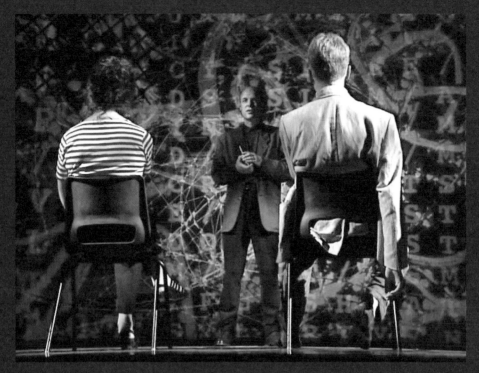

Arts Council money, I think. Well, there are simple answers to why we spend so much money on defense. The simple answer is because there are a lot of greedy defense contractors and a lot of paranoid politicians, and they make a powerful combination. I think there's another story behind this, though. It's a story that interests me because it doesn't assume malice, or greed, or paranoia. Those explanations are fine and obvious and probably not wrong because of that, but we've heard them before.

I want to imagine a president who's really a nice chap, somehow or another this guy got elected. He's clever, alert, forward-looking, actually a pacifist—his name is Dickie Dove, actually—and suddenly he is in the White House. Of course he has a vision of the future, and of course part of that vision is technological. He wants to see the

country as a great power in the future; he doesn't want it to slip behind. He wants it to be at the forefront, at the cutting edge; he wants it to be a great country to live in. That's reasonable enough. He has the best advisors in the country, he has several think tanks working for him, he has information that none of us have access to about the future, he knows a lot. He is in a position, he believes, to make good judgments about what's going to happen. A lot of his judgments will be technological. His advisors tell him: "Dickie, the important things for the future we understand from these guys at Stanford are: parallel processing computers, advanced laser technologies, noble metals research, but they're not going to show results for fifteen years or so." So what does the president do? Does he come out to the country and say "We've got this great idea for parallel processing

computers, I know you need a hospital, old people's homes, new schools, better roads, but parallel processing computers are where it's really at. I mean, we're not really sure but we think in fifteen years' time, that's where it's going to be at—well, maybe not fifteen, could be twenty-five. We're not quite sure." What chance would Dickie's program have of being carried through? These people here are all citizens, Democrats, say I think we should be looking after crime. We want more policemen. No, I want a hospital, old people's homes, education, and so on down the line. So Dickie's big budget for parallel processing computers gets cut into lots of little pieces, which go into projects that don't benefit Dickie's technological dream. This is called democracy, you see. But now another scenario: Dickie has a defense program. A defense program is very valuable for him because it's secret. For one thing, he doesn't have to tell on which basis he's made those decisions. He says to these people: "We're in a bad situation. There are threats all around us. Paraguay might invade any moment. There are all kinds of rumbling in Fiji—you never know. We need those four Trident submarines, and they're only 27 billion dollars each, at the moment." Dickie knows he doesn't need four Trident submarines, especially to ward off Fiji; we could probably do that here on this stage. And there are no longer any credible enemies. But what Dickie does need is a way of supporting all of his technological programs. Of course he gets every encouragement, the defense contractors are very pleased, the economists are very happy because the economy is kept turning, lots of people are kept in work. There's every conceivable encouragement for him to take this course of action.

Now, to give you two examples of programs like this, star wars. Star wars within a few months was dismissed by the Pentagon itself as militarily useless. There was considered to be very little chance of a useful result from it. Of course, they were taking the narrow view. There was a very useful result as far as Dickie Dove or, in fact, Harry Hawk as it was in that occasion saw it. The very useful result was that most of the population of

California was kept at work on defense contracts, and a lot of very advanced research into extremely sophisticated computer applications was allowed to take place under the aegis of this.

So what is defense, actually, defending us against? The first theory, then, is that defense is defending us against democracy. We always used to think it was defending democracy. It isn't. It's actually defending us against it. It's defending us against your shortsightedness. You can't understand where parallel processing computers are more important than old peoples' homes. Defense defends a government against its peoples' empathies, not their enemies. But that isn't really what's happening. Defense isn't defending us against democracy, actually. It's defending us against the consequences of an inappropriate language. All governments frame their claims in an old language. That language is the language of capital letters. I've mentioned them before: Freedom, Justice, Democracy, Truth, Liberty, and the enemies are Communism, Totalitarianism, and so on down the line. Unfortunately, this absolutist language, this language of certainty, affixed divisions, doesn't map well onto the world. The world isn't like that. The world is in motion, in flux, and this grid doesn't describe anything any longer. There's a gulf; in fact that's the real Gulf Crisis: the difference between the language of politics—the necessary language of politics, actually—and what happens. People expect those words, they like those words, they are inspired by those words. Politicians are too timid not to use them. They want to get elected. No politician is going to stand up and say, "Well, you know, I'm sort of a Democrat but occasionally I'm actually gonna have a bit of a command economy here." Defense is a command economy. One way of looking at defense is to say it's a form of Socialism that is concealed at the heart of Capitalism. I've got nothing against Socialism—the problem is concealing it. It's concealed, it warps a process because the only way of doing that, of making that work, is by somehow circumventing, circumnavigating your own claims. Defense is really a language for negotiating the

shortcomings of our absolutist concepts, of our old pictures of the world. Its problem is that it's dangerous, you may have noticed. All those things really shoot. Can we visualize any kind of future? I ask this as a rhetorical question—I don't know the answer. Can we visualize a future where citizens can be inspired by vague ideas? Where they can be inspired by politicians who dare to say, "I'm not certain. I don't know what sort of future we're going to have." Sometimes I might have to be a socialist. Sometimes I might have to be a capitalist. Sometimes I might have to believe in the market. Sometimes I might not have to. Is this conceivable? Can we live with the uncertainty of that? This talk and the one before are both about living with uncertainty, developing languages for uncertainty. The next section will be about an uncertain situation. Thanks. Thank you. [End of part II]

DAVID BOWIE'S WEDDING

Are we troubled by our inability to locate this event comfortably either in the category *real life* or in the category *theatre*? Similarly, are we troubled by our inability to locate it in the category *private* or *public*? Or *sincere, ironic*? Does this lead us to look again at those distinctions and to ask whether instead there is a continuum between them, upon which all the things that humans do in the sight of other humans are somewhere located. If we accept that, could we move on to the idea that it is possible to occupy several positions on this continuum at the same time? Can we believe that it is possible to be involved and yet to make stylistic observations about one's involvement? To manipulate a situation at the same time as being moved by it? Even though we might accept that it is, we're still left worried by the cameras.

Cameras are much more of a problem for cultivated, literate people than for anyone else because they keep raising this question: if I do something specially for the camera haven't I told some kind of a lie? Faked the past? We sense that the time machine of photography can plant into the past things that didn't quite happen, somehow eroding our sense of reality. Cameras turn us, reluctantly, into ironists—people who stand outside their own behavior, people who watch themselves. But just as we are suspicious of ourselves in front of the camera, we're even more suspicious of the people behind them. It's understandable. These people are designing our past. They have become the curators of our memories. That's not the only thing that disturbs us. We are unsettled by people behind cameras because we know that they are dead, and there is something unsettling about having dead people around. They're dead in the sense that they don't occupy the same present as us. What they see through their viewfinders is not the world here and now, but a picture of the world as it will appear in the future. They are already looking back at us at the event in which we are so naively embroiled from a future time and another place. They are outside; as such they are the ultimate ironists. If you doubt this, consider the several times that cameramen have assiduously filmed their own murders. Remember the anti-Pinochet demonstration in Chile where through the camera we watched a soldier raise his gun and aim directly at us? The camera held steady as the trigger finger closed until it was suddenly thrown wildly into the air by the impact of the bullet hitting the cameraman's body. He, presumably, was not aware that he was there, that it was really happening. He was already watching the movie. We might call this kind of behavior courage, and perhaps one kind of courage is exactly that kind of loss of understanding: being dead to the present, being all-observer and no participant. Being disembodied. But perhaps another kind of courage is the converse of that: being simultaneously in several presents, plus a few pasts and futures as well, and yet not being either paralyzed or embarrassed by

the confusion. Having the nerve to play to the whole spectrum of possibilities, to mix and match from whatever is around from the most revered to the most profane.

I was moved by this wedding in ways that, still being rather pre-postmodern myself, I hadn't expected to be. It was a performance, a potpourri, but it was committed and bold and very touching because of that. In our heritage culture, where rising above your station is the high road to ridicule, that kind of experimentation is usually described as pretentious. I'm of course grateful that my own modest efforts in this direction have not passed totally unnoticed by the press. Actually, when I hear the word pretentious I reach for my notebook. It normally means I'm about to see something new, or at least get so annoyed that I locate a raw nerve that I might not have known about. It's an early warning system that you'd think ought to be profusely rewarded, but its usual return is the mild disdain of all those fighting the two-thousand-year war between real and synthetic, natural and artificial, artificial and fake, substance and appearance. That whole territory has turned into a tangle of muddy trenches, clamoring with antique, ideological artillery. From that vantage, those who refuse to take sides, or even to make the same distinctions, seem simply irresponsible. You can fight over it forever, but it doesn't seem to get you anywhere: you still don't know how to behave in front of a camera, how to inhabit four different cultures in a day, where to draw the limits of your empathy, and how to live and act and jump about all over time and still come up smiling.

Thank you very much. [End of part III]

Excerpted from the original lecture.

TOP DOWN
GENIUS
CAUSE & EFFECT
CREATION

CONTROL
FUNDAMENTALISM
'GOD'
FOUNDATI

AUTHENTICITY
PYRAMIDAL
HEIRARCHIES
ROOTISM
PLATONISM

STRONG
CENTRES
ARMY
CHURCH
ORCHESTRA
FIXED
'INTRINSIC'
VALUES
'ORIGINA

'TRUTH'
'PROOF'
GUARDIAN
MORALITY:
Defensive,
traditional, anti–trade
CULTURE AS
DOWNWARD
TRANSMISSION
CULTURE AS
TRANSMITTER

EITHER/OR:
POLARITY
THINKING
HISTORY AS
OBJECTIVE
SINGULAR
TRUTH
MESSAGE
CONTRIVE
RAREFACTI

'US AND THEM'
OBJECTIVE
OBSERVER
ARTIST AS
LONELY
INNOVATOR
'GOOD' = 'TRUE'

ZONE C
PRAGMA
DECEI

DIRECTIONALITY
ARTIST v
VIEWER
THE HISTORY
OF ART

REDUCTION
TO ESSENCE
NARRATIVE v
TIMBRE
TELEOLOGY

THE MACHINE
ARROW OF
PROGRESS
MISSING
CENTRE:
EDGE CULTUR

DUALISTIC
'SPIRITS'

PROLIFERATIN
WORLDS

EFFLORESCENCE
TO COMPLEXITY
THE HIVE

VECTORS OF
EXPERIENCE
NO GRAND PLAN
SIMULTANEOUS
WORLDS

HOLISTIC
NETWORKS

NO 'THEM'
EVOLUTION
CONTINGENCY
MESHES

ERNAL LAW

TIMBRE v
NARRATIVE

ERTAINTY

IMMERSION
Heavy metal,
Ambient

DEFENCE:
SIDESTEPPING
DEMOCRACY

SAMPLING
RESAMPLING
RERESAMPLING

FASHION,
REFASHION

UREAUCRACY
AS FILTER:
REEN CARD'

THE CURATOR
AS STORYTELLER

P.R.
SELF
RECREATION

THE HISTORY OF
THE HISTORY OF
ART

UNSYCHRONISED
OVERLAY: VARIETY
THROUGH
RECOMBINATION

PRETENDING

'ANYONE CAN
DO IT'
(BUT NOT REALLY)

DIFFUSION OF THE
AUTHOR

HAIRCUTS,
RAMBO

SRI
BHAGWAN
BEUYS

FAKES

COMMERCE
MORALITY:
translation, novelty,
negotiation

CULTURE THE
SIMULATOR

SELF–
RATING

ORACLES

'FAITH-HEALING'

DETACHMENT

CULTURE AS
TRANSMUTER

SHAMANISM

SINCERE
IRONY

CULTURE AS
TRIGGER

OOD' = 'USEFUL'

FLUID
LOCATION
OF VALUE

CONSENSUS
AND
CONFERRAL

DAVID'S
WEDDING

STRUCTURES
OF
CONFIDENCE

FLOATING
CURRENCIES

ATTENTION
CREATES
VALUE

CULTURE AS
SOCIAL
CONVERSATION

XIS THINKING
ntinua not poles

UNMAPPABILITY

SEX, DRUGS,
RELIGION,
ART

GOSSIP
SCANDAL
SOAPS

'HELLO'
MAGAZINE

ACCEPTING
UNCERTAINTY

PERFUME

CONTROL/
SURRENDER
AXIS

BOTTOM(S) UP

NTERACTIVE
GANISATIONAL
TRUCTURES/
COMPLEXITY

NON–LINEAR
CHOICE SPACES

INTERACTION
SURRENDER
PARTICIPATION

SCENIUS

Quiet Club [Quiet Room], Frankfurt, Germany, April 1989

Quiet Club [Quiet Room], ca. 1985–2005, location unknown

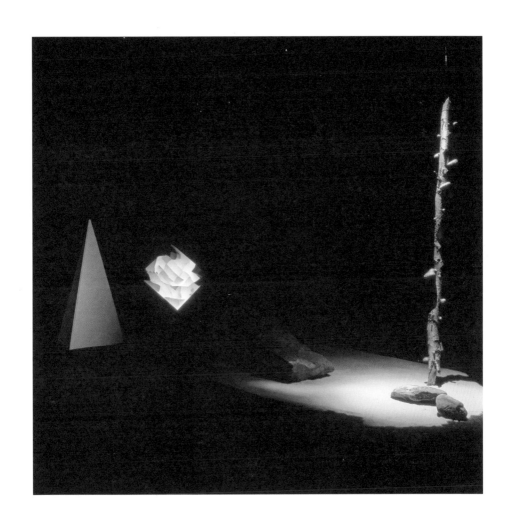

241

Quiet Club [Living Room], Cologne, Germany, 1989

Quiet Club [Generative Light Lounge #35], Amsterdam, the Netherlands, 1999

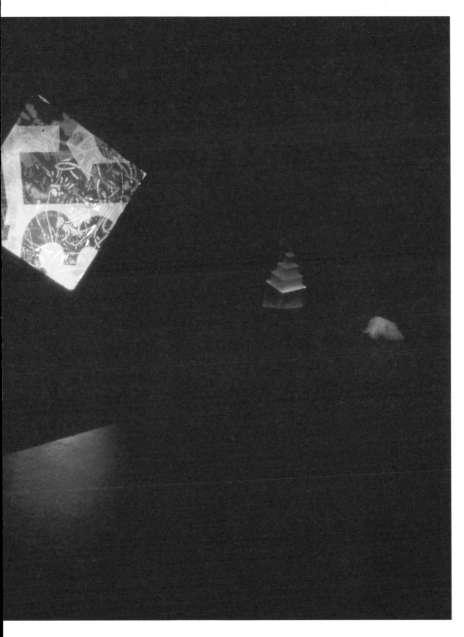

Quiet Club [Living Room], San Francisco, California, USA, 1988

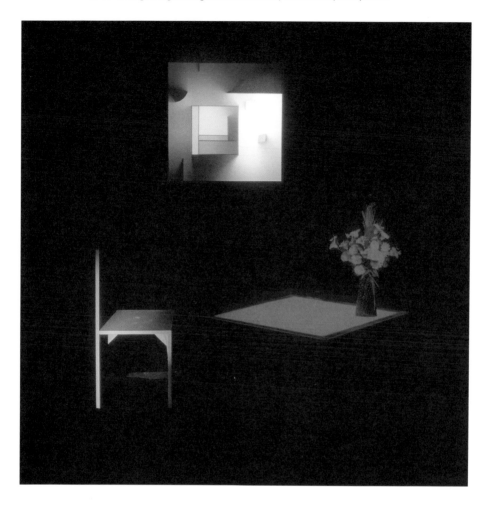

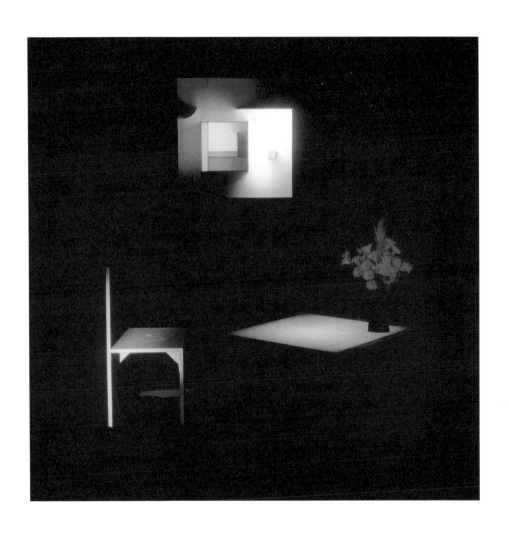

Quiet Club [Future Light Lounge Proposal], Bonn, Germany, 1998

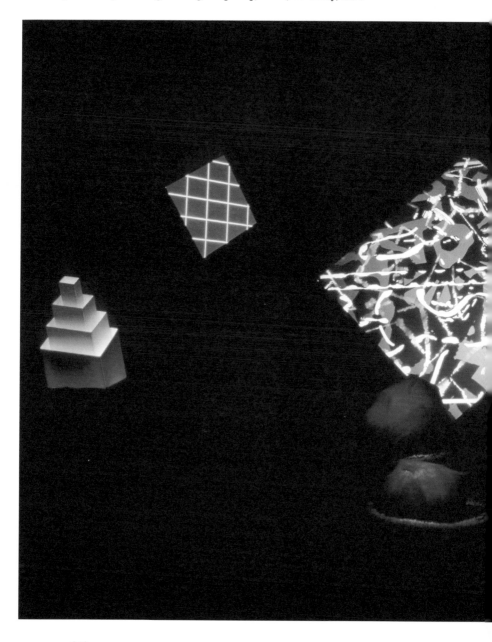

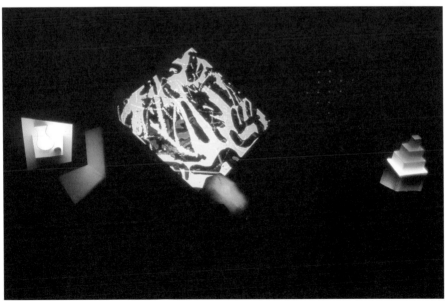

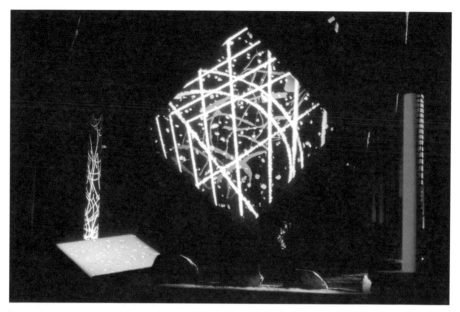

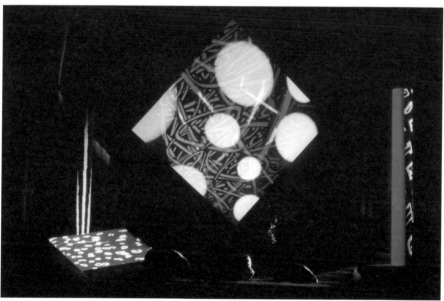

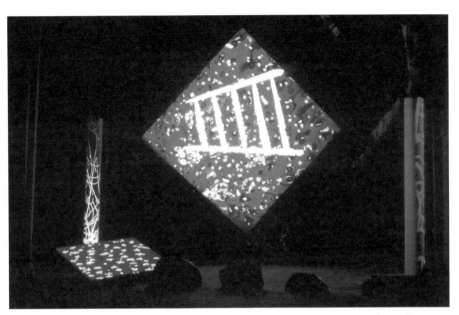

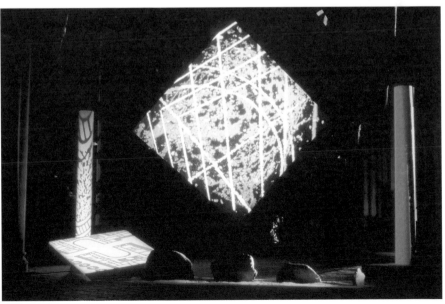

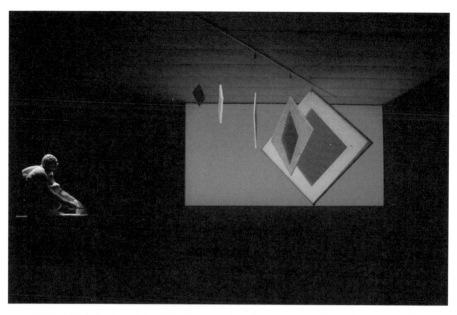

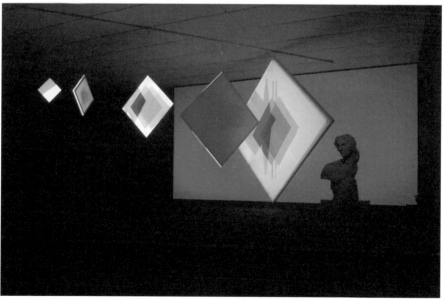

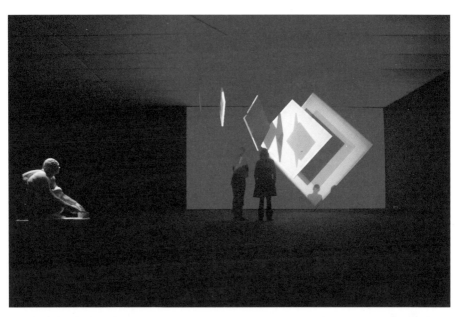

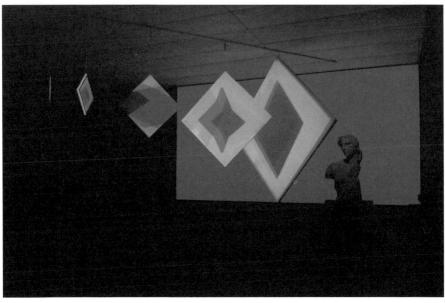

255

Quiet Club, Frankfurt, Germany, 2004

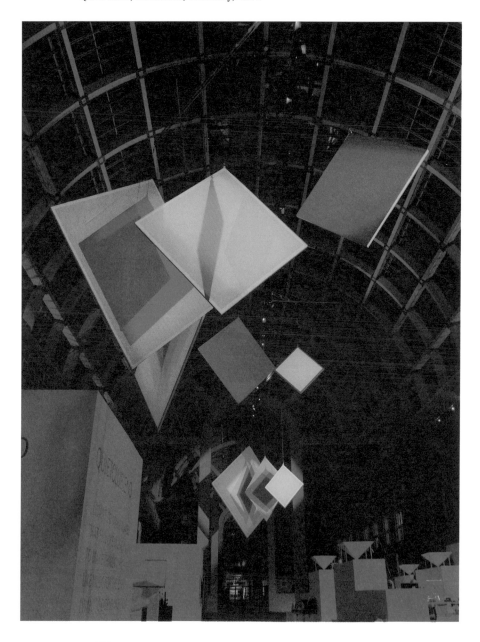

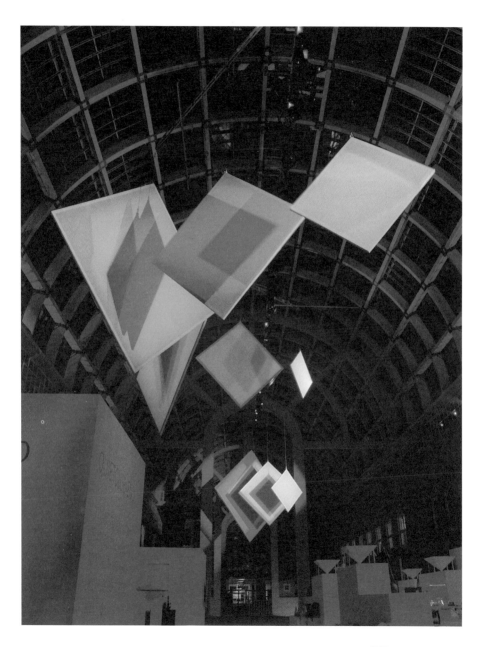

Quiet Club (details), Wattens, Austria, ca. 2000s

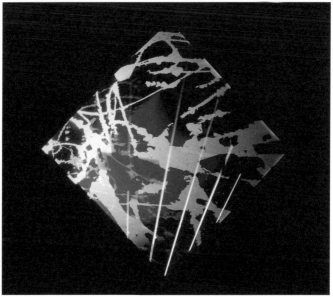

Quiet Club (Map I), (details), Berlin, West Germany, 1988

Quiet Club (Peacock), (details), Stockholm, Sweden, 1985

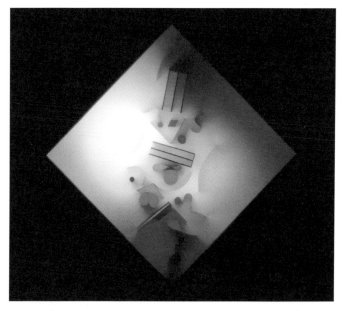

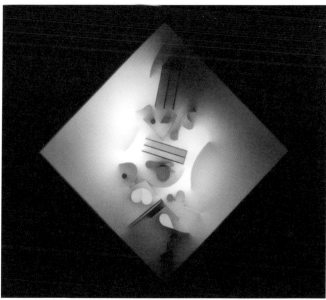

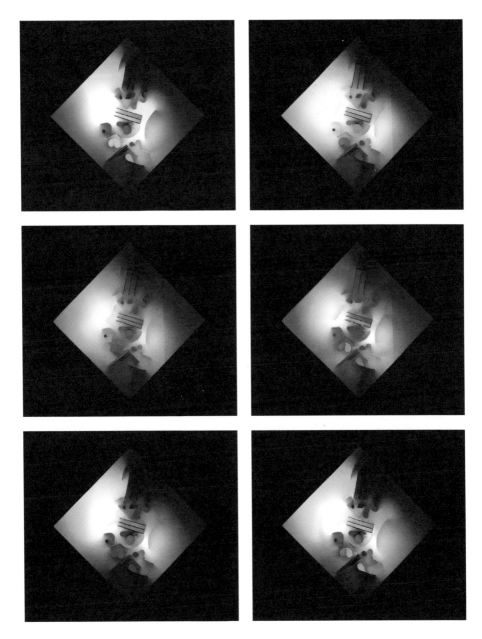

Quiet Club (Chevron), (detail), San Francisco, California, USA, 1988

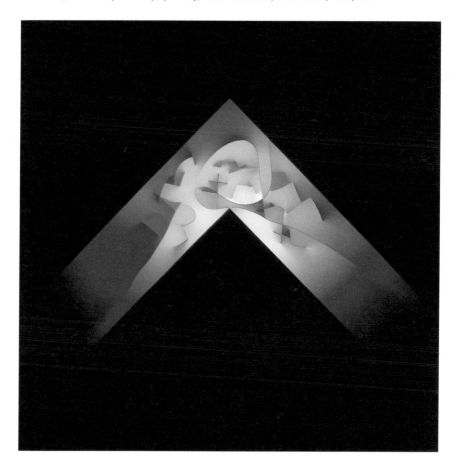

Quiet Club (Cross), (details), Stockholm, Sweden, 1985

Quiet Club (Cross I), (details), Cologne, West Germany, 1985

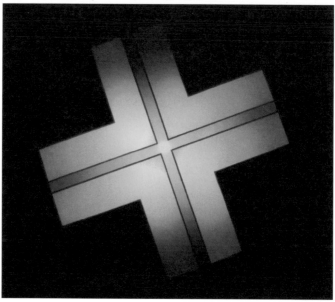

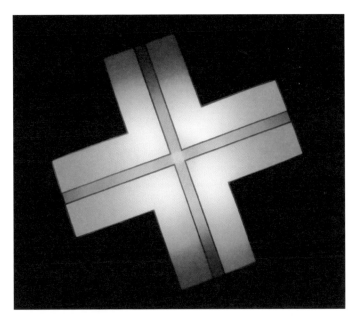

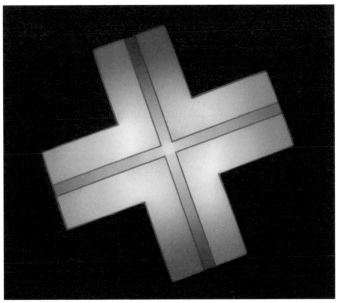

Quiet Club (Cross II), (details), Cologne, West Germany, 1985

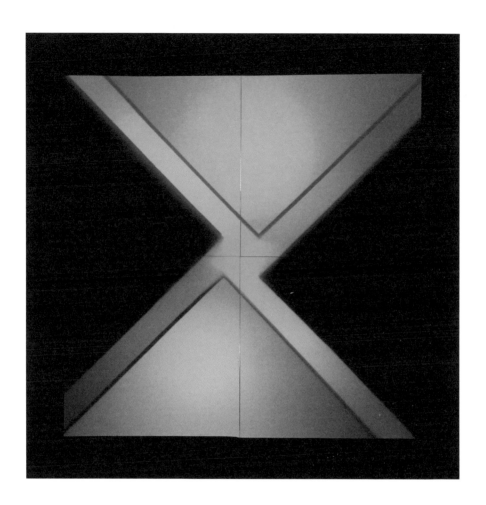

Quiet Club (Ikebana I), (details), Frankfurt, Germany, 1989

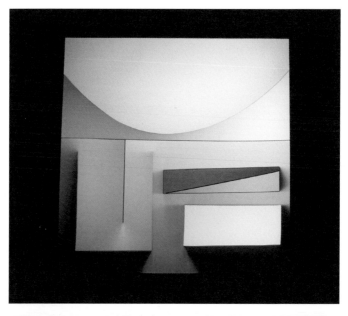

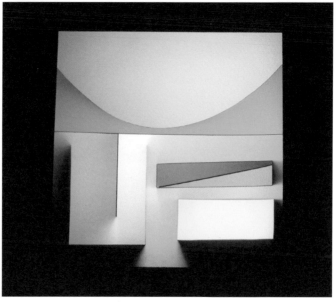

Quiet Club (Ikebana II), (details), Frankfurt, Germany, 1989

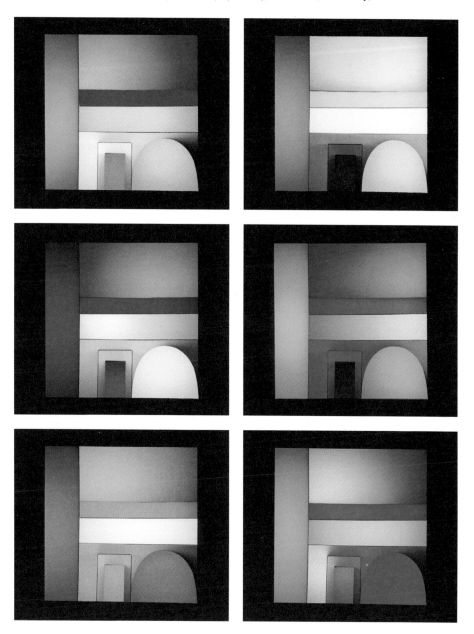

Quiet Club (Egyptian), (details), Berlin, West Germany, 1988

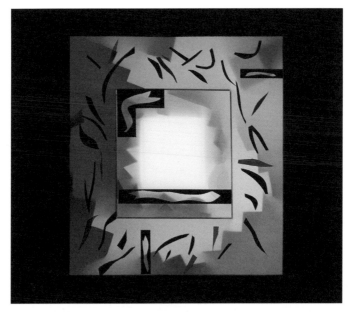

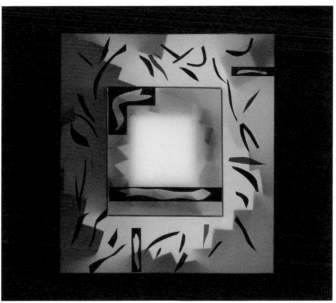

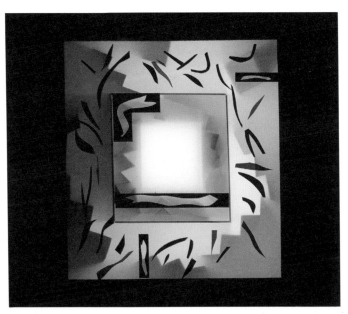

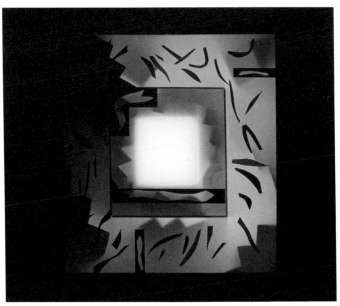

Neroli, Madrid, Spain, 1993

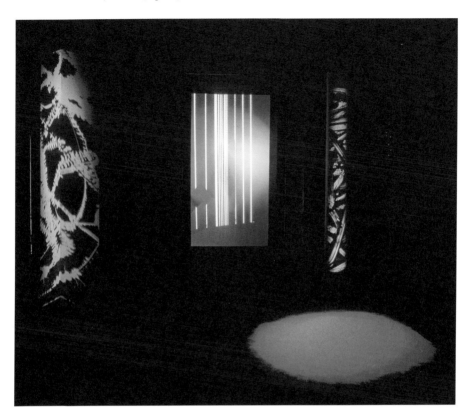

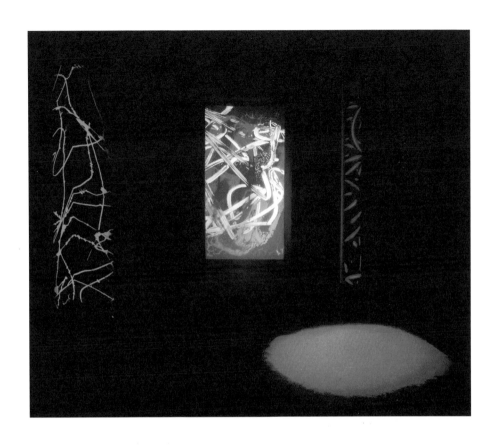

Neroli, Madrid, Spain, 1993

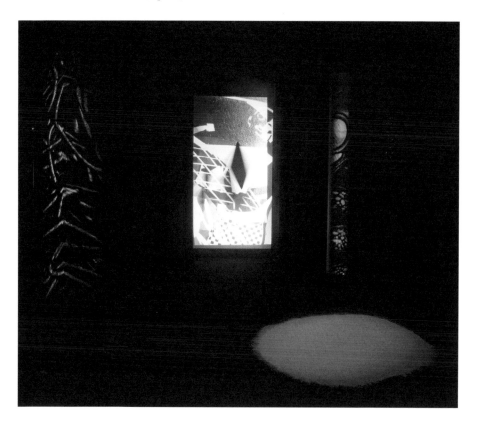

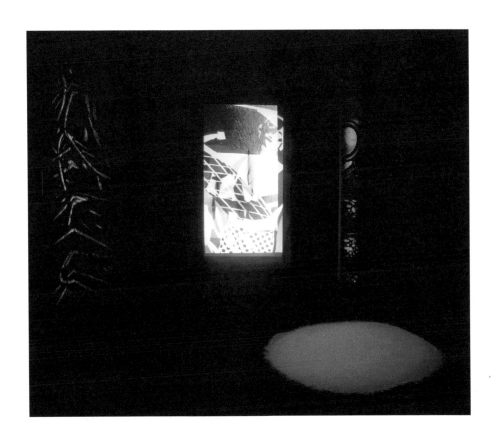

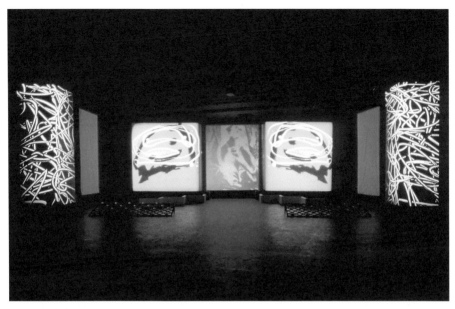

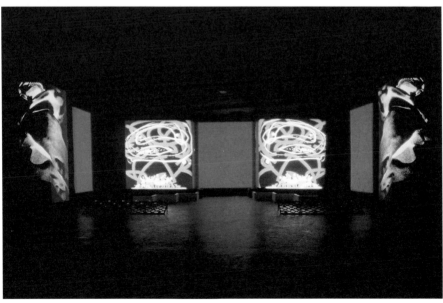

The Future Will Be Like Perfume, Hamburg, Germany, 1993

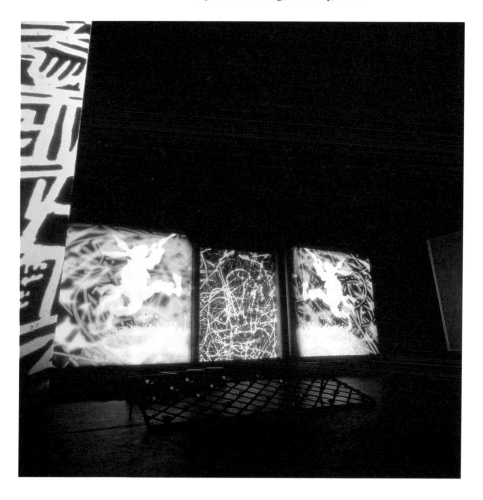

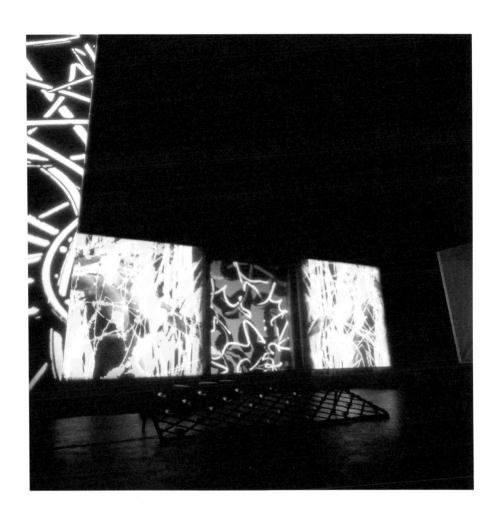

The Future Will Be Like Perfume, Hamburg, Germany, 1993

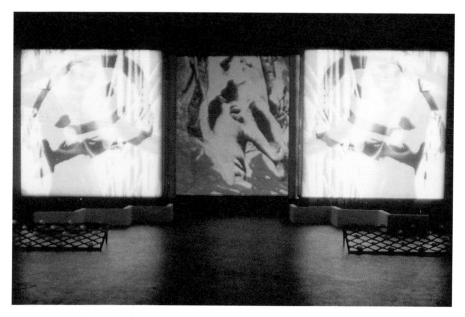

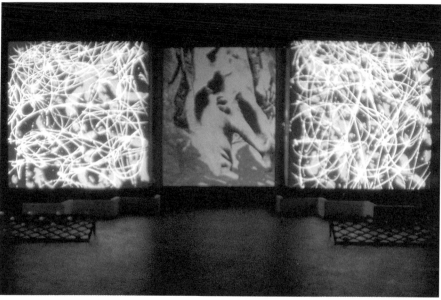

LEARNING FROM ENO

STEVE DIETZ

Brian Eno is renowned for his diverse career, including glam rock star, ambient music godfather, champion of the experimental, producer to rock royalty, video artist, installation artist, sound artist, pioneering crossover artist, committed politico, and big thinker.

What is remarkable—and less remarked on—is that undergirding this polymorphous activity is a surprisingly consistent and simple set of principles or practices from his earliest endeavors to the present day.

Even in the new media art world, despite the fact that much of this principled activity is based on cybernetics and the possibilities of generative art, Eno's ideas and work have not been as popular or influential as in the culture at large. Nevertheless, there is much to learn from what may be termed his new media strategies for producing culture.

This learning, however, is not best approached as a chronology of works or as a linear progression of theories. It is better thought of as an atlas to navigate Eno's "ideascape," as he outlined his own reading process in a 1982 interview.

> Have you seen a book of section maps called The A–Z of London? On one side a map will be continued on page 64; on another side it will be continued on page 48, and so on. I've always liked that idea. In my book, certain important ideas are underlined, and on the side of the page it says "go to page 28"—where you'll find a longer discourse on that idea. Within that discourse, other ideas will be mentioned. . . . You can read this book from beginning to end, but you don't have to. That's my way of defeating linearity.[1]

Learning from the Scenius

While Eno is often credited for his prescience in terms of his successes, he is quick to acknowledge, in opposition to the traditional notion of individual genius, what he calls "scenius," "the intelligence of a whole . . . operation or group of people,"[2] in which any individual contribution to culture is grounded.

Certainly, this was true for Eno. Besides his personal biography of a DIY grandfather (see Learning by Doing), Eno happened to attend a local art school run by Roy Ascott and his radical, interdisciplinary Groundcourse, which "focused on process and method over product" and was "developed around cybernetic theories of systems of communication." One of his tutors, Tom Phillips, suggested he look into tape recorders based on the work of Steve Reich, whose "It's Gonna Rain" "blew [Eno's] mind for its complete simplicity"[3] (see Playing by the Rules).

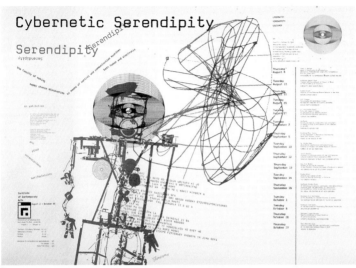

fig. 1
Exhibition poster
for *Cybernetic
Serendipity*, Institute
of Contemporary Arts,
London.

fig. 1

This ferment of technical experimentation, process over product, cybernetics, complexity from simple rules, video, computers, and generative art gave rise to a heady scenius, much of the work of Brian Eno, and at least a couple of generations of the new media art world, beginning with Jasia Reichardt's 1968 *Cybernetic Serendipity* exhibition at London's Institute of Contemporary Arts (fig. 1).

Eno's future close collaborator, Peter Schmidt, was the musical director for *Cybernetic Serendipity*, and he included John Cage's 1960 "Cartridge Music" on a record of computer music accompanying the exhibition (see Playing by the Rules) and an excerpt from Cage's "A Year from Monday" was included in the catalog, which approvingly discusses Charles Ives on what could only be described post-Eno as ambient music.

> Charles Ives had this idea: the audience is any one of us, just a human being. He sits in a rocking chair on the verandah. Looking out toward the mountains, he sees the setting sun and hears his own symphony: it's nothing but the sounds happening in the air around him.[4]

Stafford Beer, a cyberneticist whom Eno often refers to throughout his career, also had an installation of his "Stochastic Analogue Machine," which was not unlike a contemporary pachinko game. Beers designed the

machine for the random movement of ball bearings to "elucidate the natural design of stochastic interactions," such as the economy or a Sheffield steelworks, where it was installed in 1955.[5]

It is not known whether Eno visited *Cybernetic Serendipity*. It is certainly possible, but in a sense it doesn't matter. The exhibition is an example of the scenius of Eno's milieu and time, not a causal effect. "Learning from Eno" is about this interchange between Eno and the scenius of his times. Sometimes the lines of influence are direct and sometimes they are not, and they can go in either or both directions, but today's new media art scene, if one wants to call it that (see Unlearning), would not be possible or intelligible without the scenius in which Eno has played and contributed to and learned from for the past half century.

Learning by Doing

Eno often refers to the fact that his grandfather, besides his day job as a postman, repaired mechanical musical devices, such as hurdy gurdies, music boxes, and mechanical pianos, which he analogizes as the "synthesizers of their day."[6] What is particularly germane, however, is less the idea of a keyboard making different sounds than the fact it was just a bunch of "stops, keys, valves, and miscellaneous mechanical parts"[7] when it wasn't working. As Eno quotes inventor Danny Hillis, "[T]echnology is the name we give to things that don't work yet. When it works we don't call it technology anymore."[8] In this sense specifically, Eno was and is interested in technology.

One of Eno's earliest efforts with such technology circa 1964 was a kind of unprepared piano piece with one of his tutors at Ipswich, Tom Phillips. They collected broken pianos and placed them in a hall where they played hand tennis, the balls would strike on the piano strings and the resulting notes became the score.

While "Piano Tennis" has obvious parallels, from John Cage's "Bacchanale," his first work for prepared piano in 1940,[9] to the Velvet Underground's piano modification using a string of paperclips for "All Tomorrow's Parties"[10] to Olivia Block's contemporary experiments with piano, field recordings, and electronically generated sound,[11] the real lesson is in Eno's exploratory attitude about technology as a tool, which he describes in an interview with rock critic Lester Bangs.

> I'm very good with technology, I always have been, and with machines in general. They seem to me not threatening like other people find them, but a source of great fun and amusement,

like grown-up toys really. You can either take the attitude that it has a function and you can learn how to do it, or you can take an attitude that it's just a black box that you can manipulate any way you want. And that's always been the attitude I've taken.[12]

Eno's attitude is essentially that of a hacker, "A person who delights in having an intimate understanding of the internal workings of a system."[13]

Just a couple of years before "Piano Tennis," in 1962, "hackers" at MIT created the world's first video computer game, *Spacewar!* Initially, the program was developed for one of the first mini computers, the DEC PDP-1, to "*demonstrate* as many of the computer's resources as possible, and tax those resources to the limit."[14] Like Eno, the MIT hackers were trying to understand their new instrument by taking it through its paces, only their novel instrument was a PDP-1 computer and Eno's, a few years later in 1970, was a VCS3 synthesizer (see Learning How to Play the Studio).

To do this, however, required various kludges—or hacks. For instance, to play *Spacewar!* the equivalent of a modern-day joystick was needed but no such thing existed at the time.

> So Alan Kotok and Robert A. Saunders, who just happened to be members of the [MIT] Tech Model Railroad Club, trundled off to the TMRC room, scrabbled around the layout for a while to find odd bits of wood, wire, bakelite, and switch-board hardware, and when the hammering and sawing and soldering had ceased, there on the CRT table were the first *Spacewar!* control boxes.[15]

This hacker attitude is central to the production of much of contemporary art, except that as various technologies become commodified—there is more "firepower" on your smart phone than that original PDP-1 mini computer—the hacking becomes, in a sense, more Eno-like. Rather than how can you "demonstrate" the underlying technology, the pertinent epistemology is how can you "manipulate [it] any way you want?"

Cory Arcangel's 2002 hack of Nintendo's NES game console for Super Mario is exemplary in this regard. Arcangel opened the game cartridge and swapped Nintendo's graphics chip with one he had programmed and burned himself. The resulting *Super Mario Clouds* erases all the graphics in the game except the clouds[16] (fig. 2). Arcangel then "open sourced" the code he used, making it available for anyone else to use—part of the scenius.

fig. 2

Much of Eno's "genius" lies simply in non-normative use of the technology and tools at his disposal, including understanding "things" such as a recording studio as a system for manipulation (see Learning to Rule Complexity).

Learning How to Play the Studio

In 1970, Eno had a chance encounter with a former collaborator, Andy Mackay, who asked him "Have you still got some tape recorders? I'm in this band, we need to get some proper demos made."[17] When Eno first met this band—Roxy Music—Mackay had a VCS3 synthesizer, which he didn't really know how to use. Neither did Eno, but he was used to learning by doing and did not have to be persuaded to take it home to run it through its paces.

> First he plugged the synth into his ex-Pearl & Dean PA amplifier, then he fed it into his tape recorders. He was immediately in his element. The VCS3 synthesizer was essentially a noise-generator with various switches and a multi-colored pin-board for cross-patching, allowing diverse permutations of oscillation, filtration and envelope shape to be deployed.[18]

Out of this scenius, Eno quickly began mixing his synth effects of Roxy Music's performers with a range of tape delays, offsets, repetitions, and speed variations to create a distinctive sound for and with the band. Initially, this was all done live, but eventually, when Roxy Music went to the recording studio to record their first album, Eno began to treat the studio itself as a playing instrument, not just as recording instrumentation.

For Eno, the studio gave rise to a whole new way of thinking about music, not as something existing out there in the world to be reproduced but the seed of something to be coaxed and cajoled into being.

> In-studio composition, where you no longer come to the studio with a conception of the finished piece. Instead, you come with actually rather a bare skeleton of the piece, or perhaps with nothing at all. I often start working with no starting point. Once you become familiar with studio facilities, or even if you're not, actually, you can begin to compose in relation to those facilities. You begin to think in terms of putting something on, putting something else on, trying this on top of it, and so on, then taking some of the original things off, or taking a mixture of things off, and seeing what you're left with—actually constructing a piece in the studio.[19]

The studio had become an instrument, not just a playback device.

Again, there is an interesting parallel to discovering and inventing uses for the computer. In a famous demo at Bell Labs in 1962, an IBM 704 computer was programmed to sing "Daisy Bell."[20] In 1975, at the fourth meeting of the Palo Alto Homebrew Computer Club, Steve Dompier had painstakingly coded in to the world's first home computer model, an Altair 8600, something it was definitely not designed to do; its unshielded circuits caused the static of a nearby radio to change pitch. Dompier's program caused the radio static to play "Daisy" to a rapt audience of once and future nerds.

> The significance of "Daisy" was obvious, and the room went wild. The Homebrew Computer Club was staking its claim to a world that once belonged only to university labs, corporations, and government agencies. After that night, the power of computing would be open to all.[21]

The home computer had become, within months of its invention, a personal recording studio. In 2009, as computing moved into the

fig. 3
Aaron Koblin and Daniel Massey, *Bicycle Built for Two Thousand*, 2009, musical composition comprised of 2,088 voice recordings.

fig. 3

"cloud," yet another example of the unexpected interchange between computers and recording studio occurred. Aaron Koblin and Daniel Massey used Amazon's "Mechanical Turk" to hire more than 2,000 people to reproduce individual notes based on "Daisy Bell." These were then compiled into "Bicycle Built for 2,000" (fig. 3). Interestingly, the visual format of the recording was based on a player piano scroll, Eno's grandfather's métier.[22]

The calculating machine had become a generating machine, and the studio was a kind of Turing machine. Eno would soon take advantage of these crossover capabilities for many of his generative music and visual art projects (see Generating Eno).

Playing by the Rules
From early on, Eno was interested in rules—not just breaking them. One set of rules came to be codified as *Oblique Strategies*, which was published in several decks of cards[23] with Peter Schmidt, whom Eno found out had been developing a similar set of instructions.

won't be a sty- lish mar-riage. I can't af- ford a car- riage But you'd look sweet upon the seat of a bi- cy- cle built for two.

Oblique Strategies grew out of the fact that the recording studio (see Learning How to Play the Studio) is not just a collection of instruments; it is a social system of people interacting (see Learning to Rule Complexity). These people can get in ruts, fights, embraces, depression, backstabbing, and other human situations and feel inordinate pressure to produce something remarkable in a minimal amount of time.

> Honour thy error as a hidden intention. Abandon normal instructions. Ask your body. Try faking it. Get your neck massaged. Consider transitions. Distort time. Go slowly all the way round the outside. Feed the recording back out of the medium. Go to an extreme, come part way back.

As instructions, *Oblique Strategies* are not unlike any number of other systems from the *I Ching* to the *Kama Sutra* to Emily Post. Artists have not only used such systems, formally and informally, but they have also created them. Curator Hans Ulrich Obrist has been "collecting" such

Equipment
2 wooden planks,
1" x 4" x 18," labeled A and B.

1. Place bug on end of wooden plank A.

BUG

A

2. Strike area where bug is located on plank A with plank B.

B

A

3. Remove remains of bugs from both planks and repeat with successive bugs as necessary.

fig. 4

projects since 1993 in the archive DO IT[24] (fig. 4). Like *Oblique Strategies*, the earliest projects date from the 1970s and range from how to turn kitchen utensils into electrical appliances (Mona Hatoum) to computer programs (Feng Mengbo) to how to kill a bug (John Baldessari).

Broadly speaking, there are two trajectories for such instructional projects. The point of many of them is to startle the user out of his or her complacency and to encourage a creative approach/response to the issue at hand. *Oblique Strategies* were essentially a codification of Eno's experience in the studio (see Learning How to Play the Studio) doing just this.

An important precursor to *Oblique Strategies* is the idea of the *derive* and the origins of the idea of *psychogeography*, which has been extensively theorized by Guy Debord,[25] "The derive grants a rare instance of pure chance, an opportunity for an utterly new and authentic experience of the different atmospheres and feelings generated by the urban landscape."[26]

A second trajectory for instructions is when they are deployed based on a set of simple rules. John Cage is renowned for his use of the *I Ching* as a system to create compositions such as his 1951 "Music of Changes."[27]

Eno, especially post-1975 with the issue of *Discreet Music* and *Music for Airports* (1978), is aiming to create an authentic experience in the listener generated by his aural landscapes similar to the idea of the derive, but he is also beginning to use a set of rules to create these landscapes (see Learning to Rule Complexity).

Learning to Rule Complexity

Eno was particularly inspired by Steve Reich's 1965 "It's Gonna Rain," which plays back two identical tape loops of a San Francisco street preacher slightly out of phase creating a "controlled chaos."[28] Eno says the following of the piece: "[I]t gave me an idea I've never ceased being fascinated with—how variety can be generated by very, very simple systems."[29] In fact, this system of phasing passages is at the core of all of his ambient music, including the groundbreaking *Music for Airports*.[30]

In this context, *Oblique Strategies* (see Playing by the Rules) can also be thought of as reset buttons for the creative process—or (the game of) life.

The Game of Life is a cellular automata game invented by mathematician John Conway in 1970. For Eno, "it's one of the great experiments of the twentieth century. The Game of Life is like the Beatles in science,"[31] and he claims to have spent literally weeks playing it and watching people interact with it on a daily basis at the Exploratorium in San Francisco in 1978.

> I wanted to train my intuition to grasp this. I wanted this to become intuitive to me. I wanted to be able to understand this message that I'd found in the Steve Reich piece, in the Riley piece, in my own work, and now in this. Very, very simple rules, clustering together, can produce very complex and actually rather beautiful results. I wanted to do that because I felt that this was the most important new idea of the time."[32]

On one of the tracks for *Music for Airports*, for example, Eno set up a simple set of rules that govern the length of repetition for three loops, "One of the notes repeats every 23 ½ seconds. . . . The next lowest loop repeats every 25 ⅞ seconds or something like that. The third one every 29 ¹⁵⁄₁₆ seconds or something." The result is mesmerizing—and "incommensurable . . . not likely to come back into synch again."[33]

Eno is not the only artist to grasp the complex beauty achievable through systems-based art making. Sol Lewitt's drawings use a similar process, such as *Four Geometric Figures in a Room* (1984), which is created with these instructions.

> Four geometric figures (circle, square, trapezoid, parallelogram) drawn with four-inch (10 cm) wide band of yellow color ink wash. The areas inside the figures are blue color ink wash, and the areas outside the figures are red color ink wash. On each side of the walls are bands of India ink wash.[34]

Certain parameters such as the shapes and the band of yellow are fixed, while others such as the wall and the size of the shapes are variable. And "resetting" any of the parameters would give rise to a different drawing. As with the excitement of the Homebrew Computer Club (see Learning How to Play the Studio), there is something democratic or at least participatory about this scenius. The drawing is something that "anyone may execute, in any location, any number of times."[35]

Justin Bakse and Eric Ishii Eckhardt's *Life vs. Life* turns Conway's *Game of Life* into a video game with winners and losers (fig. 5). *Life vs. Life* adds a couple of rules to Conway's system with the addition of another player. There are two colors of cells in any board competition, red and blue. When the game is activated and the cells start interacting they follow the same basic rules of *Life* and expand into each other's territory. However when the red cells interact with blue cells the resulting cells are either red or blue.[36] They win. In a sense, *Life vs. Life* allows a player to train his or her sensibility about the *Game of Life*—and complexity—by ranking the success of each starting condition to carry on generationally.

Learning to Go Heuristic

Despite his interest in and championing of rules, for much of his career, Eno has been both sanguine and skeptical about them. He spoke of this in one interview.

> The avant-garde technique would be to go ahead with it anyway, because the process is supposed to be interesting in itself. I don't go for that. I think if something doesn't jolt your senses, forget it. It's got to be seductive.[37]

Part of his skepticism, no doubt, is his genuine interest in pop culture (see Unlearning), and part of it may be related to having no formal training in music and both producing and making it by ear. It has to sound right, not just sound like a process that might end up sounding right. Part of what surprised and excited Eno about Reich's "It's Gonna Rain" was precisely how rich and seductive it was, not a dry, formalist "experiment." Seduction—and surrender—is a big part of Eno's pragmatic idealism. Without it, he's not interested.

Through Roy Ascott (see Learning from the Scenius), Eno was introduced early on to the field of cybernetics, particularly the ideas of Stafford Beer, a British cybernetician and a participant in the *Cybernetic Serendipity* exhibition, and interestingly, a management consultant. For Beer, cybernetics was the "science of effective management."[38] Beer's ideas about the poverty of top-down management structures—like, according to Eno, the church, corporations, and the orchestra—influenced his understanding of process in relation to music making, saying in an interview with Kevin Kelly the following oft-repeated point: "Classical music . . . represents old-fashioned hierarchical structures . . . Orchestral music represents everything I don't want from the Renaissance: extremely slow feedback loops."[39]

fig. 5

fig. 5
Eric Ishii Eckhardt and
Justin Bakse, *Life vs. Life*,
2003, two-player online
adaptation of the mathe-
matical *Game of Life*.

The idea of the feedback loop is extremely important here. It's not just a rule that is initiated, but it has at least the potential to be affected in its execution by feedback. In cybernetics, this is the idea of heuristics. Eric Tamm writes about this as follows.

> Eno quotes cybernetician Stafford Beer's definition of a "heuristic" with approval: "a set of instructions for searching out an unknown goal by exploration, which continuously or repeatedly evaluates progress according to some known criterion." Eno cites Beer's example of a non-musical heuristic: "If you wish to tell someone how to reach the top of a mountain which is shrouded in mist, the heuristic "keep going up" will get them there.[40]

In a joint talk at the Long Now Foundation, game designer Will Wright pressed Eno on how a heuristic for good versus bad "Eno music" might be encoded, and Eno suggested that it was a Sisyphean task at best, if only because one's tastes change as one experiences more. There is a feedback loop of experience.[41] One cannot help but think of all those hours Eno spent at the Exploratorium, watching the *Game of Life* and trying to train his intuition—as to which starting conditions of the game might lead to the most seductive results (see Learning to

fig. 6
Ben Rubin and Mark
Hansen, *Moveable Type*,
2007, 560 vacuum-
fluorescent display
screens, site-specific
installation for the *New
York Times* building.

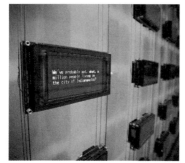

fig. 6

Rule Complexity). How to encode that knowledge and instinct for the seductive may not be possible, which is different than saying it is not achievable (see Generating Eno).

The promise of interactivity—of feedback—is itself a seductive siren call for many new media artists, who, like Eno, long to get beyond a debased idea of interactivity as pressing this button or that button. One of the most successful projects in this regard is by Ben Rubin and Mark Hansen. *Moveable Type* is an installation of 560 small display screens hung in a grid along the entry corridor to the *New York Times* building (fig. 6). The screens display data from that day's *Times* newspaper and website using statistical methods and natural-language processing algorithms. The result could be pure garbage, little more than bad graffiti, and actual but uncompelling. But Rubin and Hansen have managed to create algorithms (rules), feedback loops (research), and display templates that David A. Thurm, the chief information officer at the New York Times Company, described as functioning "like a homage to the news ticker but one that followed the advice of Emily Dickinson: 'Tell all the Truth but tell it slant.'"[42] Rubin and Hansen put it accurately.

> "We want it to feel almost like an organism that is living and breathing and consuming the news," Mr. Rubin said, adding that someone who had not seen the paper or Web site would be able to watch the screens for several minutes and begin to get a sense of that day's biggest events, though in a way that might feel more like floating on the newspaper's stream of consciousness than reading it.[43]

Is it possible to do for Brian Eno or any artist what has been done for the *New York Times*?

Generating Eno

> I want to be able to sell systems for making my music as well
> as selling pieces of music. In the future, you won't buy artists'
> works; you'll buy software that makes original pieces of 'their'
> works, or that recreates their way of looking at things. You could
> buy . . . a Brian Eno box. So then I would need to put in this box
> a device that represents my taste for choosing pieces. . . . It is a
> kaleidoscopic music machine that keeps making new variations
> and new clumps.[44]
> —Brian Eno

In 1996 Eno produced his first aptly named generative music,
Generative Music I. Generative here meaning that some part of the
"decision making" process is out of Eno's hands—and mind. He's not
"simply," as with *Music for Airports*, recording sounds and then playing
them back out of phase. As installed at the 11th Urban Aboriginals
Festival at the Parochialkirche in Berlin,

> [T]he music was generated by a PC set up between two rows of
> pews. With the help of a software program called SSEYO Koan,
> it continuously produced short ambiance pieces which were
> all situated within certain parameters determined by Eno, but
> which were changed each time by the computer brain. . . . This
> program was able to select from among about 200 sounds and
> then compose a piece out of them. In this way, new improvisa-
> tions and variations were perpetually created.[45]

The Koan program allowed Eno to control up to 150 parameters in order
to generate unique combinations of harmony, rhythm, tempo, vibrato,
pitch, and other variables with probabilistic rules expressed as percent-
ages—in other words, heuristically (see Learning to Go Heuristic).

Generative Music 1 as well as Eno's *Blisses 1–87 Koans 1–29* (2000) still
used sampled sounds rather than computer-produced MIDI sounds as
the building blocks or cells of their growth. However, rather than rely-
ing on phasing to generate the composition, as he had primarily done
since *Discreet Music* (1975), including his series of ambient recordings,
the Koan software directed the computer to dynamically modify the
samples according to probabilistic or heuristic rule sets with the result
that the music would not repeat during any normal listening period.
77 Million Paintings uses similar software to collage together visual

fig. 7

samples created by Eno, either by hand and scanned or directly on the computer. In 2008, Eno and his collaborator Peter Chilvers also worked on the sound for the Will Wright-designed game *Spore* using a Koan-like software program called the Shuffler, which procedurally generates fragments for the soundtrack of *Spore* from a number of samples.

As a contrasting example of procedural creation, artist Harold Cohen began developing software called AARON in 1973, which creates original images purely from instructions with no sampling (fig. 7). Broadly speaking, Cohen has programmed into the software information about the human form, potted plants, and other simple shapes and objects—AARON's "declarative knowledge." The program then also has rules for how to paint, which activate, so to speak, the forms being drawn. This is shown in the following example.

> if (left-arm-posture is "hand-on-hip")
> (add-upper-arm left -.3 .5 .65)
> else
> if (left-arm-posture is "arms-folded")[46]

This is a classic recursive statement or feedback loop, and it is how the AARON program monitors its progress. So, while broadly speaking, as with the *Game of Life*, there is an arbitrary starting condition, which then plays out according to a set of rules, in AARON's case, these rules are not quite so simple precisely because there is a more specific representational goal along the lines of "draw three figures in a three-dimensional

space with a potted plant and a table." In a sense, for Cohen, realistic representation is the heuristic Wright was asking Eno about, which the computer uses to evaluate its "progress" toward an end result.

Eno's generative music does have such a programmed heuristic. It is Eno deciding each of the 150 variables in the Koan software, starting the process, listening to the results for a few seconds or tens of hours, until he has encoded a satisfactory probability for each characteristic, and then the program is "baked." It will never produce the same result twice, but Eno himself was the feedback loop for instantiating the set of rules.

Nevertheless, for all of his software-based projects, Eno surrendered a significant degree of control over the process, creating *Game-of-Life*-like algorithms to grow the final composition based on its initial conditions—the seed. Neither process of generating art, purely through instructions or through instructions and samples, is better than the other. Both create a dynamic, non-repeating result, which is not fixed in a final format on a CD or DVD. And it is this distinction that is crucial in differentiating Eno's generative works, such as *Generative Music 1* and *77 Million Paintings*, from his earlier ambient music. The latter is fixed, always the same each time you hear it, and the former is not. With these projects, Eno had succeeded in creating a system to make his music—or paintings—which keeps on making "new variations and new clumps."[47]

Becoming Eno

I had realised three or four years ago that I wasn't going to be able to do generative music *properly*—in the sense of giving people generative music systems that they could use themselves— without involving computers. And it kind of stymied me: I hate things on computers and I hate the idea that people have to sit there with a mouse to get a piece of music to work. So then when the iPhone came out I thought "oh good: it's a computer that people carry in their pockets and use their fingers on," so suddenly that was interesting again.[48]

—Brian Eno

If Eno's *77 Million Paintings* is a system for "generating Eno" with a great deal of flexibility for display from a personal computer screen to an immersive gallery installation to projecting on the exterior of the Sydney Opera House, it remains a closed system, where all the variables have been preset. Eno succeeded in providing that "Eno box,"

which one could choose to play when tired of the "Shostakovich box." Nevertheless, without implying any hierarchy of value, Eno had not yet provided that open platform, which would allow the listener to play at being Eno, not just play Eno.

In 2008, Eno and Chilvers released an app for the iPhone called *Bloom* (see page 324–25), which allows for user input, and creates unique visual patterns and correlated sounds.

> Part instrument, part composition and part artwork, *Bloom*'s innovative controls allow anyone to create elaborate patterns and unique melodies by simply tapping the screen. A generative music player takes over when *Bloom* is left idle, creating an infinite selection of compositions and their accompanying visualisations.[49]

In 2009, they released *Trope*, which is substantially similar to *Bloom* only "darker," and you drag your finger to create the interaction rather than tapping the screen. As with the series of ambient albums, the apps are related but distinctive.

As sample-based, protocol-driven, ambient-functioning sound works, they continue a distinctive thread in Eno's oeuvre beginning with *Discreet Music*. For the first time in over 35 years, the user/listener can "play" Eno's role in creating live sound events. In a very real sense, without implying any hierarchy of value, they represent a culmination of Eno's "cybernetic concept of the adapting, intelligent, complex, heuristically-directed organism finding its way amongst a pleroma of environmental and evolutionary alternatives."[50]

Unlearning

> The traditional sites for art activity seem to be losing their power, while new sites for art are becoming powerful. We have been looking for art in the wrong places.[51]
> —Brian Eno

In Roy Ascott's Groundcourse at Ipswich, each student had to create a game, which tested other students' responses to the protocols of the game. The results of all the games went into a mindmap of each student, who was then required to behave for the rest of the term in an opposite manner to his or her original profile.[52] The goal, in large measure, was to destabilize expectations and preconceptions about what art is and what happens at art school and what an artist does.

It would be an oversimplification to say this is what Brian Eno has been doing ever since. On the other hand, Roselee Goldberg introduced him at the Museum of Modern Art for a discussion during the exhibition *High & Low: Modern Art and Popular Culture*, as an "extrovert pop star" who is also "an introvert philosopher."

> He was someone who was able to mix mind and body, Apollo and Dionysus, and in fact Eno gave these classical western dichotomies a very contemporary dimension, for he went ahead and mixed them all up electronically.[53]

The contemporary scenius that Eno grew up in and out of, broadly speaking, was on the cusp of what the French sociologists Alain Minc and Simon Nora referred to in 1978 as the "computerization of society"—the rise and intersection of networks and computation, stating simply, "The applications of the computer have developed to such an extent that the economic and social organization of our society and our way of life may well be transformed as a result."[54] This intersection has inarguably changed the world.

Through his music, his visual art, and his ideas, Eno has surfed this computerization of society and surrendered himself to it. In doing so he has contributed enormously to defining it. Part of what he found—and practiced—is that the traditional notions of high art and fine art are not as useful as they once were. "The traditional sites for art activity seem to be losing their power, while new sites for art are becoming powerful."[55] It behooves us to learn from Eno.

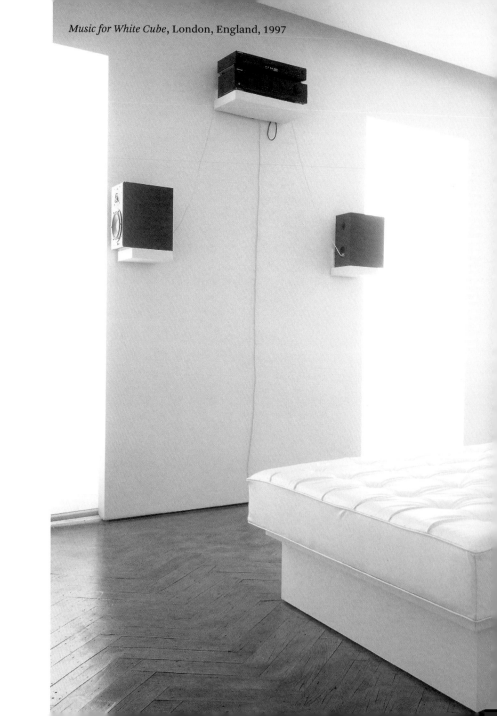

Music for White Cube, London, England, 1997

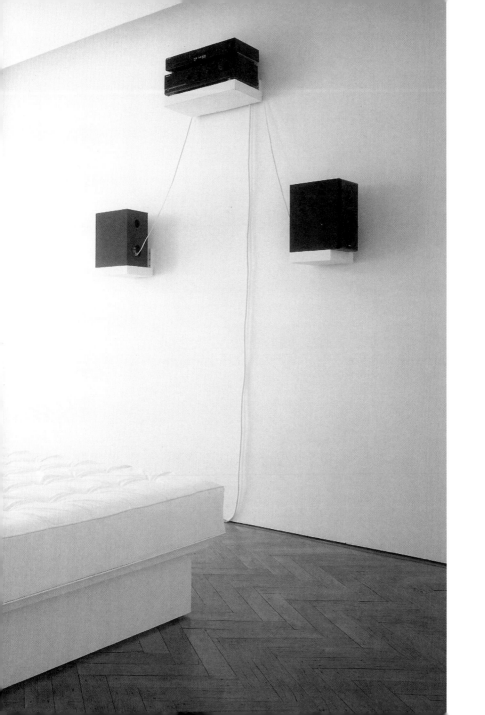

Music for Prague, Prague, Czech Republic, 1998, collaboration with Jiří Příhoda.

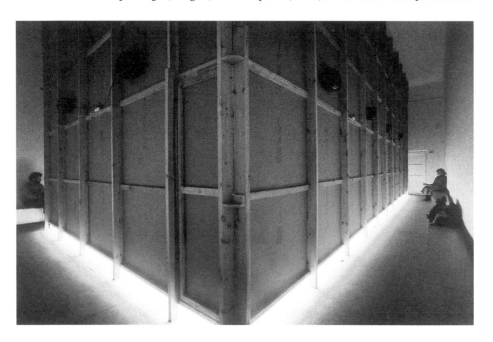

Kite Stories, Helsinki, Finland, 1999

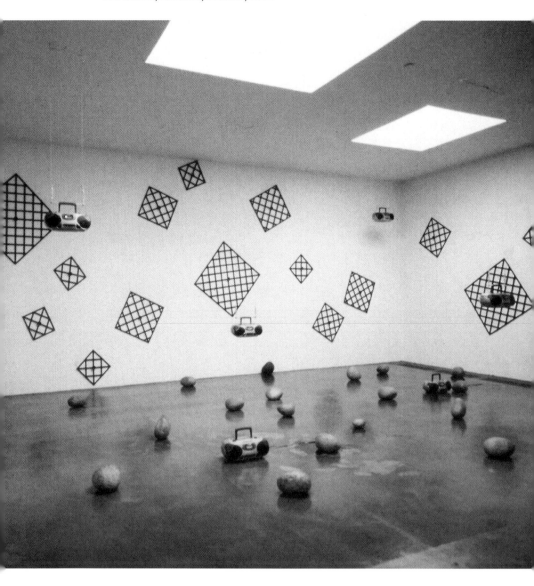

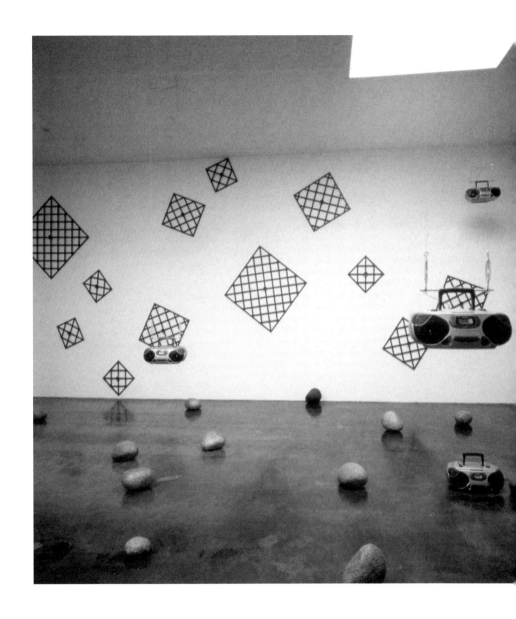

Images generated by vidro feedback through quantize, mirror and invert at the rate of 90000 (25 × 60 × 60 per hour)

No two were identical

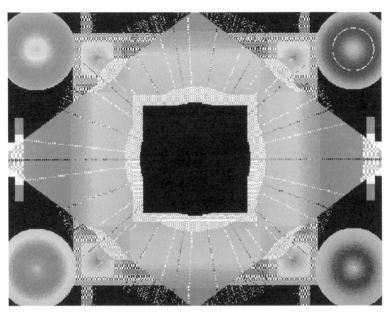

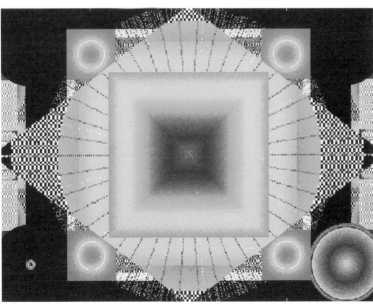

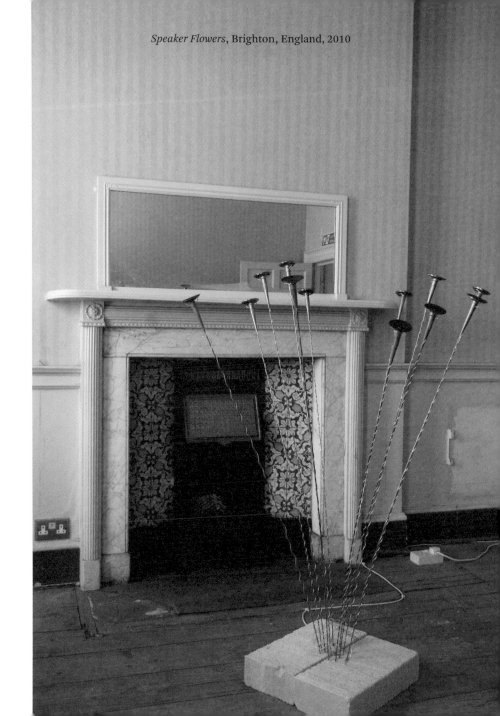

Speaker Flowers, Brighton, England, 2010

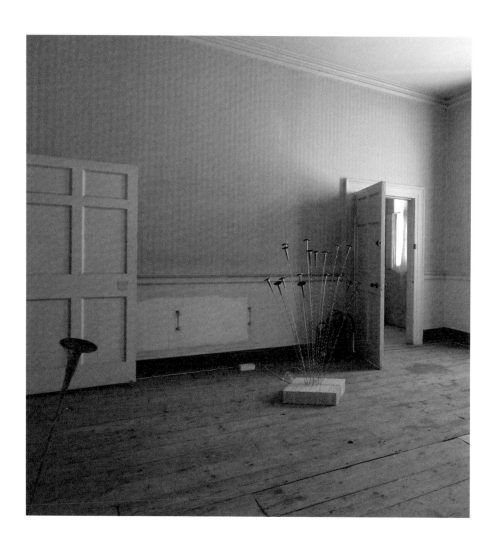

319

Lydian Bells, Naples, Italy, 2008

Lydian Bells, Naples, Italy, 2008

Bloom, 2008/2010, collaboration with Peter Chilvers.

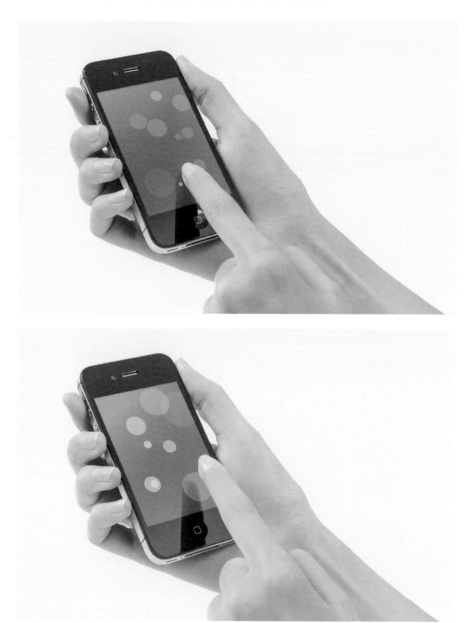

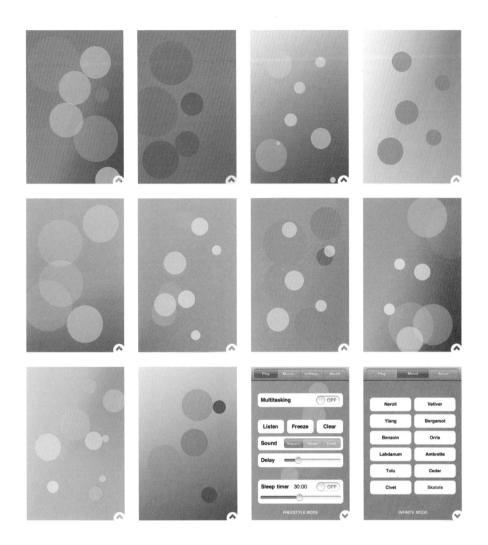

325

Trope, 2009, collaboration with Peter Chilvers.

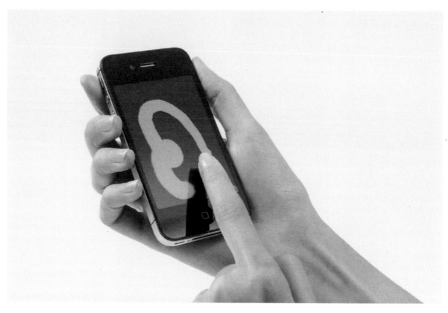

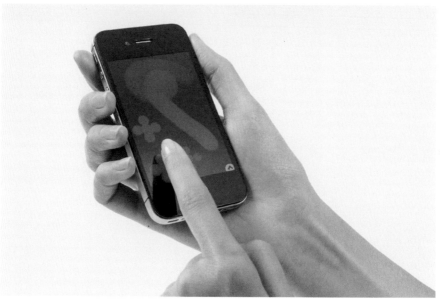

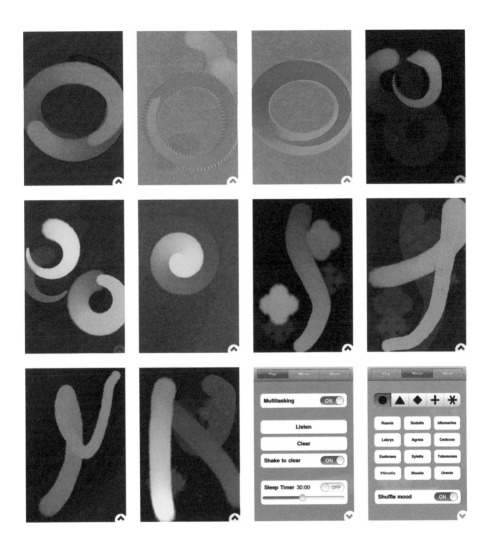

Bloom, 2008/2010, collaboration with Peter Chilvers.

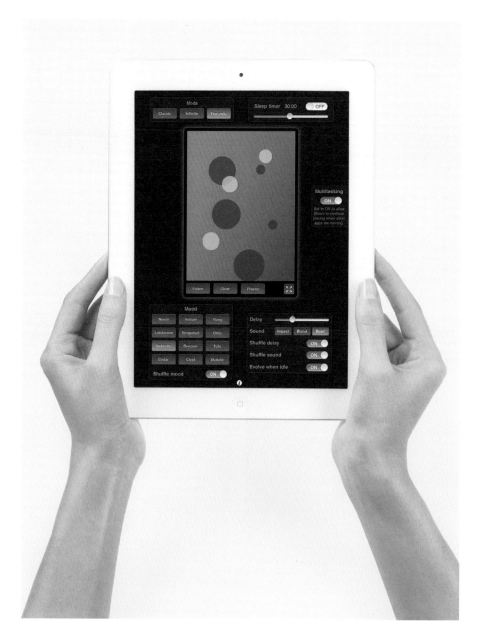

THE AESTHETICS OF TIME

77 MILLION PAINTINGS: EVOLVING AND LIVING IN TIME

CHRISTOPHER SCOATES

If a painting is hanging on a wall where we live, we don't feel that we're missing something by not paying attention to it. . . . Yet with music and video, we still have the expectation of some kind of drama. My music and videos do change, but they change slowly. And they change in such a way that it doesn't matter if you miss a bit.[123]
—Brian Eno

In the late nineteenth century, a disparate group of artists, writers, and inventors coined the term *color music* to describe an art form that was independent of the easel and made with colored lights. The term referred to electromechanical devices, invented in the eighteenth century, that produced sound accompanied by a visual representation. In 1725 the French Jesuit monk and mathematician Louis Bertrand Castel illustrated his optical theories with a proposal for an ocular harpsichord. The harpsichord had sixty small colored-glass panes, each with a curtain that opened when a key was struck. Subsequently a long list of mathematicians, inventors, and scientists added to the medium's development. In the early nineteenth century, the Scottish scientist and inventor Sir David Brewster proposed the kaleidoscope as an instrument of visual music. More than half a century later, Bainbridge Bishop, an American, designed and patented the first electromechanical instrument that could synchronize colored lights with a musical performance.

The best known of the color instruments from this period was designed in 1893 by Alexander Wallace Rimington, a British painter and professor at Queen's College, London. Rimington's color organ was similar to a church organ—over ten feet high with a five-octave keyboard controlled by conventional organ stops (fig. 51). The colors were "played" and altered through the use of a swell pedal that controlled the brightness and created visual dissolves and fades.[124] The first musician to incorporate projected light with a full orchestra was the Russian composer and pianist Aleksandr Nikolayevich Scriabin. Scriabin composed *Prometheus: The Poem of Fire*, a symphonic work for piano, orchestra, optional choir, and color organ; it was a multimedia event using the color organ to create a projected dramatic backdrop behind the orchestra, thus creating a visual parallel to the music being performed.[125]

At the time, a debate began to take place concerning the accuracy of, and the physical associations between, the note played and the color simultaneously projected. The color and notes varied widely from one machine to another, and providing any visual consistency during a performance was nearly impossible.[126] Because different colors were

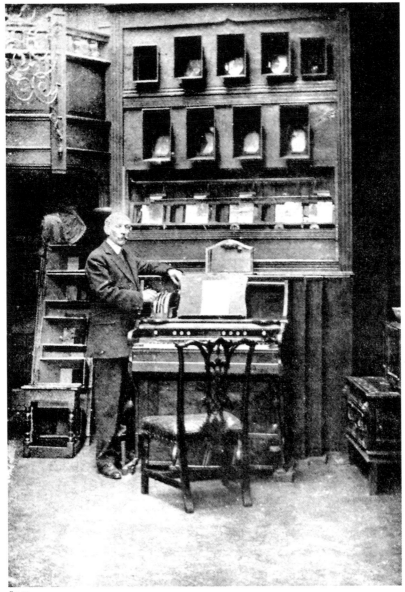

fig. 51

fig. 52
Thomas Wilfred with
a later model Clavilux
Home Instrument
("Clavilux Jr.") keyboard,
built in 1930.

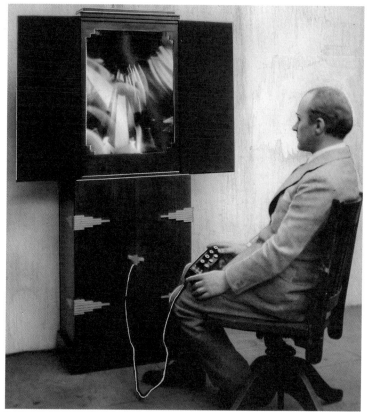

fig. 52

projected for the same musical composition, musicians and designers began to distance themselves from instruments with both sound and light, in favor of machines that projected only colored light. Many color-projection instruments appeared during this time, but beginning in 1919 the Danish-born artist Thomas Wilfred designed the most significant of these, which he called the Clavilux (fig. 52).[127]

Wilfred became the most successful artist working with colored light in the United States and the first to describe his work as a type of painting that used light as its medium.[128] He called these works *Lumia* (fig. 53), and they would go on to gain in popularity as he toured with his Clavilux machine in 1933.[129] Wilfred's *Lumia* did not fit any accepted aesthetic category, but he was eager to see them attain the

fig. 53
Thomas Wilfred, *Opus
136, Vertical Sequence
I*, 1940.

fig. 53

same respect accorded to traditional paintings. In an interview for the *New York Times*, Wilfred stated, "This painting, said to be the first to use light, is intended to be 'hung' in the home as are oil paintings."[130] *Lumia* were soon added to art history books, and one critic devoted an entire chapter to Wilfred's work, which he described as "the beginning of the greatest, the most spiritual and radiant work of all."[131] Wilfred's work subsequently came to the attention of Alfred H. Barr Jr., the director of the Museum of Modern Art in New York, who acquired *Vertical Sequence, Opus 137* (1941) for the museum's collection, and with the museum's imprimatur additional acclaim soon followed.

In 1952 Wilfred's work was included in the Museum of Modern Art's landmark exhibition *15 Americans*, along with works by notable artists such as Mark Rothko, Clyfford Still, and Jackson Pollock.[132] In his catalog statement, Wilfred borrowed heavily from the language of modernist painting, "The *Lumia* artist visualizes his composition as a drama of moving form and color unfolding in dark space. In order to share his vision with others he must materialize it. This he does by executing it as a two-dimensional sequence projected on a flat white screen. . . ."[133] Despite having his work collected by and exhibited at the Museum of Modern Art, Wilfred never gained the kind of critical recognition that other artists of his generation received. His struggle to have his work accepted into the mainstream is typical of artists whose work challenges convention, and the use of technology—until recently perceived as the realm of the sciences and not the arts—only exacerbated this struggle. Often marginalized as an art form, *Lumia* did not fit the narrow constraints that defined art at the time.

fig. 54
Page from one of Eno's notebooks with drawings of Tours Cathedral Windows, ca. February–October 2010.

fig. 54

This history serves as an apposite lens through which to view Eno's most ambitious installations to date. *77 Million Paintings* synthesizes many of the ideas that have preoccupied Eno over the course of his career. In this work, the key ideas of his past projects coalesce: the conceptual threads of his early video portraits, the architectural scale of *Natural Selections*, the immersive environments of the *Quiet Club* series, and the generative systems of *Music for White Cube* and other sound installations. The meditative quality and slowly changing abstract colors of *77 Million Paintings* suggest a stained-glass window—the cluster of video screens, the darkened space, and the low volume of the generative music position the viewer squarely in the space of a secular cathedral.

The analogy is one that Eno has himself made in regard to his career-long interest in color and light, "Think of the impact a big cathedral must have made in the fourteenth century. I try to imagine what that must have felt like. The cathedral experience must have been heavenly—to see the light in that way, through the stained glass, so unlike any experience of the time"[134] (fig. 54). Like Eno's generative installation, the window for Cologne Cathedral designed by the German artist Gerhard Richter in 2007 incorporates strategic compositional systems (fig. 55). Richter's stained-glass window, which soars more than sixty-five feet high, takes its inspiration from the artist's painting

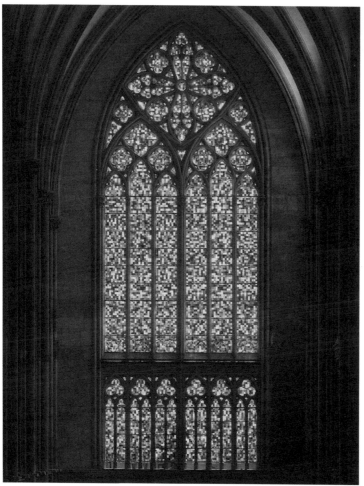

fig. 55

4096 Colours (1974).[135] The window is composed of 11,500 squares of handblown glass in seventy-two colors generated using a limited palette of the three primary colors and gray, and arranged using a specially designed computer program. Eno's desire to blur the boundaries between light and sound and provide a meditative experience for his audience echoes the effect of Richter's contemporary pixilated tapestry, which has been called "a symphony of light."[136]

77 Million Paintings has been presented in museums and galleries, as well as less conventional sites, including the Sydney Opera House, where it was projected onto the landmark structure for the inaugural Luminous Festival in 2009 (see pages 348–78 and 389–401). Ironically though, *77 Million Paintings* did not start out as a large-scale project—quite the contrary, in fact. Eno was originally intent on creating a work based on his early slide projections but one that could be viewed in the privacy and seclusion of one's own surroundings. He approached it in terms of a computer-generated work that could be watched at home; the images and sound would change randomly in an infinite set of combinations so that even if it was running 24 hours a day, 365 days a year, one would never hear or see the same work twice.

According to Eno, *77 Million Paintings* was inspired by a late-night walk through his neighborhood, "I walked past a rather posh house in my area with a great big huge screen on the wall and a dinner party going on. . . . The screen on the wall was black because nobody's going to watch television when they're having a dinner party. Here we have this wonderful, fantastic opportunity for having something really beautiful going on, but instead there's just a big dead black hole on the wall. That was when I determined that I was somehow going to occupy that piece of territory."[137] Eno wanted to create an audio painting that continually changed and generated new images as the viewer sat watching, but at the time there was no software available that could achieve his vision. While previously he had incorporated generative systems in the creation of music, it would be the first time he translated this approach to the visual realm, where millions of visual combinations could be created to make a work that could continually evolve. He said, "What I'm really doing when I work generatively is I'm making seeds. Then I'm planting them, in the case of *77 Million Paintings*, in your computer. Then the seed grows into all the different kinds of flowers it can produce."[138] The installation's title references "all the different kinds of flowers" possible—by Eno's calculation, the generative possibilities extend to seventy-seven million iterations.

As an installation, *77 Million Paintings* has been shown in numerous configurations, tailored to the venues in which it is presented. Over the years this experimentation has taken different forms, most memorably in a Tokyo exhibition in which the walls and floor of the venue were mirrored to transform the piece and take the installation experience to dizzying new heights.[139] Fractal-like patterns are composed with multiple screens in multiple sizes, arranged in varying shapes and geometries. Abstract gestures, amoeboid forms, geometric shapes, and

fig. 56

fig. 56
Eno at his slide table.

representational images all collide and float slowly across the screens, imperceptibly dissolving from one to the other—combined yet entirely separate. These multiple representational languages—evoking surrealism, minimalism, abstract expressionism, and experimental film—fuse and overlap to structure a kaleidoscopic effect of light, color, and sound in which unintended references to the history of art flow past.

The final iteration of any one image on the screen is actually composed of four images, each pulled from a vast inventory of Eno's visual work. Over the course of his career, he has amassed an enormous slide library documenting his output, which served as raw material to be remade and remodeled into the new work (fig. 56). These existing resources were digitized, bringing the scratched and inked slides from installations such as *Natural Selections* into a digital environment. While the processes that Eno used to create the original slides are reminiscent of Fischinger's use of film as well as the liquid light designers' psychedelic rock shows, they also parallel the artistic process of the New Zealand–born filmmaker, painter, and kinetic sculptor Len Lye and the American experimental filmmaker Stan Brakhage. Both men subverted the conventions of the filmic medium by abandoning the camera and scratching and painting directly on the film stock. Lye's four-minute experimental film *Swinging the Lambeth Walk* (1939) is hand painted with abstract strokes and shapes that dance and flitter across the screen (fig. 57). It was inspired by a then popular dance of the same name,

fig. 57

and Lye used the music to accent the visual dynamics on screen.[140] In describing his technique, he wrote, "If you also synchronize the visual accenting with sound accenting of music with say, a rhythmic beat, then you've got something you can look at. . . . One enhances the other, one sharpens up the other."[141] For one of Brakhage's best-known films, *Mothlight* (1963), he collected moth wings, flower petals, blades of grass, and other plant and insect material and collaged them between splicing tape that approximated the format of 16mm film (fig. 58). The four-minute silent work, made with neither camera nor film, pushed filmmaking to new extremes.[142] By collaging, painting, and scratching the film stock, avant-garde filmmakers such as Lye and Brakhage "revolted against the indexical identity of cinema," according to new-media theorist Lev Manovich. "They were working against 'normal' filmmaking procedures and the intended uses of film technology. . . . Thus they operated on the periphery of commercial cinema not only aesthetically but also technically."[143]

The experimental filmmaker Jordan Belson began as a painter but became inspired to make abstract films while attending the influential Art in Cinema screenings at what was then the San Francisco Museum of Art, where he watched films by Norman McLaren, Hans Richter, and Oskar Fischinger.[144] Belson created more than thirty nonobjective films between the late 1940 and 2005, sometimes called "cinematic

fig. 58
Stan Brakhage, *Mothlight*,
1963, 16mm, color,
silent, 4 minutes.

fig. 58

fig. 59
Jordan Belson, still from
Allures, 1961, 16mm,
color, sound.

fig. 59

paintings" (fig. 59).[145] In 1957 he began to collaborate with the American sound artist Henry Jacobs on a series of electronic music concerts accompanied by lavish visual projections at the Morrison Planetarium in San Francisco.[146] Belson took responsibility for the imagery, as the visual director for what would become the infamous Vortex concerts. Bringing together electronic music with abstract images in an immersive environment, the concerts proved hugely popular, drawing hundreds of people. The Vortex program notes capture the experience, "The name—Vortex—is derived from the ability to move the sound around the dome in either clockwise or counterclockwise rotation, at any speed. . . . This is not a stereophonic sound but an entirely new aural experience."[147] Belson's films and the theatrical environments that he created with Jacobs are important in the context of Eno's *77 Million Paintings* because they represent some of the first attempts to integrate sound and visuals as an immersive experience.

To supplement the historical material, Eno also created new imagery aided by the computer; a twenty-year-old inked and painted image could be juxtaposed with a digital one made just weeks ago. "The avant-garde became materialized in a computer," Manovich postulates about the technological shift. "One general effect of the digital revolution is that avant-garde aesthetic strategies came to be embedded in the

commands and interface metaphors of computer software."[148] Nowhere is this more evident than in *77 Million Paintings*, which highlights the collision of old and new, analog and digital, hand drawn and computer rendered, all existing cheek by jowl. Owing to the software, it is impossible to predict which four images will come together at any one time, which images will appear on adjacent screens, and which images will precede and follow. As Eno acknowledges, "I love to see its history written in there as well. I like to see some of the earlier decisions. Instead of seeing a thing at one moment in time, like a snapshot, you're seeing like a tunnel in time: you're seeing it having progressed through a period."[149] In remaking and remodeling old and new work, the installation stands as something of a retrospective of Eno's visual trajectory; it borrows from both the frame-by-frame sequential condition of film and the layer-on-layer atemporal condition of computer imagery experienced simultaneously as both synchronic and diachronic structures.

If, for the modernist artist, the trope of originality served as a birthright, for Eno originality is itself something to be questioned. With *77 Million Paintings*, he set out to dismantle the cherished notion that originality is a core tenet of artistic practice, a position that had its seeds planted as far back as his Ipswich education under Ascott. Through the digital medium, Eno challenges the notion that a reproduction is further removed from the authentic original.

> It is precisely a computer's ability to clone exactly that is at the centre of this piece and to understand it we must re-examine what we mean by an "original." If traditionally an original piece was unique as an object, *77 Million Paintings* uses the uniqueness of a passing moment, which has almost certainly never existed before. It is a passing mood, a configuration of elements, which settles before moving on to something else. The transient nature of this ever-changing piece, acts on memory and the immediacy of experience. . . . Evolution and organic growth dictate the life of this piece and we can only accept its presence and watch it unfold.[150]

Originality has long been celebrated as the apotheosis of artistic achievement. Marcel Duchamp's *Fountain* (1917) leveled the first serious critique by introducing the concept of the readymade thereby suggesting that "an artist is somebody who creates the *occasion* for an art experience" (fig. 60).[151] Once unleashed, this challenge assumed various guises in the hands of successive generations. Pop artists such

fig. 60
Eno lecturing at the
Museum of Modern Art,
New York, 1990.

fig. 60

as Roy Lichtenstein and James Rosenquist used the appearance and techniques of mechanical reproduction as a conceptual filter to critique notions of authorship, duplication, copying, and graphic reproduction (fig. 61, 62). This critique would reach its apogee in the 1980s in the work of "appropriation" artists such as Sherrie Levine. With the transition to the digital world, and its copy-paste mentality, these issues are becoming ever more complicated. The idea that digital files are just a series of binary numerical codes that can be endlessly copied would seem to render the idea of originality more precious as a conceit. Yet

fig. 61

fig. 61
James Rosenquist, *House of Fire*, 1981, oil on canvas, 78 x 198 inches. The Metropolitan Museum of Art, New York, New York, Purchase Arthur Hoppock Fund, George A. Hearn Fund and Lila Acheson Wallace Gift, 1982 (1982.90.1a-c).

fig. 62
77 Million Paintings, 2006–12, screen capture.

fig. 62

for Eno quite the opposite is true. He writes, "The original in art is no longer bound up in the physical object, but rather in the way the piece lives and grows. It is moving in time and each moment is an original."[152] Indeed, as Manovich writes, a shift in media creates a paradigmatic shift that has the "potential to change existing cultural languages."[153]

As with *Crystals* and *Music for White Cube*, the audio component of *77 Million Paintings* consists of layered prerecorded tracks that play in and out of sync to create a generative interpretation from a fixed framework. The tracks themselves are lengthy and, when played in varied combinations, are seemingly infinite in compositional possibilities. Eno states, "The technical problem involved was trying to make a piece of music which I would never hear and could never predict. Obviously,

I have never heard this piece of music properly—maybe only for 300 hours, but that is only perhaps for 3% of its life."[154] He cites the ubiquitous wind chimes dangling from your neighbor's front porch as an example of a generative system but one that is limited in terms of compositional control to the choice of notes that make up the pattern. The advent of more advanced computer technology—and with it the rise of sampling and sequencing—has revolutionized recorded music. For Eno, it has paradigmatically shifted the musical experience.

> Until 100 years ago, every musical event was unique: music was ephemeral and unrepeatable and even classical scoring couldn't guarantee precise duplication. Then came the gramophone record, which captured particular performances and made it possible to hear them identically over and over again. But now there are three alternatives: live music, recorded music and generative music. Generative music enjoys some of the benefits of both its ancestors. Like live music it is always different. Like recorded music it is free of time-and-place limitations—you can hear it when and where you want.[155]

There is no length of time specified to spend in front of an artwork. Common sense dictates that the longer one spends looking, the more familiar one becomes with it. Eno's work challenges this assumption. A viewer can never experience *77 Million Paintings* in its entirety. It is almost a certainty that the same combination of images will never be seen and the same arrangement will never be heard. The slowly changing images trigger a focus on the act of looking yet seemingly rebuff that focus with their glacial pace of change. Indeed, the nature of the work demands a different experiential engagement as it oscillates between the conditions of painting and those of film. Eno explains, "I like to see a painting on the wall and I like to look at it. I can stay for as long as I want and then get on with what I am doing, then I can go back to that again and then get on with what I am doing again. So I want to make music that has that condition of being almost static but not completely so."[156]

Like the aspirations for his music, *77 Million Paintings* allows the listener to drift in and out of the landscape that Eno paints, "It's a bit like you're sitting at the riverbank, watching the subtle changes of the river."[157] In its temporal exploration, the work amplifies an interest that is widely shared by other contemporary artists. Works such as Douglas Gordon's *5 Year Drive-By* (1995), Michael Snow's *Sheeploop* (2010), and Christian Marclay's *The Clock* (2010) challenge narrative time with

durational inaction. While traditional cinema was unique among the arts in its ability to capture time, in the hands of contemporary artists like Eno, narrative time, form, and content are challenged by a meta-narrative on the structure of real time.

Where Sounds Become Visual and Visuals Become Sound

Like the artists, filmmakers, and lighting designers who came before him, Eno has established a dialogue that repositions the relationship between sound and image. He is interested in the convergence and blending of disciplines, media, and content. Eno has never looked to the traditional art establishment for answers or approval but has instead turned to a wider set of philosophical experiences, questions, and concerns to build on his thinking and working methodology. He is part of a rich history of contemporary artists, writers, and thinkers whose ideas add to the discourse on sensory perception. Using light, color, sound, movement, and physical space, his work expands our experience of visual and auditory stimuli.

Eno's videos, stand-alone works, installations, and environments reshape the audience's relationship to music and visual experience. He refutes a traditional object-subject dialectic in favor of an experiential condition: "Art is a transaction between somebody and something rather than the quality of an object. When we engage in this transaction we let down certain psychic defenses, allow ourselves to become party to something that we don't completely understand—an emotional power or an intellectual power that we lose ourselves in."[158] His works represent a nonnarrative, nondiscursive mode of expression that transcends language. Throughout the decades, it has stimulated an altered state of experience and questioned the role of the artist and the notion of creativity.

Eno's oeuvre is rooted in the relationship between a work's physical manifestation and the viewer's perception. Ultimately, this dialogue compelled him to abandon the production of discrete objects in favor of environments. They subtly reveal the complex interplay between individual perception and artistic creation, as well as visual and auditory perception. Eno's visual work has paradigmatically reconfigured the boundaries between light, space, sound, and art, echoing his accomplishments in experimental music. Both continue to evolve and prompt new thinking and ideas. As Eno himself says, "One of the great breakthroughs of evolution theory is that you can start with simple things and they will grow into complexity."[159]

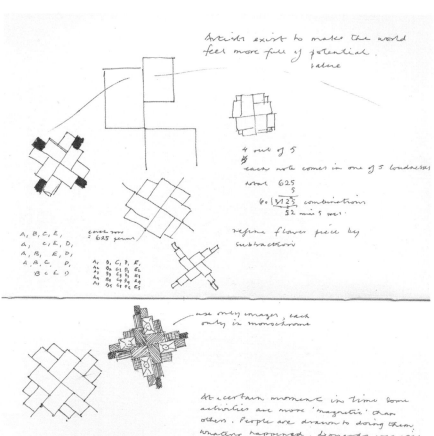

Artists exist to make the world feel more full of potential.
value

4 out of 5
each note comes in one of 5 loudnesses
total $\dfrac{625}{5}$

$60 \overline{)3125}$ combinations
$\dfrac{}{52 \text{ min } 5 \text{ sec}}$

refine flower piece by subtraction

$A, B, C, E,$
$A, C, E, D,$
$A, B, E, D,$
$A, B, C, D,$
$B c E D$

each row
= 625 perms

$A_1 \ B_1 \ C_1 \ D_1 \ E_1$
$A_2 \ B_2 \ C_2 \ D_2 \ E_2$
$A_3 \ B_3 \ C_3 \ D_3 \ E_3$
$A_4 \ B_4 \ C_4 \ D_4 \ E_4$
$A_5 \ B_5 \ C_5 \ D_5 \ E_5$

use only images, each only in monochrome

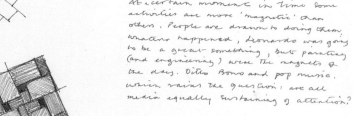

At a certain moment in time some activities are more 'magnetic' than others. People are drawn to doing them whatever happened, Leonardo was going to be a great something, but painting (and engineering) were the magnets of the day. Ditto Bono and pop music. which raises the question: are all media equally sustaining of attention?

intelligent potatoes

clean trunks
ceiling → trees → lights
vermiculite →
lights

BOZAR

347

77 Million Paintings, 2006–12 (various installations in progress)

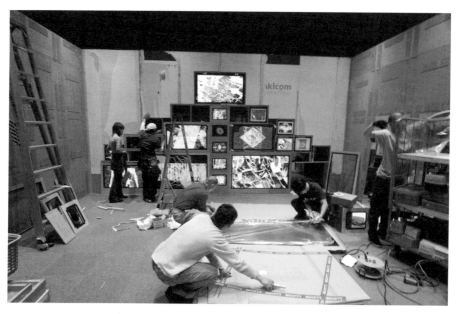

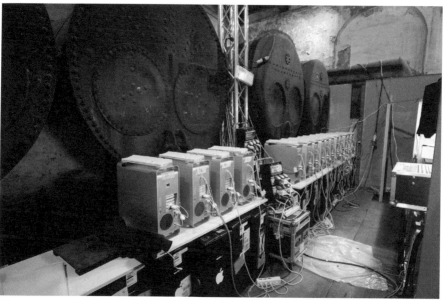

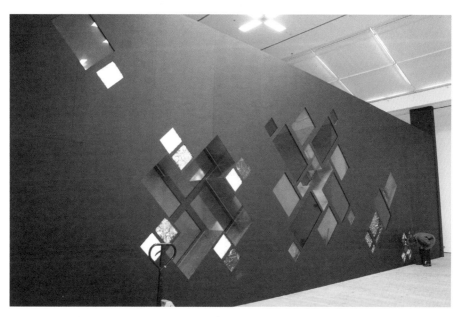

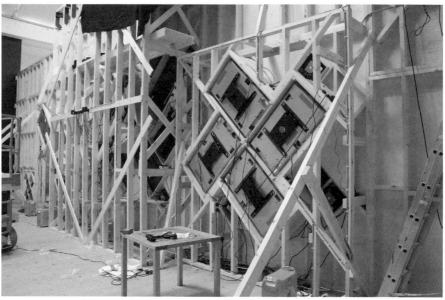

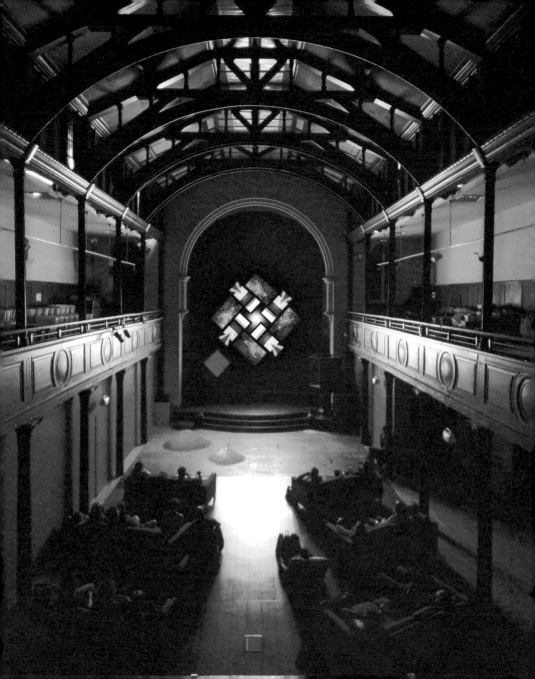

77 Million Paintings (details), Wattens, Austria, 2007
OPPOSITE: *77 Million Paintings*, Brighton, England, 2010

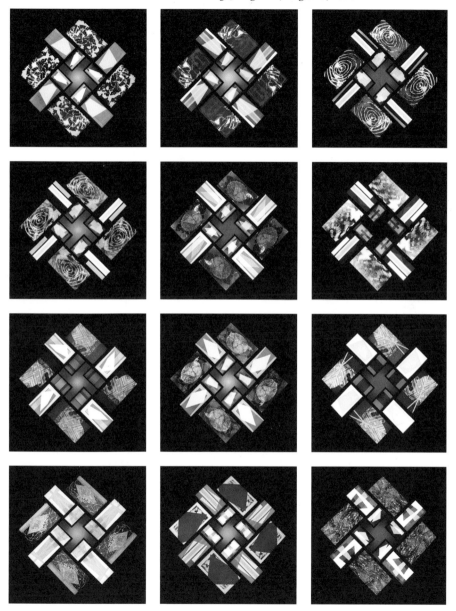

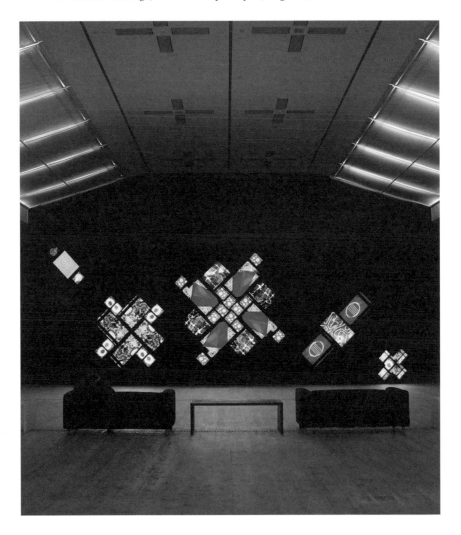

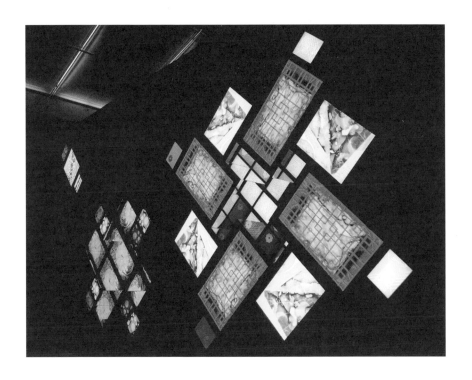

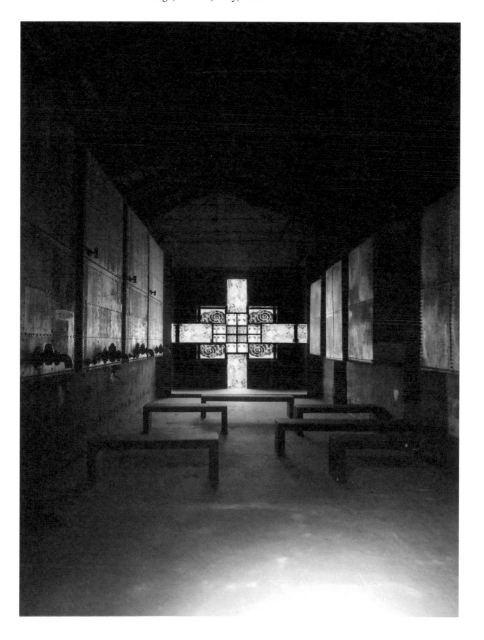

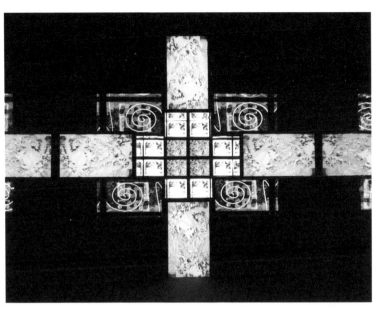

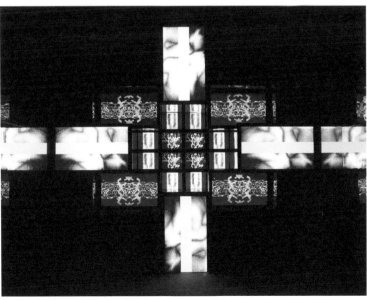

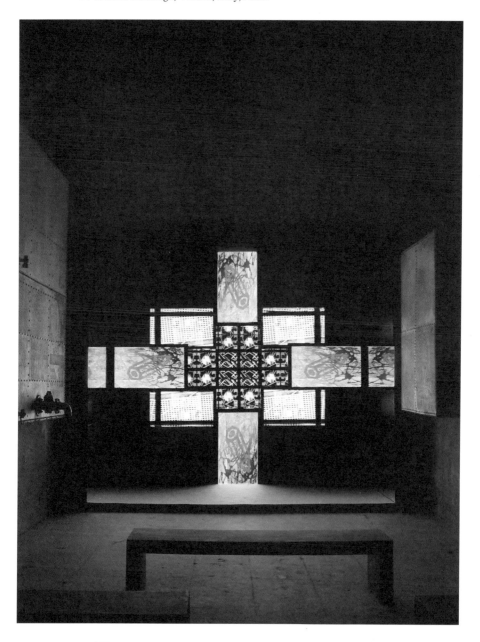

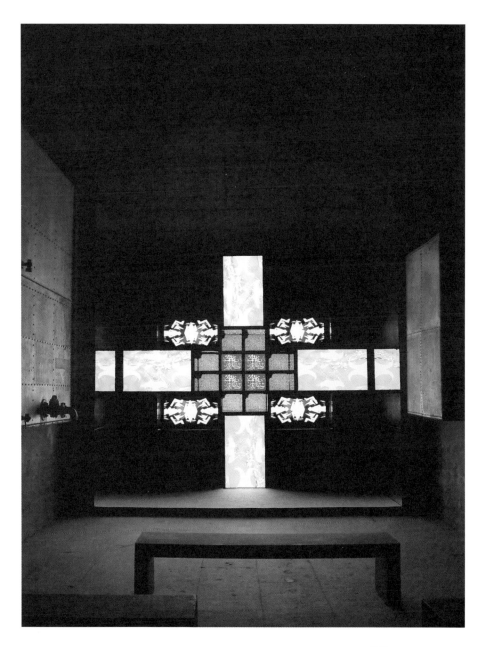

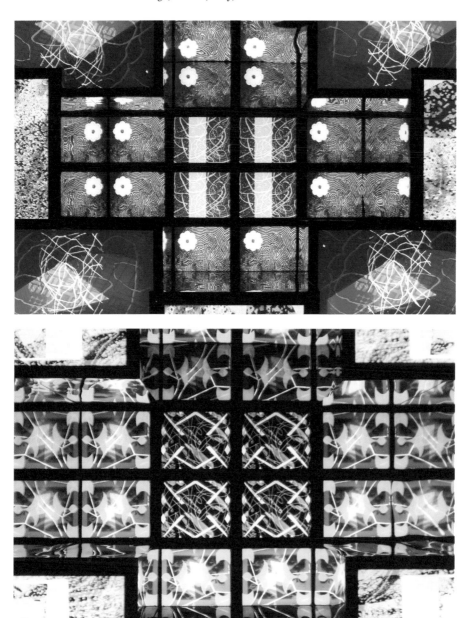

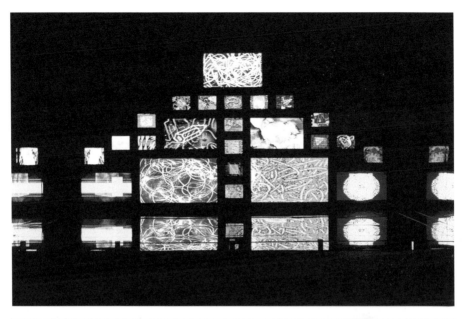

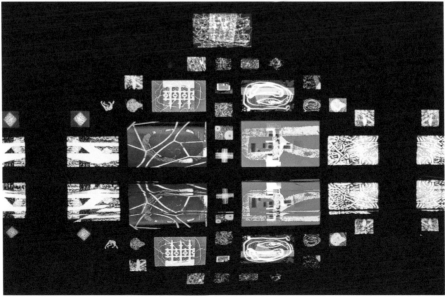

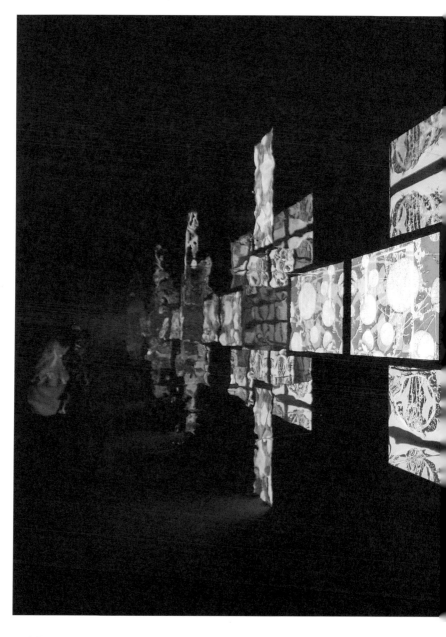

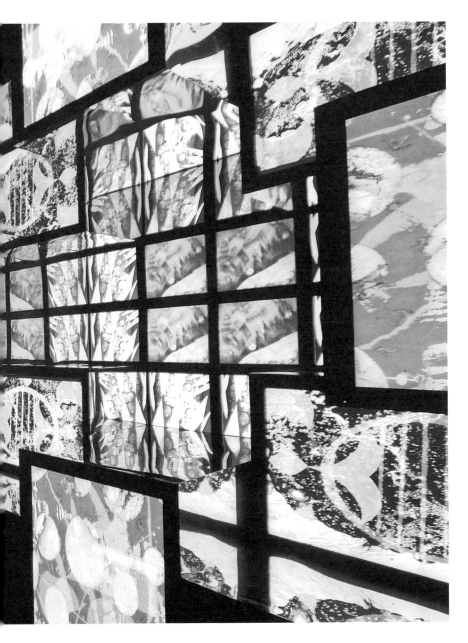

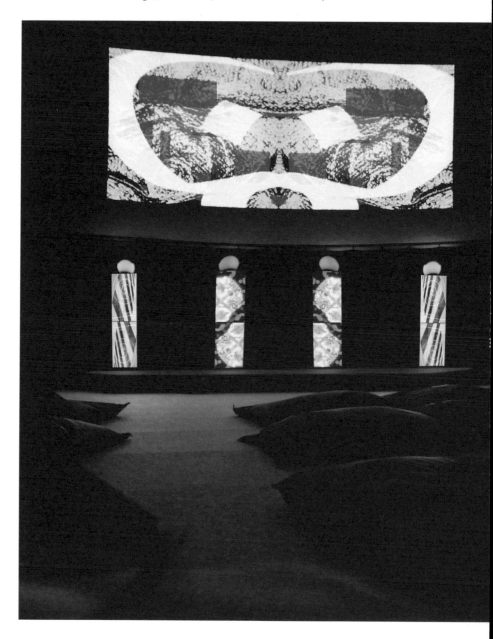

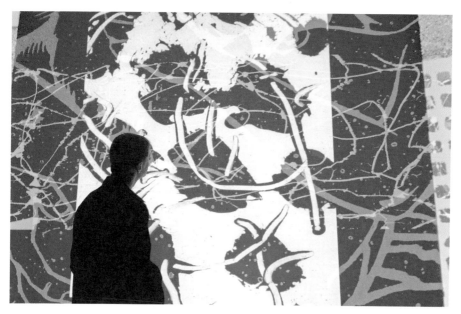

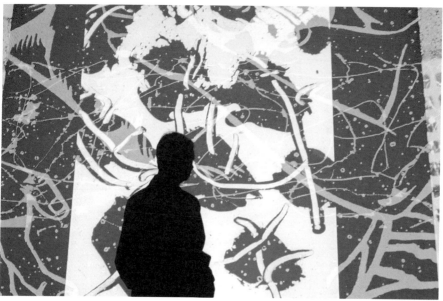

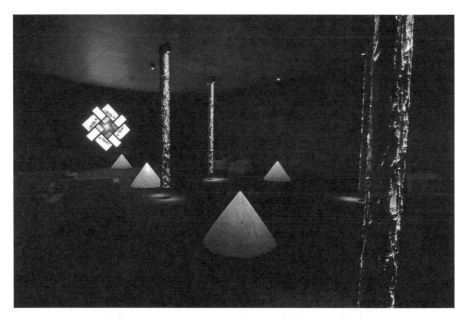

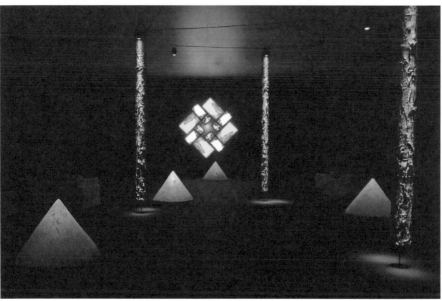

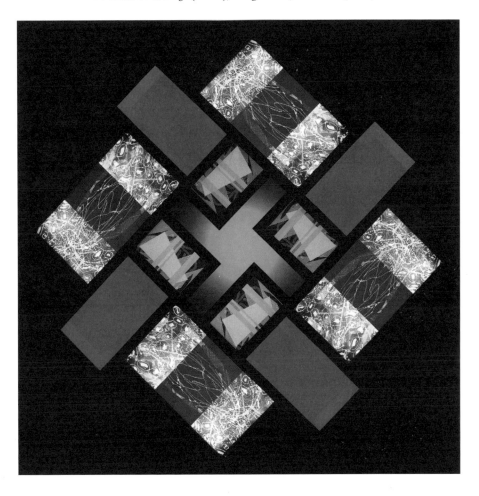

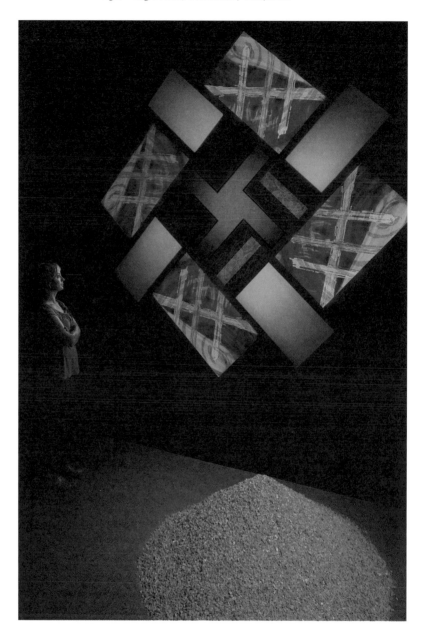

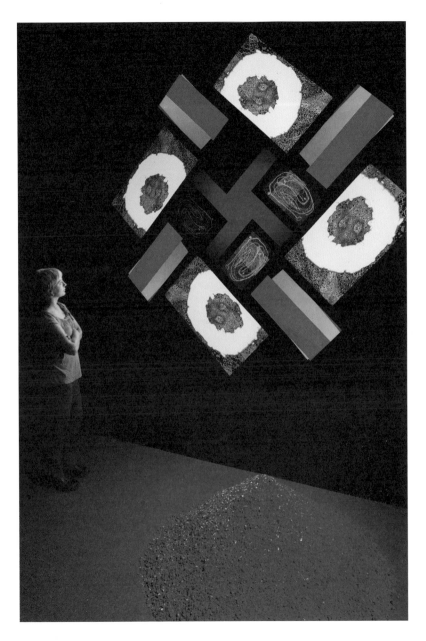

371

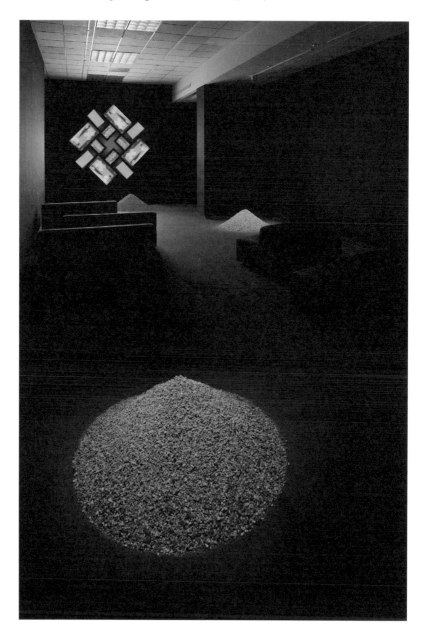

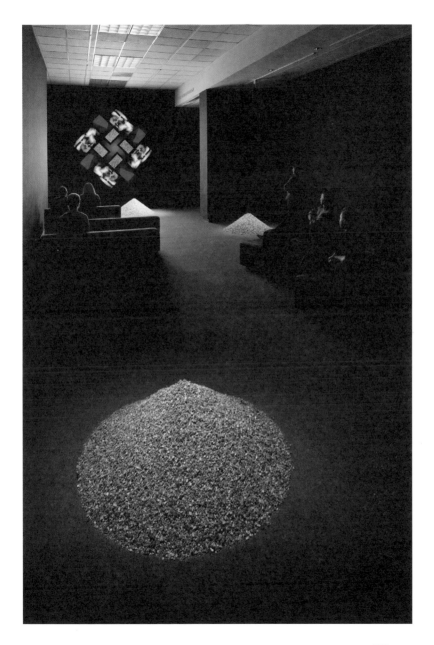

77 Million Paintings (screen captures), 2006–12

A CONVERSATION BETWEEN WILL WRIGHT AND BRIAN ENO

JULY–AUGUST, 2012

Will Wright: When you think of generative systems you think of things that are pristine, mathematical, very, very simple rules. It seems like so much of our intelligence is basically searching for patterns, right? And it seems even music, I've heard one of the theories of music is setting up an expectation of a pattern in your head, but then it breaks that pattern in an unexpected, interesting way and that's what we tend to find musically pleasing.

Brian Eno: That's definitely part of what's going on, yes. And for that to be the case you have to be able to sense what the system is. This is why free jazz is quite hard to listen to—there's not really a pattern of expectation built up—and it's also why a lot of attempts to generate music from randomizers haven't worked very well. There isn't a matrix of expectation which you can move away from or resolve back to, on the other hand. You're either moving away from it, which creates tension and excitement, or you're resolving back to it in which case it has a sort of satisfying completeness. If you're not aware of the matrix at all it just doesn't make much sense.

WW: Yes, it seems like a very, very thin line to surf.

BE: Yes, yes it is, I think. And I suppose it is a line that changes in time as well, although people are very reluctant to admit this about art and culture. Objects of art and culture can lose their power over time, some of them very quickly and some more slowly. Not everything is going to last forever, because if the pattern of expectation has been broken enough times, it's not actually very interesting to hear it broken again; it's become part of the expectation, so it's not breaking a rule.

WW: Do you think our aesthetic sensibilities are linked to the idea of generative systems? In other words, do you think the amount of underlying algorithmic patterns might be connected to what we call beauty?

BE: This is not a type of language in which the arts are usually discussed, but the discussion of the arts has generally produced such dismal results that a change of language is long overdue.

One of the things I think we respond to is a sense of magic. Magic is what happens when something apparently simple and predictable suddenly turns out to be complex and unpredictable. You thought it was just a hat, but—amazing!—there's a rabbit in it. A lot of art seems to work like that: it seems to make us have feelings much stronger than we would expect to have given the situation. We can see the ingredients: paint, musical tones, words—and we've had a lot of experience of them. How could any new configuration surprise us? And yet sometimes it does.

I think we're all unconsciously paying attention to the algorithms being used to generate things, and we're fascinated when what gets generated is beyond what we would have expected from that algorithm. John Conway's *Game of Life* is a very clear example of this, it is entirely deterministic and yet it behaves in a way that is (at least to humans) unpredictable and counterintuitive. I think this happens—in a less clear way perhaps—with much art. We know we're just looking at brush marks on canvas or hearing vibrations in air and yet occasionally we are taken somewhere quite unexpected.

WW: In some sense it feels like that's the "magic" of all symbolic expression. A string of words turning into philosophy or poetry, a set of numbers and equations turning into a concise mathematical description of physics. It's almost as though by appreciating how simple components can work together to encapsulate great complexity we are paving the way for the reverse process, parsing that complexity back into simple parts. Do you think that's perhaps the primary way our brain is wired to work? . . . to attempt to reduce every experience and observation into the most concise form possible?

BE: I like this idea. I think a lot of our art experience is rehearsal, a flexing of cognitive muscle. I think we get a thrill from being presented with things at the edges of our experience and

watching how our brains perceive it, parse it. We like to watch ourselves think and feel. We like to be presented with new things to have feelings about. We like to be surprised at our own feelings.

I very clearly recall the first time I saw a Mondrian painting. My uncle had a tiny volume in some sort of Art of Today series published in the late '50s. One of those was dedicated to Mondrian and I recall the shock and thrill of seeing those archetypal pictures for the first time. There were two feelings intermingled: "*Wow!* I love those pictures" and "What is it that I am loving? How is it done?" The questions were as big a part of the experience as the feelings. The questions were feelings, actually.

The pictures said to me, among other things, "You never knew you could have an art experience over something like this, did you?" and I wondered (still do) what I was feeling and why I was feeling it.

Every art object is really a package of possibilities for a kind of world that could exist. Mondrian to me felt like someone celebrating a progressive vision twentieth century, a world of clarity and transparency with a certain joy in the interaction between humanity and machinery.

Similarly when we make algorithmic art we are celebrating (or actuating) a world in which we accept the primacy of instruction sets, of rules and processes, of code, and emergence. When we enjoy such art we are rehearsing living in such a world, and getting a feeling for our relationship to it. Every art experience is an immersion in a set of ideas about how the world could be, and a chance for us to see what we feel about it.

This for me is the difference between art and science. There have been so many attempts to unite them—idealistic and well-meaning attempts by people who think artists and scientists are intelligent, creative people and, therefore, they ought to be able to make things together. In fact that very rarely happens; for when something is good as science, it is rarely good as art and when something is good as art, it is usually trivial as science. I think this is because art and science have a fundamentally different intention. Science wants to

know about this world here, this real world, this one and only world. Art on the other hand wants to constantly invent new worlds, new scenarios in which to test our feelings about things.

WW: Generative systems have been used in many different art forms. How would you compare the challenges of harnessing algorithmic processes to visual forms versus musical forms?

BE: They are remarkably transferrable. Since algorithms generally are specifying procedures rather than forms, they are versatile and transferrable across different media. For instance, the algorithm "take two cycles of different durations and let them run against one another"—which is the basis of a lot of Steve Reich's work as well as a lot of mine—can apply as easily to both visual and musical art.

The word that has been used in art circles in place of *algorithmic* is *procedural*, but I think they mean essentially the same thing. The idea is that you think about the process of making something in terms of what procedures you use to cause it to come into existence. These procedures become the focus of your attention at least as much as the specific nature of the results.

WW: It seems as though our brain must process time-based media (music, video, narrative) very differently than other media (static visual forms). Do you think somewhere deep inside the two types are converted to some compatible format? Do you think we build a "map" of a song once we hear it so that we can consider and appreciate the entire song as a whole?

BE: I'm not sure about internal conversion. I tend to think that the formal elements that distinguish an art experience we really like from one that leaves us stone cold can be very tiny. Why do I like this Flemish painting better than that other one? Would a martian or a machine (or a Mongolian) be able to see any difference between them at all?

I'm often thinking of those terrible home disco lights that divide the music into three

bands—highs, mids, and lows—and then assign a color to each band. The result is some kind of conversion but one that makes no sense to our brain. We don't listen to music as a sequential experience of high, mid, and low frequencies . . . for instance a semitone shift we might hear in a melody and which might be the whole dramatic center of the song entirely escapes such a conversion.

Similarly I've seen attempts to "read" paintings musically—to convert the visual forms into sonic ones. When these work as music, it is because the composer has dealt so liberally with the initial information that the conversion might as well have been random. What this says to me is not that algorithmic transformations don't work, but that you have to be very careful about what you use as inputs to any algorithmic compositional system. Certainly one reason that Steve Reich's "It's Gonna Rain" is so powerful is that it's built around, or rather built of, a voice full or power and pathos and history and anger and yearning. . . .

When I first started working with generative musical systems I thought there might be a way of "training" them . . . forcing the systems to evolve by, for example, pressing a button whenever a bit happened that I particularly like (this is evolution with me as the environment) and then replicating the conditions of that moment. The problem with this is that it is very difficult to know in music, how much of the history of the moment you like is part of the experience. For instance, the semitone shift I mentioned [earlier] is only dramatic because a mesh of expectation has been set up within which it is "unexpected."

So, yes, I do think we hear songs as whole objects with their own internal rules, and, yes, I think we look at paintings the same way. The difficult part is knowing at what level conversion is possible or fruitful. As I said, the algorithmic level is promising.

WW: The concept of emergence is closely linked with generative art. As a result, working in this area seems to be much more about discovery and exploration rather than design and composition.

As an artist do you feel that you need to take a fundamentally different approach to creativity when working in these areas?

BE: The difference in approach is really a difference in what you think an artist does. Classically, the artist was the person who specified every detail of something—painting, building, or symphony. Generative art is quite different in that what the artist is specifying is (a) how the generative process will work, (b) what the inputs to it will be, and (c) whether and how the landscape in which this happens will be allowed to have an effect on the outcome. I like to make an analogy with gardening—the generative artist is somebody who is making seeds, which, when "planted" will flower in different and individual ways depending on whatever the circumstances happen to be. This is in contrast to the architect, who, in classic Frank Lloyd Wright style, wishes to design every teaspoon and tile in the building.

WW: Is the difference in approaches such that the direct designer is trying to hit a specific target or destination (in their creative imagination) while the generative designer is exploring using a "creative" compass?

BE: Yes, that's an important distinction. It seems to me you have to think about algorithmic art as a process of bootstrapping your own tastes; you design something to evolve beyond the parameters of your aesthetic, to pull your tastes somewhere they haven't been before.

WW: I think this is very relevant because we have these cultural patterns that we are raised with or have become very familiar with, but again there's always novelty, new things coming up, fads, whatever, that are kind of playing off the old patterns, right?

BE: Yes, exactly. Well, there's also the astonishing fact of context change, so that something that has been done to death for a decade disappears for two decades, and then reemerges shiningly

new in a new context and suddenly has a completely different meaning. So that's the way in which things can keep alive, actually. They come back and we hear them differently. We don't think of them in the same matrix as we did the first time around.

WW: So I guess it's like these nested systems embedded in each other and you can take the core out of one nest and when it has a different shell around it—it has almost a different harmonic.

BE: Yes, yes exactly, that's right. Exactly. Do you know that phenomenon called fundamental tracking? Have you ever heard of that?

WW: No.

BE: It's the explanation for why you can hear music on a telephone. You're not actually hearing anything below, I don't know what it is, 200 cycles or so, so all of the bass information is missing, all of the fundamental notes of the lower instruments is missing, but there's this thing called fundamental tracking which is when you hear a set of harmonics in the range that you can hear on a telephone your brain quickly computes what the fundamental must be and says "oh yes, that's a bass guitar." So you're not hearing any of the bass part of the bass guitar at all. And I think something similar to that happens with culture. After a little while you only need to hear a little bit of something, a little sliver of something to pick up all of the deeper resonances of it; your brain fills it in very quickly. So for example, if you see a piece of film and it's black and white and a bit jerky and scratchy you know you're in the '40s or the '50s or something like that. You suddenly have all of the associations of that time with that piece of film and I think that's something we're incredibly good at, picking up those kinds of clues. And of course artists work with that knowledge; a filmmaker knows that by desaturating to black and white, you the viewer are immediately framing what you see in terms of another time and reality.

WW: I've heard that even in regular conversation you actually only understand and hear about half the words, but your brain fills in from context and grammar, you know, and you think you've heard all the words.

BE: Yes, that's quite alarming, isn't it! It makes you wonder how much you are filling in. Are you hearing what the person said?

WW: Well it makes misunderstandings so much more explainable. Have you ever heard of this area of research called Inattentive Blindness? These are mostly visual experiments where your brain is expecting or focusing on one thing and other things that should be totally obvious to you are totally invisible—you become blind to things.

BE: Ah, I know that one experiment with the gorilla.

WW: Yeah! Exactly, exactly. That's a good example of it.

BE: That's so funny, and when I saw that and fell for it like everybody else I didn't see the gorilla.

WW: Yeah, almost nobody does and it's amazing when you go back and first you think you were fooled and it's a different video, but no it's the same video. But it's amazing that your brain can trick you that thoroughly or just be that blind to something.

BE: Oh, it's completely alarming. The other thing is that there's been a series of ads here in England on the tube system and they just have a long, long text, it's sort of a long paragraph and every single word has all the letters mixed up except for the first and last letter, and you can read it at normal reading speed. It's fantastic that you can do all of that filling in without any hesitation at all.

WW: Yeah, the brain is such an amazing thing to hack, in a way, and it's funny with all of these hundreds of years of study it feels like we still haven't a clue as to how it actually works.

BE: Yeah, I mean you think of actually trying to create any type of machine that could do that. It's so beyond what we can do, as far as I know—guesswork, really, filling in intelligent guesswork.

WW: So what have you been working on?

BE: I think I've made the first sort of serious step forward in generative music in quite a few years. I've just been working on a piece for a palace in Turin in Italy. And I've made a piece that I'm really very pleased with, it's the best thing I've done in a long time, I think. And that's a piece that started out as generative and in fact it was made generatively and then I fixed it at a certain point and then started working on the fixed version—wring on it in the way I'd work on a song, as a distinct piece with form and structure and duration. And so, I don't know quite what sort of biological model that is, where you suddenly say, okay, stop evolving. That's the one we're going to breed from.

WW: Well, artistically it sounds like a collaboration. So it's like a collaboration between you and mathematics or . . . How is it generated?

BE: Yes, you're right. That's a good way of putting it.

WW: Was it a mathematically generated system?

BE: Well, it partly is. There's a combination of generators going on, so part of it is mathematics, but it's very simple mathematics. I'm working with a limited palette of just seven notes that are used throughout the piece and in each section of the piece—there are twelve sections—I use only five of the notes, if you see what I mean, so there are twenty-one possible distinct five-note groups in a set of seven notes. In this piece I use just twelve of those groups. It's been very interesting to me finding out what a different personality this group of five notes has compared to the next one, which may have only one note changed. It's amazing what a different emotional personality each one has. So that's the other thing about this piece,

it's a generative piece in origin, but it has sections which generative pieces don't usually—generative pieces usually are fairly flat in the sense that they don't go very far. Oh! And I've got a new thing coming out; I've got a new app coming out. You must see that, that will be in about three or four weeks' time. In fact, quite a lot of the app was based on experiments we made for *Spore*, actually. And so this is a new thing.

WW: Cool! What's it called?

BE: It's called *Scape*.

WW: Okay, and it should be out in a few weeks?

BE: I think about four weeks. Four to six weeks. It's a really good one, I think. I often get asked for film soundtrack music and I thought "I wonder if I could think of a way of generating film soundtracks pretty reliably, some kind of generative tool?" So Peter [Chilvers], with whom I worked on *Spore*, and myself have come up with this one which has some very interesting secret rules built into it. There are all these probability matrixes which say if *a* and *b* are happening, then *c* cannot happen, if *c*, *d*, and *e* are happening then *f* must happen, and if this is that long, then this one has to be very short, and so on and so on—rules that are built in underneath the bonnet of the system that actually make it a lot more musical.

WW: What are the inputs? Are the inputs dramatic inputs?

BE: So what you have is a toolbox, essentially, of about a hundred different types of sounds, usually a range of sounds under one heading. One group of sounds might be thought of as "meteors," long dopplered sounds that sit high above the piece. Another group of sounds are "grounds," constant and drone-like, backgrounds. Then there are "airs," thinner and grainier sounds that occupy the mid to top range, and so on. What you do is you move these things onto a surface and they start performing with each other according to the

internal rules that they have, but those internal rules are not revealed. You only find out what they are by playing with them.

WW: So is it sort of like improv where you are putting characters on the stage and then see what happens?

BE: Yes, that's right, you're putting characters on the stage and then you see what they do together. So you can keep moving things around if you want, but ideally what I find myself doing is putting a few things in place and then seeing what they do. They behave in quite complex ways in relation to each other. That's quite a new step in generative music as well.

WW: Yeah, it sounds like a step towards something I've always wanted, which is a soundtrack for my life.

BE: This is what you need.

WW: A system like that will basically have some awareness of what is going on around me, kind of like the game I'm working on now. We're trying to build a very deep awareness of what's happening on your day-to-day, minute-to-minute, hour-to-hour life. And if you had the right inputs for that you could then generate an appropriate soundtrack for scoring your life for your just average day.

BE: Well, actually we're thinking of . . . This current one doesn't really pay attention to what's going on, other than what you are doing to it. But we've been thinking of doing a follow-up version of this where we start to incorporate quite a lot of other information that the iPad can pick up, like where you are, for example, who you are, what choices you've made before, so we're thinking like that for our next one.

WW: Yeah, we've been looking into a lot of mood-tracking things where there are different technics you can use to try to discern a person's mood. And then you think about all of the automatic sensor and data collection you have, location, time of day, weather, that kind of stuff. I think we're right on the verge of being able to do that.

BE: How do you do mood tracking then? Are you checking temperature and things like that or . . .

WW: No, it's more a bit more psychological where we'll present simple little things, almost like psychological tests where you choose an image out of five images, or you have a word cloud and you're clicking on words, and we compare it against your previous behavior. We try to build up a long-term profile where we get a sense of who you are, what you typically pick, what you pick when you're sad or happy, but we try to make all these minigames so it doesn't feel like you're sitting there taking a test but you're actually completing these little minigames, but embedded in these minigames is a more subtle, psychological mood-tracking thing.

BE: That's very clever. It's a good idea, yeah. And so presumably you can't make very fine deductions about people beyond the fact that you can tell that they are impulsive or thoughtful, or things like that.

WW: Yeah, I mean there's been a lot of different ways to categorize moods but one of the most effective ones turns out to be the simplest, which is a very simple two-dimensional matrix with basically low energy, high energy in one dimension, and then negative and positive in the other dimension. So high energy positive might be elation, or I want to go dance. High energy negative might be anger. Low energy negative might be depression. But basically you can just look at that two-dimensional grid and that's something that's not that hard to track and you could even go within that grid and assign emotions to every spot in that grid. You could also take music and plug it in there. How docs this music make you feel? It turns out that mood can be treated as very multidimensional, but actually this two-dimensional system seems pretty effective for a lot of purposes.

BE: How fascinating, that's really interesting. If we get onto our next recursion of this we'll be looking at that, I suppose. This one, actually, has taken about two years to make. It turned out to be quite . . . it's very subtle, actually. The only thing I worry about is that people might not realize that. It's much more complex than the previous one we did, which was very successful, but this is a much more complicated one. It's not more complex to use, but it's more complex to realize what is actually going on and the temptation is to keep fiddling around with it rather than to stop and listen to it for a while and hear it composing itself.

WW: Is there much in the way of visuals along with it?

BE: Yes, but there's not much motion in the visuals, so you sort of compose a picture which is like an abstract landscape, you know they are sort of mountain-like things, and sky-like things, and so on. So it's sort of like creating a landscape, but a very abstract version of a landscape, and the pictures can be very attractive, actually. So the way we've tried to slow people down a bit is to, well initially like some games, you don't get all the features so when you first get it you get a simplified version of it, and as you use it, it gradually unpacks more and more of the possibilities. By doing that people might realize that even with quite a small number of possibilities there is a very, very wide range of outcomes. I still don't know whether it's a good idea or not. You probably have more experience with that than me. I mean, do people resent having things denied?

WW: I think once again this is one of those things that has a very sweet spot you have to surf. You can go way too slow with that and people get bored or you throw too much stuff in the air and it feels almost random and they don't appreciate it. That's something in my experience you can only discover empirically by testing it and being ready to tune it a lot. There have been some theories of games like that where it's satisfying when it's setting up these patterns you have to discover

and if they're too simple and too easy to discover the game is instantly boring. If they're too complex it feels random to you, and there's a very, very small, sweet spot between the two where you get into this flow state and your brain just loves it. And if you can get to that sweet spot your brain just totally jams on it.

BE: Yes, yes, well I'm hoping we'll find that. Peter has tested it on a few friends and watched carefully to see what they do. It's very, very interesting. As soon as you show something to somebody you see.

WW: That's kind of the new model now for game development that people used to spend several years working on a game, taking their best guess as to what was the right tuning, but now what people are doing is getting the simplest thing out there as quickly as possible, and then they attach metrics and then they observe 10,000 people playing it and hill climb from there. And then they retune it on the fly.

BE: Yeah, yeah, yeah, well that makes sense, really, because otherwise you end up taking a lot of it apart again to get back to a place where people can use it.

WW: Which is probably a general property of generative systems. It's such a large space that a sizeable change in the rule set can put you in a totally different kind of landscape. So really the only way to explore it is a massively parallel search.

BE: Yes, yes, yes, exactly. Well I've started working with this idea, I don't really know whether I got this idea from biology or . . . I call it "chunking up," so making ever larger clusters of things. Have you ever heard that phrase, "chunking up"?

WW: I heard "chunking" in a different context, I think. Is this basically when a set of things only makes sense as a set?

BE: Well, I think I may have made this phrase up because I thought I'd heard it somewhere or read

it in some biological context but I've never met anyone who's actually heard that phrase, "chunking up," so maybe I did make it up. Basically what it means is when I'm working with generative systems now I'm looking at the system generating its output, saying well, that's very nice, that's very nice, ah, now that's particularly nice! So what I sometimes find is a chunk and then make that the beginning of a new generative system. I keep it together as a chunk, and then the whole chunk becomes a single element in another generative piece. It's a little bit like when bacteria first invaded whatever they invaded and we formed cells, from this very complex thing called a cell is really a set of symbioses living together, so it's sort of trying to replicate that process.

WW: There is a kind of biological, computational equivalent to that. You've heard of the term "schema"?

BE: Yes, I know the word, but I don't know what it means in that context.

WW: A schema is when you're discovering almost an abstraction that becomes very re-purposeable, and usually you do it from a large set of examples. So for instance you might go into a restaurant, you've never been into a restaurant before, and they give you a menu, they take your order, maybe this restaurant has singing waiters or something like that, and a couple of other oddball things. But then you go to four or five restaurants and you start noticing a pattern where they all bring you a menu, they take your order, but most of them don't have singing waiters. At some point you start abstracting out the things that are common in all of your restaurant experiences and you start discounting the things that are out of the norm. And what you are doing is you're building a schema, an expectation that now becomes your basic pattern for what to expect in a restaurant. So it is an abstraction that now fits a much more general case that you can use as the basis, now when you want to create your own restaurant you take that schema and now you can start adding unique things to that schema, but that's the very basic pattern that basically all restaurants share.

BE: Yes, yes, I see, yes. That is rather similar to meshing together a lot of elements and realizing in that particular group in that particular configuration that can be a new starting point for you so you're not going back to basics every time, you're going back to what you call a schema. Saying okay, that is where we're going to start this time.

WW: Yeah, and you're starting with a pattern that is proven to have a wide variety of useful offspring. I mean as a kid you, over time, by the time you are three or four years old, you've developed a very elaborate schema of a dog and a cat to the point where you can very easily tell the difference between a dog and a cat, although when you're describing a dog and a cat it is pretty much very similar, but yet the schema distinguishes the two.

BE: Yes, completely, yes.

WW: We talked a bit about how our mind seems to look for an optimum balance between order and chaos. Too much order and we find it boring and predictable, too much chaos and it just seems random and noisy. But somewhere between the two extremes our mind becomes very engaged, searching for patterns in the noise. Why do you think we gravitate to this balance?

BE: I think we have very strong feelings about that particular cusp. We are of course drawn to order—that's what makes life somewhat predictable and makes it possible for us to keep going—but we are thrilled by those moments when suddenly something happens that our sense of order didn't predict. That something has to fall within certain boundaries to be acceptable though, we wouldn't be cognitively thrilled by a sudden and unexpected flood of our house, or by a stroke. We like unpredictability and our body and mind seem to thrive on it, to be excited by it, but we want that unpredictability to fall within safe boundaries . . . and of course art is always

safe (though artists who want to be heroic would not like you to believe that). You can always close the book or leave the gallery or switch off the TV. You don't have to do it, and you know that nothing really bad is going to happen to you if you do. You can have the psychic thrill of novelty without any attendant physical cost.

The other thing about that cusp is that our brains like playing the meaning game. We enjoy things that stretch us a bit. We get bored with things that don't—which is why, as you grow up, you stop doing the jigsaw puzzles that you found so gripping as a child. You either move on to more challenging puzzles or you start looking for different types of challenge. We like challenges, and there are very good evolutionary reasons why we should—the humans who gave rise to us were presumably the ones who made the right calculations about the degree of challenge that was acceptable (assuming that the "play safers" never broke out of their niches, and the "madcaps" got killed early). Everywhere along the line that leads to you there were people assessing risks, and getting it right.

That's the kind of thing that needs a lot of practice, and art is one of the places we go for practice. Children learn by playing, adults play through art.

WW: I love that quote. I think new patterns that surprise us might perhaps represent "growing" our model of how the world works and what can happen within it. Perhaps we find it pleasing to not only refine our model of the world but also to see the range of possibilities expand as well.

Conducted July 20, 2012, by telephone and August 17, 2012, by e-mail.

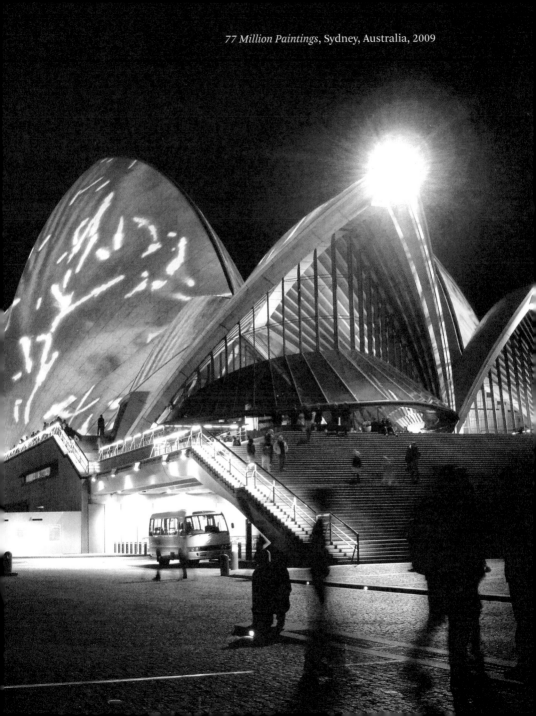

77 Million Paintings, Sydney, Australia, 2009

77 Million Paintings, Sydney, Australia, 2009

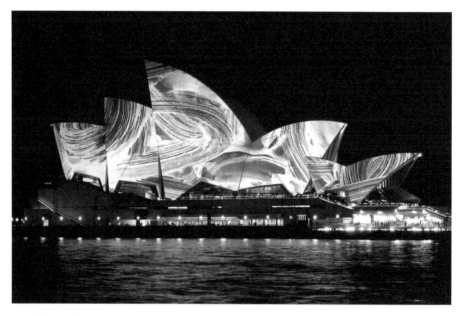

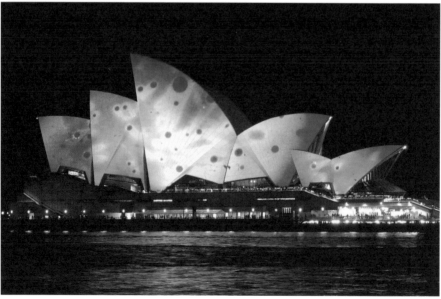

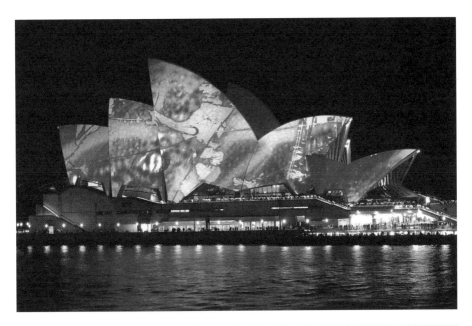

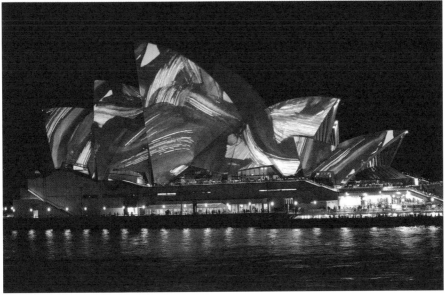

77 Million Paintings, Sydney, Australia, 2009

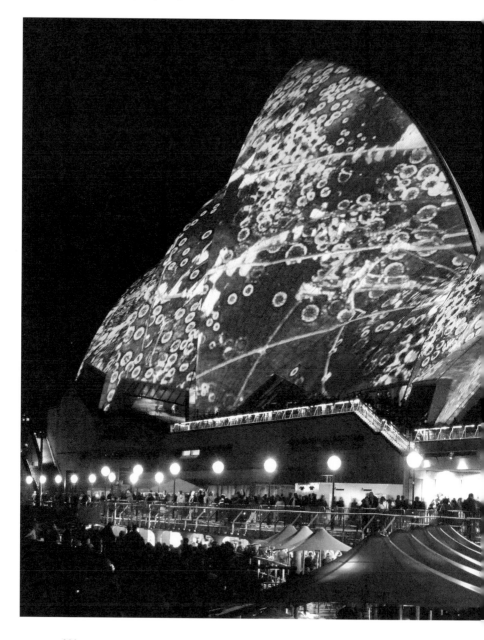

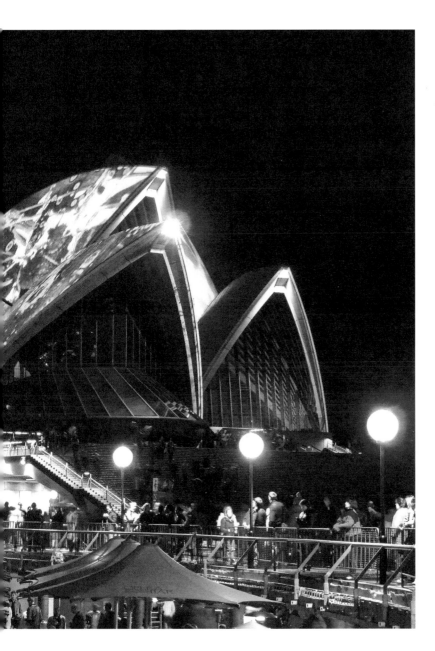

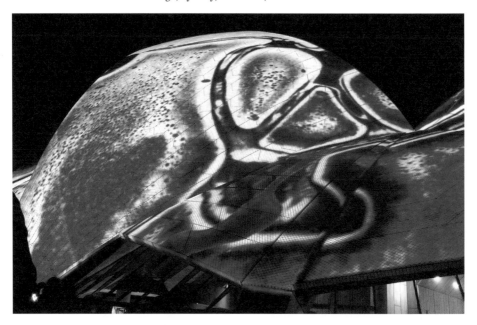

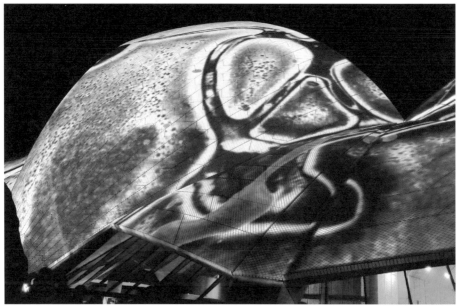

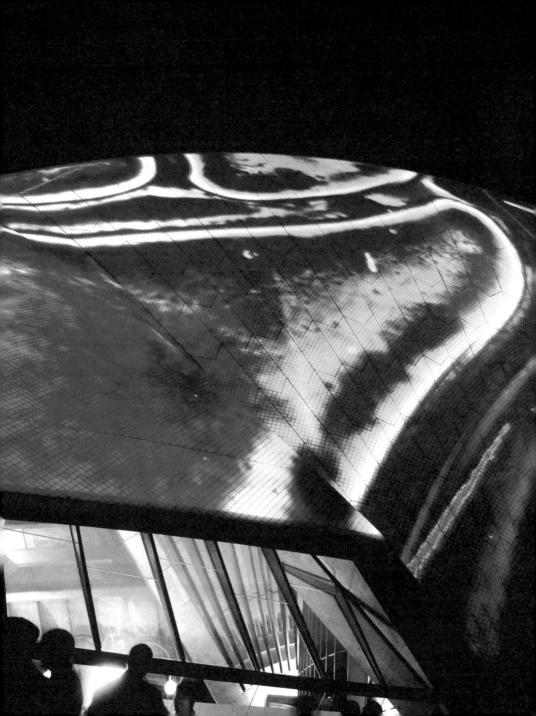

77 Million Paintings, Sydney, Australia, 2009

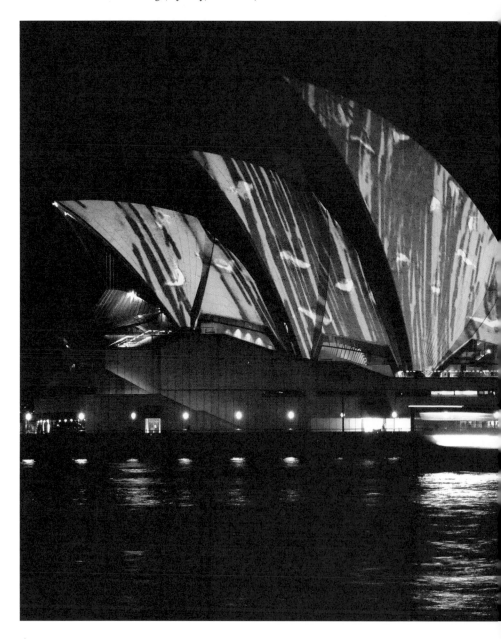

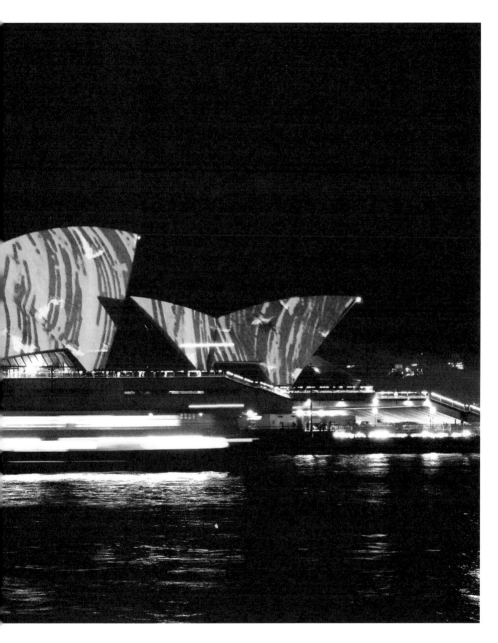

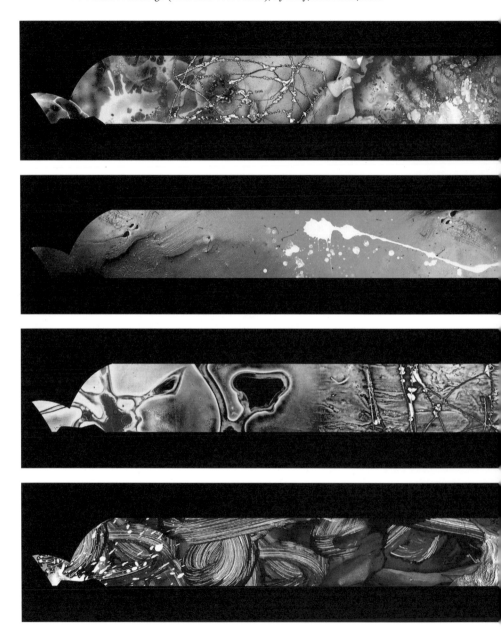

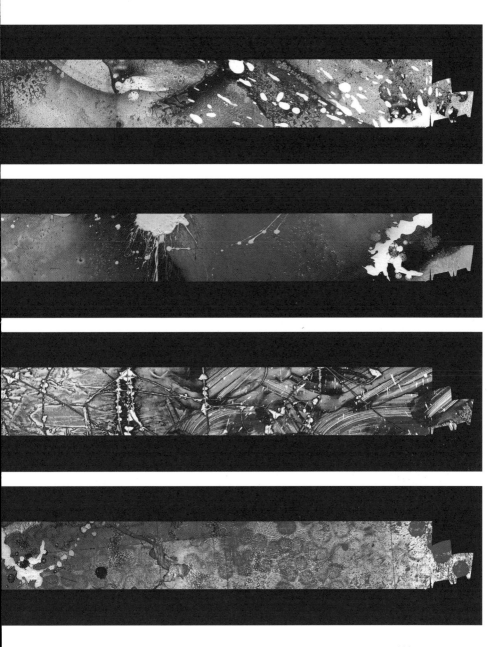

77 Million Paintings (foreground stills), Sydney, Australia, 2009

40. *Untitled, (yellow circle)*, ca. 1964–65, typewriter drawing on paper, Ipswich Civic College, class project.

41. *baroque (etceterart)*, ca. 1964–65, typewriter drawing on paper, Ipswich Civic College, class project.

42. *THE NATIONAL ANTHRAX. ARISE.*, ca. 1964–65, typewriter drawing on paper, Ipswich Civic College, class project.

43. *Untitled*, ca. 1964–65, typewriter drawing on paper, Ipswich Civic College, class project.

44. *Untitled (...)*, ca. 1964–65, typewriter drawing on paper, Ipswich Civic College, class project.

45. *NNNNNNNO*, ca. 1964–65, typewriter drawing on paper, Ipswich Civic College, class project.

47–59. *Permutational Drawings (Square)*, ca. 1966–69, graphite on graph paper, Winchester College of Art, class project.

61–69. *Permutational Drawings (Nodal)*, ca. 1966–69, graphite on graph paper, Winchester College of Art, class project.

70. *testing old wives.*, ca. 1966–69, event score, Winchester College of Art, class project.

71. *simplepiece for two players.*, 1968, event score, Winchester College of Art, class project.

72. *2 projects for a painting.*, ca. 1966–69, event score, Winchester College of Art, class project.

73. *readymade error paintings !*, ca. 1966–69, event score, Winchester College of Art, class project.

74. *cities with multi-level transparent floors.*, ca. 1966–69, event score, Winchester College of Art, class project.

75. *identikart.*, ca. 1966–69, event score, Winchester College of Art, class project.

76. *film 3.*, ca. 1966–69, event score, Winchester College of Art, class project.

77. *A positive Use of the Puddle.*, 1967, event score, Winchester College of Art, class project.

78. *series 1 (do nothing until a mistake is made)*, 1968, event score, Winchester College of Art, class project.

79. *series 2*, 1968, event score, Winchester College of Art, class project.

80. *first performance of 'do nothing until a mistake is made,'* 1968, performance ephemera, Winchester College of Art, class project.

81. *.switch on tape recorder.*, ca. 1966–69, event score, Winchester College of Art, class project.

82. *self-regulating drawing tactics.*, ca. 1966–69, event score, Winchester College of Art, class project.

83. *Untitled (two performers)*, ca. 1966–69, event score, Winchester College of Art, class project.

84. *SONGMAKING SYSTEMS*, ca. 1966–69, event score, Winchester College of Art, class project.

85. *WHEN I RAISE MY HANDS YOU STOP DEAD.*, ca. 1966–69, event score, Winchester College of Art, class project.

86. *Untitled (British Standard Time)*, 1968, event score, Winchester College of Art, class project.

87. *the story so far*, 1968, self-reported evaluation, Winchester College of Art, class project.

88. *examining carefully the corners of my eyes*, ca. 1966–69, concrete and phonetic poem, off-set printing, Winchester College of Art, class project.

104–111. *Oblique Strategies*, 1974, original mock-up on balsa wood.

112. *Oblique Strategies*, 1975, Brian Eno and Peter Schmidt.

138–141. *White Fence*, 1979, four-monitor video installation.

142–143. *2 Fifth Avenue*, 1979, four-monitor video installation with sound.

145–151. *Mistaken Memories of Mediaeval Manhattan*, 1980–81, four-monitor video installation with sound.

152–155. *Portraits (Manon, Patti, Alex, Janet, Sophie)*, 1981, five-monitor color video installation.

156. *East Village (Blue)*, ca. 1980–82, single channel video with sound.

157. *East Village (Magenta)*, ca. 1980–82, single channel video.

158. *Evening View Over East Chinatown (Views out of focus—Parisian phase)*, ca. 1980–82, single channel video.

159. *The Williamsburg Bridge (Mediaeval View)*, ca. 1980–82, single channel video.

160–161. *Beach (Two Parts)*, ca. 1980–82, single channel video.

162–165. *Slow Waves*, ca. 1980–82, single channel video with sound.

167–173. *Thursday Afternoon (seven video paintings of Christine Alicino)*, 1984, single channel video with sound.

174–175. *Christine*, ca. 1980–83, experimental video treatments for *Thursday Afternoon*.

176–177. *Nude Turning (Four Parts)*, ca. 1980–83, experimental video treatments.

178. *Beach #1*, ca. 1980–83, color enhanced video experiment.

179. *Reflections*, ca. 1980–83, color enhanced video experiment.

180–181. *Panel in the Sun with Dove and Night Frog (Three Sections)*, ca. 1980–83, experimental video treatment.

182. *Broadway (Sunday Morning)*, ca. 1980–82, experimental video treatment.

183. *East Towards Delancey (Midday)*, ca. 1980–82, experimental video treatment.

184. *Spring Street (Saturday, May 1983)*, 1983, experimental video treatment.

199–201. *Crystals*, 1984, notebook pages.

202–205. *Crystals*, 1985, mixed-media installation with modified color television monitor and foam-core constructions with sound. Installation at Art Cologne, Cologne, West Germany: 1985.

207–208. *Pictures of Venice*, 1983–85, notebook pages and views of installations in progress.

ENDNOTES

Chapter 1.1

1. Wassily Kandinsky, *Concerning the Spiritual in Art*, trans. Michael T. H. Sadler (1911; New York: Dover, 1977), 25.

2. Camille Mauclair, "La peinture musicienne et la fusion des arts," *Revue politique et littéraire: Revue bleue*, September 6, 1902, 300: "chromatisme, harmonie, valeur, thème, motif, sont nécessairement en usage dans ces deux arts, et sont employés indifféremment par les musiciens et les peintres." (Translation mine.)

3. Roger Fry, "The French Group," in *The Second Post Impressionist Exhibition*, exh. cat. (London: Grafton Galleries, 1912), 14–15.

4. Synesthesia was the subject of extensive research in the nineteenth century, with studies by the German physician George Sachs and the anthropologist Francis Galton among others.

5. "On Stage Composition" also addressed his belief in the *Gesamtkunstwerk*, or total work of art, for which he found parallels in Wagner's music.

6. Quoted in Howard Risatti, "Music and the Development of Abstraction in America: The Decade Surrounding the Armory Show," *Art Journal* 39 (Fall 1979): 9.

7. "Art/Fluxus Art-Amusement," included in a broadside manifesto published by Fluxus in September 1965; reproduced in *Fluxus Etc: The Gilbert and Lila Silverman Collection,* exh. cat. (Bloomfield Hills, MI: Cranbrook Academy of Art, 1981), 260, no. 565.

8. The Fluxus artist Dick Higgins was the leading theorist of the intermedial approach, which he articulated in a 1966 statement.

9. Eno, quoted in Michael Bracewell, *Re-make, Re-model: Becoming Roxy Music* (Cambridge, MA: Da Capo Press, 2007), 252.

10. Ascott honed his two-year curriculum in the early 1960s while teaching at London's Ealing School of Art, where he brought together an established group of colleagues and collaborators, including R. B. Kitaj, Noel Forster, Bernard Cohen, and Harold Cohen.

11. Originally published in *Cambridge Opinion*, the essay has been widely reprinted. See, for example, Roy Ascott, "The Construction of Change" (1964), in *Roy Ascott: Telematic Embrace, Visionary Theories of Art, Technology, and Consciousness*, ed. Edward A. Shanken (Berkeley: University of California Press, 2007), 97–107.

12. Edward A. Shanken, "From Cybernetics to Telematics: The Art, Pedagogy, and Theory of Roy Ascott" in *Roy Ascott: Telematic Embrace, Visionary Theories of Art, Technology, and Consciousness*, ed. Edward A. Shanken (Berkeley: University of California Press, 2007), 4.

13. Ascott, "The Construction of Change," 103. Other esteemed alumni of the Groundcourse include the guitarist Pete Townshend of the Who, the cybernetics pioneer Gordon Pask, and the conceptual artist Stephen Willats, yet the impact of the Groundcourse (either at Ealing or Ipswich) on subsequent generations of artists and cultural figures remains largely unacknowledged in British art history.

14. Ibid., 104–5.

15. Roy Ascott, "Groundcourse: Background, Theory, Practice," unpublished presentation, 13–17.

16. Emily Pethick, "Degree Zero" *frieze*, no. 101 (September 2006): 14.

17. Eno, lecture for Trent Polytechnic (1974), quoted in Brian Eno and Russell Mills, *More Dark Than Shark* (London: Faber & Faber, 1986), 40.

18. Eno, e-mail correspondence with the author, November 22, 2011.

19. Eno, quoted in Eno and Mills, *More Dark Than Shark*, 40.

20. Eno, quoted in Bracewell, *Re-make, Re-model: Becoming Roxy Music*, 207.

21. Eno, quoted in Lucy O'Brien, "How We Met: Brian Eno and Tom Phillips" (interview with Brian Eno and Tom Phillips), *Independent on Sunday*, September 13, 1998.

22. Ibid.

23. Richard Kostelantez, *Conversing with Cage* (New York: Routledge, 2003), 70.

24. Eno, quoted in O'Brien, "How We Met."

25. Eno, interview in British Arts Council, Sound and the City Lecture Series, October 17, 2005, Beijing, http://www .britishcouncil.org/china-arts-music-satc_be.htm.

26. Eno, quoted in Rob Tannenbaum, "A Meeting of Sound Minds: John Cage and Brian Eno," *Musician* 83 (September 1985): 68.

27. Steve Reich, *Writings on Music, 1965–2000* (Oxford: Oxford University Press, 2002), 19.

28. Ibid.

29. Eno, quoted in Tannenbaum, "Meeting of Sound Minds," 68.

30. These are the instructions for *0'00"*, which Cage wrote in 1962 and is also referred to as *4'33" No. 2*.

31. Arthur Lubow, "Brian Eno: At the Outer Limits of Popular Music, the Ex-Glitter Rocker Experiments with a Quiet New Sound," *People Weekly*, October 11, 1982, 94.

32. Sol LeWitt, "Paragraphs on Conceptual Art" (1967), in *Sol LeWitt: A Retrospective*, ed. Gary Garrels (San Francisco: San Francisco Museum of Modern Art, 2000), 369.

33. This assignment lasted up to ten weeks at a time. Ascott, "Construction of Change," 105.

34. Ibid., 106.

35. Eno, quoted in Shanken, "From Cybernetics to Telematics," 38.

36. Lester Bangs, "Eno," *Musician, Player and Listener* 21 (November 1979): 42.

37. Ibid.

38. Eno, quoted in Bracewell, *Re-make, Re-model: Becoming Roxy Music*, 250.

39. See *Happening & Fluxus*, exh. cat. (Cologne: Kölnischer Kunstverein, 1970).

40. Dick Higgins, "Statement on Intermedia" (August 3, 1966), reprinted in *In the Spirit of Fluxus*, by Elizabeth Armstrong and Joan Rothfuss, exh. cat. (Minneapolis: Walker Art Center, 1993), 172–73.

41. Ken Friedman, *Fluxus & Co.* (New York: Emily Harvey Gallery, 1989), n.p.

42. Lester Bangs, "Brian Eno: A Sandbox in Alphaville." Originally published in *Musician* (1979), http://www.furious.com/perfect/bangseno2.html.

43. Quoted in Douglas Kahn, "The Latest: Fluxus and Music," *In the Spirit of Fluxus*, by Elizabeth Armstrong and Joan Rothfuss, exh. cat. (Minneapolis: Walker Art Center, 1993), 110.

44. Bangs, "A Sandbox in Alphaville."

45. Quoted in Michael Nyman, *Experimental Music: Cage and Beyond* (Cambridge, UK: Cambridge University Press, 1974), 15.

46. Bangs, "A Sandbox in Alphaville."

47. Eno, lecture for Trent Polytechnic (1974), quoted in Eno and Mills, *More Dark Than Shark*, 43.

48. Eno, quoted in Bracewell, *Re-make, Re-model: Becoming Roxy Music*, 252–53.

49. Anthony Benjamin, quoted ibid., 252.

50. Eno, quoted ibid., 252.

Chapter 1.2

51. Eno, in Charles Amirkhanian, "Ode to Gravity" (interview with Brian Eno), KPFA-FM, Berkeley, February 2, 1980, Archive.org/details/BrianEno.

52. In an interview for a BBC program about the Sinfonia, Gavin Bryars disputed the latter requirement, claiming that it was a "scurrilous rumor put out by the BBC." "In Living Memory," interview, BBC Radio 4, August 24, 2011, http://www.bbc.co.uk/programmes/b013fj17.

53. Geoff Brown, "Eno's Where It's At," *Melody Maker*, November 10, 1973, 41.

54. Eno also created the label Obscure Records (1975–78), which released ten albums in quick succession, including his own 1975 *Discreet Music*. The label was started to create a venue for experimental music and included artists such as Gavin Bryars, Christopher Hobbs, John Adams, David Toop, Jan Steele, John Cage, Michael Nyman, John White, Harold Budd, and the Penguin Café Orchestra.

55. John Cage, *Silence: Lectures and Writings* (Middletown, CT: Wesleyan University Press, 1961), 10.

56. Eno, in Amirkhanian, "Ode to Gravity."

57. Eno, quoted in Elizabeth Thompson and David Gutman, eds., *The Bowie Companion* (Cambridge, MA: Da Capo Press, 1996), 148.

58. Brian Eno, liner notes for "My Light Years," *77 Million Paintings*, Lumen London, 2007, DVD. Schmidt, who died in 1980, had a significant impact on many artists of his generation—Eno among them—yet goes largely under-recognized in the history of art. Schmidt was also concerned with merging his art and music interests, which culminated in *A Painter's Use of Sound*, a groundbreaking electronic music performance at London's Institute of Contemporary Art (ICA) in 1967. In addition, he was the music adviser for the landmark exhibition *Cybernetic Serendipity*, curated by Jasia Reichardt at the ICA the following year. It was the first major museum exhibition anywhere that considered the influence of the computer on all aspects of the creative field, including art, music, poetry, dance, sculpture, animation, and electronic music. The exhibition included robots, painting machines, poetry, and music and brought together internationally recognized artists such as John Cage, Nam June Paik, and Jean Tinguely. It had huge attendance and is noted as the first exhibition to analyze the interface between art and technology. See Geeta Dayal, "Brian Eno, Peter Schmidt, and Cybernetics," *Rhizome*, October 21, 2009, Rhizome.org/editorial/2009/oct/21/brian-eno-peter-schmidt-and-cybernetics/. On the ICA's cybernetic exhibition, see Rainer Usselmann, "The Dilemma of Media Art: *Cybernetic Serendipity* at the ICA London," *Leonardo* 36 (October 2003): 389–96.

59. Ascott, "Behaviourist Art and the Cybernetic Vision" (1966–67), in *Roy Ascott: Telematic Embrace, Visionary Theories of Art, Technology, and Consciousness*, ed. Edward A. Shanken (Berkeley: University of California Press, 2007), 109–157.

60. Stafford Beer, *Brain of the Firm: The Managerial Cybernetics of Organization* (London: Allen Lane, 1972), 69.

61. Ibid.

62. Morse Peckham, *Man's Rage for Chaos: Biology, Behavior, and the Arts* (Philadelphia: Chilton, 1965), 68.

63. Ibid., 314.

64. Ibid.

Chapter 1.3

65. Eno, in Steven Leckart, "The Brian Eno Evolution" (interview), *Wired Magazine* 16, no. 6 (May 2008). Wired.com/techbiz/media/magazine/16-06/st_15th_eno?currentPage=all.

66. Gene Youngblood, *Expanded Cinema* (New York: E. P. Dutton, 1970), 41.

67. Eno's acquisition of a video camera and recording equipment came about by happenstance. He was working with the Talking Heads on *Fear of Music* when a roadie in an adjacent studio wandered by trying to sell some equipment. Although initially he was not sure what he was going to do with it, Eno bought the equipment. Eno, "My Light Years," n.p.

68. Ibid.

69. Ibid.

70. Paik was trained as a classical pianist in his native Korea and later studied music history in Germany, where he encountered John Cage, Karlheinz Stockhausen, and others who would encourage his artistic practice.

71. Eno, quoted in Peter Nasmyth, "New Life of Brian," *Observer* (London), January 17, 1988.

72. Brian Eno, liner notes for "Ambient Music" (September 1978), *Ambient 1: Music for Airports*, Opal, 2004, CD.

73. This ongoing interest would be explored in later albums such as *On Land*, *Apollo*, and *Music for Films*.

74. Eno, in Michael Oliver, "Kaleidoscope" (Interview with Brian Eno), BBC Radio 4 (broadcast January 1, 1986), http://www.bbc.co.uk/programmes/p00d941z.

75. Catherine Russell, *Experimental Ethnography: The Work of Film in the Age of Video* (Durham, NC: Duke University Press, 1999), 162.

76. Michael O'Pray, "The Big Wig," *Sight and Sound* 9 (October 1999): 20.

77. Eno, in Sue Lawley, "Desert Island Discs" (interview), BBC Radio 4 (broadcast January 27, 1991), Downloads.bbc.co.uk/podcasts/radio4/dida91/dida91_19910127-1115a.mp3.

78. Malcolm Le Grice, *Abstract Film and Beyond* (Cambridge, MA: MIT Press, 1977), 93.

79. Eno, quoted in David Ross, *Matrix 44: Brian Eno*, exh. cat. (Berkeley: University Art Museum, University of California, Berkeley, 1981), 3.

80. See P. Adams Sitney, "Structural Film," *Film Culture* 47 (Summer 1969): 1–10, and *Visionary Film: The American Avant-garde* (Oxford: Oxford University Press, 1974), 369–97.

81. Le Grice, *Abstract Film and Beyond*, 88.

82. Ibid., 95.

83. Brian Eno, liner notes for *Ambient 4: On Land* (1982, revised February 1986), Music.hyperreal.org/artists/brian_eno/onland-txt.html.

84. Erik Satie, as quoted by Fernand Léger, in Alan M. Gillmor, *Erik Satie* (Boston: Twayne, 1988), 232.

85. Eno, "My Light Years," n.p.

86. Ibid.

87. Five works from this new series were shown in the exhibition *Brian Eno: Crystals* at the Institute of Contemporary Art, Boston, in December 1983.

88. Eno, "My Light Years," n.p.

89. Brian Eno, "Language and Growth: Generative Art," unpublished text, n.p.

90. Eno, "My Light Years," n.p.

91. Noam Chomsky, *Aspects of the Theory of Syntax* (Cambridge, MA: MIT Press, 1965), 4–5.

92. Ibid., 27.

93. M. Miles, *Short Talks to Art Students on Color from an Artist's Standpoint. Also Dealing with the Relations of Color to the Musical Scale* (Kansas City, Missouri, 1914), 97.

94. Paul Sharits, "On the Drawings of 'Locational Pieces,'" Paul Sharits.com/locational.htm.

95. Paul Sharits, "Hearing: Seeing," in *The Avant-garde Film: A Reader of Theory and Criticism*, ed. P. Adams Sitney (New York: New York University Press, 1978), 256.

96. Robert Irwin, "Being and Circumstance: Notes Toward a Conditional Art" (1985), reprinted in *Robert Irwin: Primaries and Secondaries*, exh. cat. (San Diego: Museum of Contemporary Art San Diego, 2008), 181.

97. Eno, quoted in Nasmyth, "New Life of Brian," 42.

98. Brian Eno, liner notes for *Thursday Afternoon* CD (1984), excerpted in "Excerpts from Interviews with Brian Eno," liner notes for *Brian Eno: 14 Video Paintings*, Opal, 2005, DVD.

99. See Russell, "Framing People: Structural Film Revisited," in *Experimental Ethnography*, 157–90.

100. Eno, liner notes for *Thursday Afternoon*.

101. Fischinger also designed a "wax slicing machine" that aided his experiments in abstraction. According to the historian William Moritz, it sliced "very thin layers from a prepared block of wax, with a camera synchronized to take one frame of the remaining surface of the block. Any kind of image could be built into the wax block—a circle getting smaller would be a simple cone, for example." Quoted in Gary Morris, "Oskar Fischinger's Visual Music," *Bright Lights Film Journal* 22 (September 1998), http://www.brightlightsfilm.com/22/fischinger.php Optical Poetry.

102. Cindy Keefer, "'Raumlichtmusik'—Early 20th Century Abstract Cinema Immersive Environments," *Leonardo Electronic Almanac* 16, no. 6–7 (September 2009): 1–5, http://www.leonardo.info/LEA/CreativeData/CD_Keefer.pdf.

103. Oskar Fischinger, "Raumlichtmusik," unpublished typescript, n.d., Fischinger Collection, Center for Visual Music, Los Angeles. Fischinger was well-known throughout Europe before he immigrated to the United States in 1936. In the late 1940s he designed his own version of a color organ, which he called a Lumigraph. The Lumigraph was used for public performances of projections set to music, including a performance at the San Francisco Museum of Art, where it captured the attention of a young Jordan Belson.

104. Eno had become friends with Rolf Engle, who owned Atelier Markgraph, a company in Hamburg, Germany, that specialized in large events like car launches. Engle introduced Eno to a slide projector software called Dataton.

105. For a further discussion of these light shows, see Robin Oppenheimer, "An International Picture Language: The History and Aesthetics of West Coast Light Shows," *Page* (Bulletin of the Computer Art Society) 58 (Autumn 2004), Computer-arts-society.com/uploads/46_4f4b553be890d307689885.pdf.

106. McKay's work has also been presented in a museum context in the form of both performances and solo exhibitions, at New York's Whitney Museum of American Art (1968) and the San Francisco Museum of Modern Art (1999), respectively.

107. For this and other biographical information on Mark Boyle, see Patrick Elliot, *Boyle Family*, exh. cat. (Edinburgh: National Galleries of Scotland, 2003).

108. Eno, "My Light Years," n.p.

109. Schwitters worked in many mediums, from sculpture and painting to collage, graphic design, poetry, and sound. He is a frame of reference in Eno's musical work as well. "Kurt's Rejoinder," from Eno's 1977 album *Before and After Science*, samples Schwitters's recording of his sound poem "Ursonate" (1922–32).

110. Elizabeth Burns Gamard, *Kurt Schwitters' Merzbau: The Cathedral of Erotic Misery* (Princeton, NJ: Princeton Architectural Press, 2000), 94. Schwitters created artwork, which he called *Merz*, using fragments and cast-off materials in an effort to create aesthetic coherence from cultural dissonance. *Merz* represented a new attitude toward the war-ravaged world around him, and as such it included not only his collages and assemblages, but grew more broadly to encompass a periodical published under the same name and even his own advertising agency.

111. Quoted in John Elderfield, *Kurt Schwitters* (London: Thames & Hudson, 1985), 31.

112. Eno, in Leckart, "Brian Eno Evolution."

113. The environment premiered at Munich's Galerie Heiner Friedrich and from 1979 to 1985 was established as an installation on Harrison Street in Lower Manhattan under the auspices of the Dia Art Foundation. It subsequently moved to Church Street, where it has remained continuously on view for nearly twenty years.

114. La Monte Young and Marian Zazeela, "Kontinuierliche Klang-Licht-Environments," *Inventionen '92* (Berlin: Pfau Verlag & Berliner Künstlerprogramm des DAAD, 1992), 45: "ein lebendiger Organismus mit einem eigenen Leben und einer eigenen Tradition in der Zeit existieren würde."

115. Ibid.

116. Eno, "My Light Years."

117. Eno chose a "deliberately clunky" title for the work because he wanted it to suggest "an architectural submission for a new space." See Jesse Hamlin, "Eno Assembles Lush Soundscape, an Urban Retreat within SFMOMA," *San Francisco Chronicle*, February 17, 2001.

118. Sites included Notting Hill, Old Brompton Road, the Oval, Regents Park, Barbican Station, Bermondsey, Kentish Town, Lavender Hill, and Camden Town.

119. Brian Eno, liner notes for *Music for White Cube*, Opal, 1997, CD.

120. Anthony Korner, "Aurora Musicalis" (interview with Brian Eno), *Artforum* 24 (Summer 1986): 77.

121. Thom Holmes, *Electronic and Experimental Music: Technology, Music, and Culture* (New York: Routledge, 2008), 49.

122. In a similar fashion, the following year Eno collaborated with Jiří Příhoda on *Music for Prague*. While the Prague piece was composed of traditional sounds, the installation was at its core an inaccessible space—a gallery constructed inside out to which visitors had no access other than the narrow corridor around the perimeter.

Chapter 2

1. W. G. Sebald, *The Rings of Saturn*, trans. Michael Hulse (London: Harvill, 1998), 207–8.

2. Ibid., 222.

3. Ibid., 229.

4. David Sheppard, *On Some Faraway Beach: The Life and Times of Brian Eno* (London: Orion, 2008), 16–24.

5. Michael Bracewell, *Re-make/Re-model: Art, Pop, Fashion and the Making of Roxy Music, 1953–1972* (London: Faber, 2007), 187–88.

6. Sebald, *Rings of Saturn*, 64, 181ff.

7. Sheppard, *On Some Faraway Beach: The Life and Times of Brian Eno*, 203.

8. Anthony Korner, "Aurora Musicalis" (interview with Brian Eno), *Artforum* 24 (Summer 1986): 77.

9. Ibid.

10. Sheppard, *On Some Faraway Beach: The Life and Times of Brian Eno*, 200.

11. Sebald, *The Rings of Saturn*, 235–36.

12. Ibid., 154.

13. Henry James, "Old Suffolk," in *English Hours* (London: I. B. Tauris, 2011), 181.

14. Jörg Heiser, "Emotional Rescue," *frieze*, no. 71 (November–December 2002): 72.

15. See, for example, Mark Fisher, "Suffolk Hauntology: Some Provisional Notes," accessed August 27, 2012, K-punk.abstract-dynamics.org/archives/009474.html; David Toop, *Haunted Weather: Music, Silence, and Memory* (London: Serpent's Tail, 2005); and *Sinister Resonance: The Mediumship of the Listener* (London: Continuum, 2012). A specifically sonic lineage of this English tendency to romantic conceptualism would have also to include certain cinematic precursors, chief among them the mid-century films of Michael Powell and Emeric Pressburger, which suggest that the landscape is precisely haunted by sounds and voices from a romantic or romanticized past: the voices or song of medieval pilgrims, or pastoralized shepherds. The prime examples are *A Canterbury Tale* (1944), *A Matter of Life and Death* (1946), and *Gone to Earth* (1950), from which the present takes its title.

Chapter 4

1. Steven Grant, "Brian Eno Against Interpretation," *Trouser Press* 76 (1982), http://music.hyperreal.org/artists/brian_eno/interviews/troup82a.html.

2. "Brian Eno's Luminous Media Conference," accessed August 5, 2012, http://www.moredarkthanshark.org/feature_luminous2.html.

3. "Brian Eno's Illustrated Talk at Moogfest 2011," accessed July 30, 2012, http://www.youtube.com/watch?NR=1&v=OnR1ogLvNiE.

4. John Cage, "A Year from Monday" in Jasia Reichardt, "*Cybernetic Serendipity*: The Computer and the Arts," *Studio International* (1968): 25.

5. Ibid, 11.

6. "Chain Reaction: Alan Moore vs. Brian Eno," BBC, February 3, 2005, http://www.moredarkthanshark.org /eno_int_bbc-feb05.html.

7. David Sheppard, *On Some Faraway Beach: The Life and Times of Brian Eno* (Chicago: Chicago Review Press, 2009), 17.

8. Brian Eno, "Brian Eno on Bizarre Instruments," *The Telegraph*, October 15, 2011, http://www.telegraph.co.uk /culture/music/rockandpopfeatures/8825418/Brian-Eno-on -bizarre-instruments.html.

9. John Cage Database, accessed July 30, 2012, http://www. johncage.info/workscage/bacchanale.html.

10. "All Tomorrow's Parties," Wikipedia, accessed July 30, 2012, http://en.wikipedia.org/wiki/All_Tomorrow's_Parties.

11. See, for example, "Untitled Composition for Piano, Field Recordings, and Sine Waves," accessed July 30, 2012, http://01sj. org/2010/performance/untitled-composition/.

12. "Lester Bangs Interviews Eno," *Musician* (1979), http:// music.hyperreal.org/artists/brian_eno/interviews/musn79.html.

13. "Internet Users' Glossary," accessed August 4, 2012, Tools. ietf.org/html/rfc1392.

14. J.M. Graetz, "The Origin of Spacewar," accessed August 4, 2012, http://www.wheels.org/spacewar/creative/SpacewarOrigin. html.

15. Ibid.

16. "Cory Arcangel, *Super Mario Clouds*," MediaArtNet, accessed July 30, 2012, http://www.medienkunstnctz.de/works/ super-mario-cloud/.

17. Sheppard, *On Some Faraway Beach: The Life and Times of Brian Eno*, 67.

18. Sheppard, *On Some Faraway Beach: The Life and Times of Brian Eno*, 71.

19. "The Studio as Compositional Tool," *Downbeat*, Part I, 50(7):56–57 (July 1983), and Part II, 50(8):50–52 (August 1983), Music.hyperreal.org/artists/brian_eno/interviews/downbeat79. htm.

20. "Background: Bell Labs Text-to-Speech Synthesis: Then and Now Bell Labs and 'Talking Machines,'" accessed July 30, 2012, http://www.belllabs.com/news/1997/march/5/2.html. Arthur C. Clarke happened to be at this demo and in *2001: A Space Odyssey*, when HAL broke down he played Daisy because that was what he was first programmed with.

21. "Homebrew meets the Altair," accessed July 30, 2012, http:// startup.nm.naturalhistory.org/gallery/story.php?ii=46.

22. "Bicycle Built for 2,000" website, accessed July 30, 2012, http://www.bicyclebuilt-fortwothousand.com/; YouTube video explanation of the project, accessed July 30, 2012, http://www.youtube.com /watch?v=Gz4OTFeE5JY.

23. "Oblique Strategies," Eno Shop, accessed July 30, 2012, http://enoshop.co.uk/shop/oblique/.

24. Hans Ulrich Obrist, "DO IT," accessed July 30, 2012, http:// www.e-flux.com/projects/do_it/homepage/do_it_home.html.

25. Guy Debord, "Theory of the Derive," accessed August 4, 2012, http://www.cddc.vt.edu/sionline/si/theory.html; "Introduction to a Critique of Urban Geography," accessed August 4, 2012, http://www.cddc.vt.edu/sionline/presitu/geography.html.

26. "Dérive," Wikipedia, accessed August 4, 2012, http://en.wikipedia.org/wiki/Dérive.

27. "Music of Changes," John Cage Database, accessed August 4, 2012, http://www.johncage.info/workscage/musicchanges. html.

28. Kevin Concannon, "Cut and Paste: Collage and the Art of Sound," *Sound by Artists* (Toronto: Art Metropole and Walter Phillips Gallery, 1990), http://www.ubu.com/papers/concannon. html.

29. Rob Tannenbaum, "A Meeting of Sound Minds: John Cage and Brian Eno," *Musician* (June 1985), http://www.moredark-thanshark.org/eno_int_musician-jun85.html.

30. Brian Eno, "Generative Music," *In Motion* (July 1996), http:// www.inmotionmagazine.com/eno1.html.

31. "Arena—Brian Eno—Another Green World," accessed July 30, 2012, http://www.youtube.com/watch?feature =endscreen&v=CPOz5-rcIeA&NR=1.

32. Brian Eno, "Generative Music."

33. Ibid.

34. Steve Dietz, "Sol Lewitt: Instructional Artist," accessed July 30, 2012, http://www.yproductions.com/WebWalkAbout/archives/ sol_lewitt_instructional_artis.html.

35. Ibid.

36. Steve Dietz, "Seriality and the Computational Sublime," accessed July 30, 2012, http://www.yproductions.com /writing/archives/seriality_and_the_computationa.html.

37. Steven Grant, "Brian Eno Against Interpretation," *Trouser Press*, August 1982.

38. "Anthony Stafford Beer," Wikipedia, accessed July 30, 2012, http://en.wikipedia.org/wiki/Anthony_Stafford_Beer.

39. Kevin Kelly, "Gossip Is Philosophy," *Wired 3* (May 1995), http://www.wired.com/wired/archive/3.05/eno.html.

40. Eric Tamm, *Brian Eno: His Music and the Vertical Color of Sound*, accessed July 30, 2012, http://www.pdfhacks.com/eno/ BE.pdf, p. 60.

41. "Will Wright and Brian Eno Play with Time," accessed July 30, 2012, http://fora.tv/2006/06/26/Will_Wright_and_Brian_Eno.

42. Randy Kennedy, "News Flows, Consciousness Streams: The Headwaters of a River of Words," *New York Times*, October 25, 2007, http://www.nytimes.com/2007/10/25/arts/design/25vide. html.

43. Ibid.

44. Kevin Kelly, "Gossip Is Philosophy," *Wired*, 3.05 (1995), http://www.wired.com/wired/archive/3.05/eno.html.

45. "Brian Eno, 'Generative Music 1,'" MediaArtNet, accessed July 30, 2012, http:// www.medienkunstnetz.de/works/generative-music-1/. In the mid-1990s, Eno was given access to a beta version of Koan Pro, a parametric software program that allows the user to establish and define a range of parameters within which the computer then generates a composition. For further information, see Tjark Ihmels and Julia Riedel, "The Methodology of Generative Art," MediaArtNet, accessed July 30, 2012, http://www. medienkunstnetz.de/themes/generative-tools/generative-art/7/.

46. "AARON the artist—Harold Cohen," accessed July 30, 2012, http://www.pbs.org/safarchive/3_ask/archive/qna/3284_cohen.html.

47. Kevin Kelly, "Gossip Is Philosophy," *Wired*, 3 (May 1995), http://www.wired.com/wired/archive/3.05/eno.html.

48. "Brian Eno," *Time Out Sydney*, updated May 5, 2010, http://www.au.timeout.com/sydney/the-bridge/features/4583/brian-eno-curator-of-luminous-vivid-sydney.

49. "Generative Music" website, accessed July 30, 2012, http://www.generativemusic.com/.

50. Eric Tamm, *Brian Eno: His Music and the Vertical Color of Sound*, p. 62.

51. Kevin Kelly, "Gossip Is Philosophy," *Wired*, 3 (May 1995), http://www.wired.com/wired/archive/3.05/eno.html.

52. Edward A. Shanken, "Cybernetics and Art: Cultural Convergence in the 1960s," in *From Energy to Information*, eds. Bruce Clarke and Linda Dalrymple Henderson (Palo Alto, CA: Stanford University Press, 2002): 155–77.

53. Roselee Goldberg, "BrianEno: Talk at Museum of Modern Art," accessed July 30, 2012, http://www.moredarkthanshark.org/feature_opal_info_19-1991.html.

54. Simon Nora and Alain Minc, The Computerization of Society: A Report to the President of France (Cambridge, MA: MIT Press, 1979): 17.

55. Kevin Kelly, "Gossip Is Philosophy," *Wired*, 3 (May 1995), http://www.wired.com/wired/archive/3.05/eno.html.

Chapter 1.4

123. Korner, "Aurora Musicalis," 78.

124. Barbara Kienscherf, "From the 'Ocular Harpsichord' to the 'Sonchromatoscope': The Idea of Colour Music and Attempts to Realize It," in *Summer of Love: Psychedelic Art, Social Crisis, and Counterculture in the 1960s*, eds. Christoph Grunnenberg and Jonathan Harris (Liverpool, UK: Liverpool University Press and Tate Liverpool, 2005), 189.

125. The first public performance took place at New York's Carnegie Hall in 1915. See Kenneth Peacock, "Instruments to Perform Color-Music: Two Centuries of Technological Experimentation," *Leonardo* 21, no. 4 (1988): 402. The instrument for the New York premiere was designed by Preston S. Miller, president of the Illuminating Engineering Society, who named it the Chromola.

126. Ibid., 404. For instance, the Australian inventor Alexander Hector argued that on his color instrument middle C translated to yellow, whereas on Rimington's it corresponded to red, and on Castel's to blue.

127. Ibid. Wilfred's instrument was built at a cost of $16,000, which represented a considerable investment at a time when, according to the U.S. Bureau of Labor Statistics, average weekly earnings were $25.61.

128. Ibid., 405.

129. Wilfred became the first *Lumia* artist to be featured at the *Exposition des Arts Décoratifs* in Paris, and while in Europe he presented his work in recitals in London as well as in a command performance at the Royal Opera House in Copenhagen. See John Gage, *Color and Culture: Practice and Meaning from Antiquity to Abstraction* (Berkeley: University of California Press, 1999), 246.

130. "New Kind of Painting Uses Light as Medium: Color Forms Projected on Canvas through Lenses in Box in Invention of Wilfred," *New York Times*, December 8, 1931.

131. Sheldon Cheney, *A Primer for Modern Art* (New York: Boni & Liveright, 1924), 188. The *Lumia* were also included in Willard Huntington's *The Future of Painting* (1923).

132. Curated by Dorothy Miller, the Modern's series of *Americans* exhibitions began in 1942 and continued until the early 1960s. The exhibitions championed a limited number of artists in order to present their work in greater depth, presenting the work of both new talent and established figures. At age sixty-three, Wilfred was the oldest artist included in the 1952 exhibition.

133. *15 Americans*, exh. cat. (New York: Museum of Modern Art, 1952), 30.

134. Korner, "Aurora Musicalis," 78.

135. Gerhard Richter, "Notes for a Press Conference, 28 July 2006," in *Gerhard Richter: Text, Writings, Interviews, and Letters, 1961–2007*, eds. Dietmar Elger and Hans-Ulrich Obrist (London: Thames & Hudson, 2009), 517–18.

136. Monsignor Josef Sauerborn, quoted in "Cologne Cathedral Gets New Stained-Glass Window," *Der Spiegel*, August 27, 2007, http://www.spiegel.de/international/zeitgeist/0,1518,502271,00.html.

137. Dustin Driver, "Brian Eno: Let There Be Light," Profiles, Apple.com, www.apple.com/pro/profiles/eno/.

138. Ibid. True to Eno's original vision, the work is also available as a DVD for single-monitor home viewing.

139. Lumen London, "Luminescence: Exhibiting *77 Million Paintings*," liner notes for *77 Million Paintings*, Opal, 2007, DVD. According to the notes, "they did a cluster in the form of a colour-pyramid. We also made a reference to the infinite aspect of the piece by mirroring the walls and floor so the pyramid shape was multiplied into a symmetrical diamond disappearing into the far distance."

140. "The Lambeth Walk" is a song from the 1937 musical *Me and My Girl* and inspired a dance popularized the same year.

141. Lye, quoted in Ray Thorburn, "Interview with Len Lye," *Art International* 19 (April 1975): 65.

142. A. L. Rees, *A History of Experimental Film and Video* (London: British Film Institute, 1999), 6.

143. Lev Manovich, *The Language of New Media* (Cambridge, MA: MIT Press, 2001), 306.

144. The series was curated by the experimental filmmaker Frank Stauffacher.

145. Cindy Keefer, "Jordan Belson," in *The Third Mind: American Artists Contemplate Asia, 1860–1989*, ed. Alexandra Munroe, exh. cat. (New York: Solomon R. Guggenheim Museum, 2009), 399.

146. The planetarium had state-of-the-art projection and sound equipment, with thirty-eight speakers configured in a circle and projection devices including a custom-built Starfield projector that created a three-dimensional audiovisual extravaganza. A custom-built rotary mechanism allowed Jacobs to "whirl" the sound around the space. See David E. James, "Light Shows/ Multimedia Shows," http://www.see-this-sound.at/print/79.

147. Vortex III Program Notes, January 1958, Belson Collection, Center for Visual Music, Los Angeles.

148. Manovich, *Language of New Media*, 15.

149. Eno, in Gene Kalbacher, "Profile: Brian Eno" (interview), *Modern Recording and Music* (October 1982): 50.

150. Brian Eno, "Presence and the Perfect Conversation: The Digital Original," unpublished notes.

151. Brian Eno, "Perfume, Defense, and David Bowie's Wedding" in this volume, p. 225. Emphasis added.

152. Brian Eno, "Presence and the Perfect Conversation: The Digital Original," unpublished notes.

153. Manovich, *Language of New Media*, 19.

154. Mark Prendergast, "Brian Eno: A Fervent Nostalgia for the Future; Thoughts, Words, Music, and Art, Part One," *Sound on Sound* (January 4, no. 3, 1989), music.hyperreal.org/artists/ brian_eno/interviews/sos1.html.

155. Brian Eno, "Generative Music," in *A Year with Swollen Appendices* (London: Faber & Faber, 1996), 332.

156. Prendergast, "Fervent Nostalgia for the Future."

157. Eno, in British Arts Council, Sound and the City lecture Series, October 17, 2005, Beijing.

158. Eno, in Korner, "Aurora Musicalis," 79.

159. Eno, in Driver, "Let There Be Light."

p. 125. *Shutter Interface*: © The Estate of Paul Sharits. Photo: Gil Blank, courtesy Greene Naftali, New York.

p. 125. **Installation drawing**: © The Estate of Paul Sharits, courtesy Greene Naftali, New York.

p. 126. *Untitled*: © Robert Irwin / Artists Rights Society (ARS), New York. Photo: Philipp Scholz Rittermann, courtesy the Museum of Contemporary Art, San Diego.

p. 129. *Thursday Afternoon* **video still**: © Opal Ltd.

p. 129. *The Messenger* **video still**: © Bill Viola. Photo: Kira Perov, courtesy Bill Viola.

p. 129. *Motion Painting No. 1* **film still**: © Center for Visual Music, courtesy Center for Visual Music and The Fischinger Trust.

p. 131. **Fischinger**: © Fischinger Trust. Courtesy The Center for Visual Music, the agent for the Fischinger Trust.

p. 131. *Natural Selections* **slides**: © 1990 Opal Ltd. Photo: Nick Robertson, courtesy Opal Ltd.

p. 132. **Jefferson Airplane performance**: © Robert Altman, courtesy Robert Altman.

p. 133. **Boyle and Hills/The Sensual Laboratory**: © Sebastian Boyle, courtesy Sebastian Boyle.

p. 134. *Merz Building*: © ARS, New York. Photo: Wilhelm Redemann, courtesy Kurt Schwitters Archives at the Sprengel Museum, Hannover.

p. 135. **Young and Zazeela, *Dream House***: © 1993 Marian Zazeela. Photo: Marian Zazeela, courtesy MELA Foundation and Marian Zazeela.

p. 138–184. © Opal Ltd.

p. 199–201. *Crystals*, **notebook drawings**: © Opal Ltd.

p. 202–203. *Crystals*: © Opal Ltd. Photo: Roland Lambrette, courtesy Atelier Markgraph.

p. 204. *Crystals*: © Opal Ltd. Photo: Roland Lambrette, courtesy Atelier Markgraph.

p. 205. *Crystals*: © Opal Ltd. Photo: Roland Lambrette, courtesy Atelier Markgraph.

p. 207. *Pictures of Venice* **notebook drawing**: © Opal Ltd.

p. 208. Top: © The Exploratorium. Photo: Esther Kutnick, courtesy The Exploratorium.

p. 208. Bottom: © 1985 Opal Ltd. Photo: Michael Brook, Courtesy Opal Ltd.

p. 209. © 1985 Opal Ltd. Photo: Roland Lambrette, courtesy Atelier Markgraph.

p. 210–211. © 1985 Opal Ltd. Photo: Roland Lambrette, courtesy Atelier Markgraph.

p. 212–213. © 1985 Opal Ltd. Photo: Roland Lambrette, Atelier Markgraph.

p. 215. © 1990 Opal Ltd. Photo: Roland Blum, courtesy Atelier Markgraph.

p. 216–217. © 1990 Opal Ltd. Photo: Roland Blum, courtesy Atelier Markgraph.

p. 218–219. © 1990. Photos: Rolf M. Engel, courtesy Atelier Markgraph.

p. 220. © 1990 Opal Ltd. Photo: Roland Blum, courtesy Atelier Markgraph.

p. 221–235. © 1992 Opal Ltd.

p. 236–239. © 1989 Opal Ltd. Photo: Heiko Profe-Bracht. Courtesy Atelier Markgraph.

p. 240. © ca. 1985–2005 Opal Ltd. Photo: Claude Michaud. Courtesy Atelier Markgraph.

p. 241. © ca. 1985–2005 Opal Ltd. Photo: Claude Michaud. Courtesy Atelier Markgraph.

p. 242. © 1989 Opal Ltd. Photo: Rolf M. Engel, courtesy Atelier Markgraph.

p. 243. © 1989 Opal Ltd. Photo: Rolf M. Engel, courtesy Atelier Markgraph.

p. 244–245. © 1999 Opal Ltd. Photo: Rolf M. Engel, courtesy Atelier Markgraph.

p. 246–247 © 1988 Opal Ltd. Photo: J. Newbury, courtesy Atelier Markgraph.

p. 248–249. © 1998 Opal Ltd. Photo: Peter Oszvald, courtesy Atelier Markgraph.

p. 250–251. © 1998 Opal Ltd. Photo: Peter Oszvald, courtesy Atelier Markgraph.

p. 252–253. © 1997 Opal Ltd. Photo: Roland Blum, courtesy Atelier Markgraph.

p. 254–255. © 2005 Opal Ltd. Photo: Nick Robertson, courtesy Opal Ltd.

p. 256–257. © 2005 Opal Ltd. Photo: Roland Blum, courtesy Opal Ltd.

p. 258–259. © ca. 2000s Opal Ltd. Photo: Margherita Spiluttini, courtesy Atelier Markgraph.

p. 260. © ca. 2000s Opal Ltd. Photo: Margherita Spiluttini, courtesy Atelier Markgraph.

p. 261. © 1988 Opal Ltd. Photo: Heiko Profe-Bracht, courtesy Atelier Markgraph.

p. 262. © 1988 Opal Ltd. Photo: T. Schwarz, courtesy Atelier Markgraph.

p. 263. © 1988 Opal Ltd. Photo: Heiko Profe-Bracht, courtesy Atelier Markgraph.

p. 264–265. © 1985 Opal Ltd. Photo: Bo Forslind, courtesy Atelier Markgraph.

p. 266–267. © 1988 Opal Ltd. Photo: J. Newbury, courtesy Atelier Markgraph.

p. 268. © 1985 Opal Ltd. Photo: Bo Forslind, courtesy Atelier Markgraph.

p. 269. © 1985 Opal Ltd. Photo: Lutz Deppe, courtesy Atelier Markgraph.

p. 270–271. © 1985 Opal Ltd. Photo: Roland Lambrette, courtesy Atelier Markgraph.

p. 272–273. © 1985 Opal Ltd. Photo: Roland Lambrette, courtesy Atelier Markgraph.

p. 274. © 1989 Opal Ltd. Photo: Heiko Profe-Bracht, courtesy Atelier Markgraph.

p. 275. © 1989 Opal Ltd. Photo: Heiko Profe-Bracht, courtesy Atelier Markgraph.

p. 276–277. © 1988 Opal Ltd. Photo: Heiko Profe-Bracht, courtesy Atelier Markgraph.

p. 278–279. © 1993 Opal Ltd. Photo: Amparo Garrido, courtesy Atelier Markgraph.

p. 280–281. © 1993 Opal Ltd. Photo: Amparo Garrido, courtesy Atelier Markgraph.

p. 283. © 1993 Opal Ltd. Photo: Roland Blum, courtesy Atelier Markgraph.

p. 284–285. © 1993 Opal Ltd. Photo: Roland Blum, courtesy Atelier Markgraph.

p. 286. © 1993 Opal Ltd. Photo: Roland Blum, courtesy Atelier Markgraph.

p. 289. *Cybernetic Serendipity* **exhibition poster**: Photo: © Institute of Contemporary Arts, London. Poster: © Tate Images, courtesy of The Tate, London.

p. 292. *Super Mario Clouds*: © Cory Arcangel, courtesy Cory Arcangel.

p. 294–295. *Bicycle Built for Two Thousand*: © Aaron Koblin and Daniel Massey, courtesy of Aaron Koblin.

p. 296. *How to Kill a Bug*: © John Baldessari, courtesy John Baldessari Studio.

p. 299. *Life vs. Life*: © Eric Ishii Eckhardt and Justin Bakse, courtesy Eric Ishii Eckhardt.

p. 300. *Moveable Type*: © Ben Rubin and Mark Hansen, courtesy Ben Rubin / EAR Studio.

p. 302. *Untitled*: © Harold Cohen, courtesy Harold Cohen.

p. 306–307. *Music for White Cube*: © 1997 Opal Ltd. / White Cube. Photo: Stephen White, courtesy White Cube.

p. 308–309. *Music for Prague*: © 1998 Opal Ltd. and Brian Eno / Jiří Příhoda. Photos: Martin Polák, courtesy Jiří Příhoda.

p. 310–311. *Kite Stories*: © 1999 Opal Ltd. Photo: Rolf M. Engel, courtesy Atelier Markgraph.

p. 312. *Blisses 1–87 Koans 1–29* **notebook page**: © 2000 Opal Ltd.

p. 313–315. **Digital stills from** *Blisses 1–87 Koans 1–29*: © 2000 Opal Ltd.

p. 317–319. *Speaker Flowers*: © 2000 Opal Ltd. Photo: Nick Robertson, courtesy Opal Ltd.

p. 320–321. *Lydian Bells*: © 2008 Opal Ltd. Photo: Nick Robertson, courtesy Opal Ltd.

p. 322. *Lydian Bells*: © 2008 Opal Ltd. Photo: Nick Robertson, courtesy Opal Ltd.

p. 323. **Installation view,** *Lydian Bells*: © The Wellcome Trust and The Science Museum, London, 2003. Photo: Gitta Gschwendtner, image courtesy Gitta Gschwendtner.

p. 324–325. *Bloom* **iPhone app**: © 2008 Opal Ltd. Photo: Patrick Kelley.

p. 326–327. *Trope* **iPhone app**: © 2009 Opal Ltd. Photo: Patrick Kelley.

p. 328. *Bloom* **iPad app**: © 2010 Opal Ltd. Photo: Patrick Kelley.

p. 331. **Rimington and his color organ**: Courtesy *Cabinet Magazine*.

INDEX

Page numbers in italics indicate photographs.

CONTRIBUTOR BIOGRAPHIES

A native of England, **Christopher Scoates** is a writer and curator whose interests encompass contemporary art and technology, design, and experimental sound. His projects include art and technology exhibitions such as *Lou Reed, Metal Machine Trio: The Creation of the Universe*, an ambisonic 3-D re-creation of the 1975 album *Metal Machine Music*, and *TAMPER: A Gestural Interface for Cinematic Design*, as well as *Picturing Power: The Art of Paul Shambroom* (2008), *LOT-EK: MDU* (2004), and *Green Acres: Neo-Colonialism in the United States* (1996). He is the author of *Bullet Proof...I Wish I Was: The Lighting and Stage Design of Andi Watson* (2011). He has contributed to numerous exhibition catalogues, and his writings have appeared in *New Art Examiner, Sculpture*, and *Art Papers*. He is also the co-founder of *5-D: The Immersive Design Conference*, a national conference about progressive film design, narrative media, and new technology. He is currently the Director of the University Art Museum, California State University, Long Beach.

Roy Ascott's most recent exhibition *Syncretic Cybernetics* was part of the 9th Shanghai Biennale, 2012. His most recent book is *The Future is Now: Art, Technology, and Consciousness* (Gold Wall Press, Beijing, 2012). He is the President of the international research network Planetary Collegium, based at Plymouth University in the United Kingdom, and is the DeTao Master of Technoetic Arts at the Beijing DeTao Masters Academy in China.

Steve Dietz is the founding Artistic Director of the biennial 01SJ Global Festival of Art on the Edge. He is also the founder and Executive Director of Northern Lights.mn, an interactive, media-oriented arts organization, which presents innovative art in the public sphere, focusing on artists creatively using technology to engender new relations between audience and artwork and more broadly between citizenry and their built environment. He is the former Curator of New Media at the Walker Art Center in Minneapolis, Minnesota, where he founded the New Media Initiatives department in 1996, the online art Gallery 9, and the digital art study collection. He founded one of the earliest, museum-based, independent new media programs at the Smithsonian American Art Museum in 1992. Dietz has written extensively and speaks widely about the art formerly known as new media.

Brian Dillon is UK editor of *Cabinet* magazine and Tutor in Critical Writing at the Royal College of Art. His books include *I Am Sitting in a Room* (Cabinet, 2011), *Sanctuary* (Sternberg Press, 2011), *Tormented Hope* (Penguin, 2009) and *In the Dark Room* (Penguin, 2005). He writes regularly for the *Guardian, London Review of Books, Artforum*, and *Wire*. He lives in Canterbury, UK.

Brian Peter George St. John le Baptiste de la Salle Eno was born in Suffolk, England in 1948. After graduating from Winchester School of Art, Eno began experimenting with the medium of television and manipulating light. Soon thereafter, he became globally known for his work as a musical collaborator with international rock musicians including Roxy Music, U2, Coldplay, and David Bowie among many others. His own series of Ambient records has influenced a whole generation of artists and artistic styles and he continues to be a major reference point for musicians, artists, and thinkers from all walks of life.

William R. Wright is an American computer game designer and co-founder of the video game developer Maxis. He is best known as the original designer of two groundbreaking computer games, *SimCity* and *The Sims*.

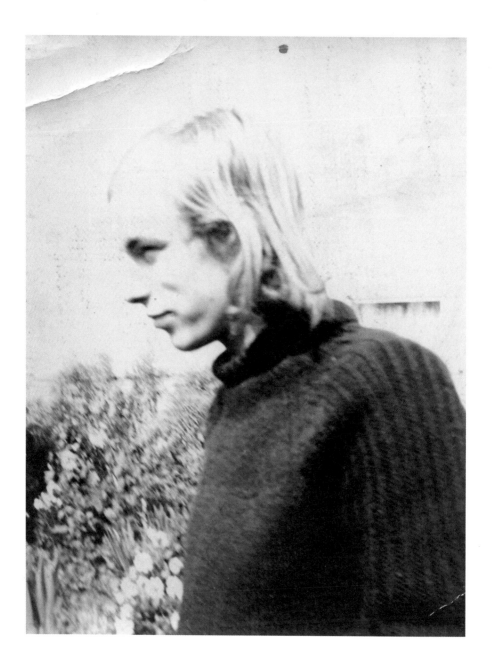